Shake, Rattle, and Shoot
The Business of Baby Photography

By Brooke Mayo

Course Technology PTR

A part of Cengage Learning

COURSE TECHNOLOGY
CENGAGE Learning·

Australia, Brazil, Japan, Korea, Mexico, Singapore, Spain, United Kingdom, United States

COURSE TECHNOLOGY
CENGAGE Learning

Shake, Rattle, and Shoot:
The Business of Baby Photography

Brooke Mayo

Publisher and General Manager,
Course Technology PTR: Stacy L. Hiquet

Associate Director of Marketing: Sarah Panella

Manager of Editorial Services: Heather Talbot

Marketing Manager: Mark Hughes

Acquisitions Editor: Dan Gasparino

Development Editor: Cathleen D. Small

Project Editor/Copy Editor: Cathleen D. Small

Technical Reviewer: Mary Heath Swanson

Interior Layout Tech: Judy Littlefield

Cover Designer: Mike Tanamachi

Indexer: Kelly Talbot Editing Services

Proofreader: Kelly Talbot Editing Services

For product information and technology assistance, contact us at
Cengage Learning Customer & Sales Support Center, 1-800-354-9706

For permission to use material from this text or product, submit all requests online at **cengage.com/permissions**
Further permissions questions can be emailed to
permissionrequest@cengage.com

All trademarks are the property of their respective owners.

All images © Cengage Learning unless otherwise noted.

Library of Congress Control Number: 2011936051

ISBN-13: 978-1-4354-5774-4

ISBN-10: 1-4354-5774-9

Course Technology, a part of Cengage Learning
20 Channel Center Street
Boston, MA 02210
USA

Cengage Learning is a leading provider of customized learning solutions with office locations around the globe, including Singapore, the United Kingdom, Australia, Mexico, Brazil, and Japan. Locate your local office at: **international.cengage.com/region**

Cengage Learning products are represented in Canada by Nelson Education, Ltd.

For your lifelong learning solutions, visit **courseptr.com**

Visit our corporate website at **cengage.com**

Printed in the United States of America
1 2 3 4 5 6 7 13 12 11

This book is dedicated to my amazing hubby.
Without his love, support, ideas, and help,
I never could've written this book.
He made me a wife and a mother and shows
me every day how selfless love is.

It's also dedicated to our daughter, Poppy Day.
She inspired me to photograph beebsters and write the book,
and she reminds me daily that no matter how important
I think work is, family is always more important.

About the Author

In addition to holding a fine arts degree in photography, **Brooke Mayo** has trained with world-renowned portrait and dance photographers from Australia to New York City. She has been featured in international publications such as *Grace Ormonde*, *Destination Weddings and Honeymoons*, and *Brides* magazine. Brooke has received numerous awards from the Wedding Photojournalist Association. Her first book, *Diving Doggies: A Celebration of Play Underwater*, was published in 2009. She resides in the Outer Banks of North Carolina. Visit her website at www.brookemayo.com.

Acknowledgments

I would like to send a massively huge thank you to Course Technology PTR for giving me the opportunity to write this book. My editor, Cathleen Small, is beyond amazing—always helping me with wording, what to include, how to say it, and which images to include...all the while growing her own beebster and taking care of her three-year-old! Thank you to Dan Gasparino for all his help and ideas and for believing in me!

Thank you to Mary Heath Swanson (www.maryheath.com) for being my wondersum technical editor, my idea gal, and the best listener and problem solver!

Thank you to Sara Ensey (scriptacuity.com), my editor before Cathleen and my dear friend, for helping me with the book proposal and providing tons of encouragement and help throughout the process!

Without my amazing clients and friends, I would have no business, so THANK YOU! Thank you for trusting me to document your lives and be a part of your child's life. You're wonderful, and I'm grateful every day for you!

Thank you to my dad and moms for raising me to know I can do anything I want to and for giving me life. To my sister for being the best sister ever and for watching Poppy for countless hours while I wrote. To my grandparents for raising my parents so they could raise me, and for being a constant support. And to my brothers for loving and helping me.

And to my new parents who I married into in 2007, thank you every day for everything you do for us. We are so lucky to have you! You make our life what it is, and you make Poppy's world go 'round. Thank you for all your hard work, past and present, that allows us to have the life we have today. Thank you for loving me like your own and for being the best Mimi and Pawpaw a kid could ask for!

Thank you to John and Poppy for your love, inspiration, and help and for the fun you bring to my life daily. I love you to the moon and back and back again. You're my amazing fruits; you complete the PB&J.

Contents

Chapter 5: Photographing the Miracle of Life: Birth through the First Year 127

Chapter 6: Post-Production 193

Introduction

In 2010, I was blessed by the birth of my first child, Poppy. Naturally, as a photographer and a mother, I took pictures of my own beautiful beebster all the time! Little did I know, there was a blessing in disguise in this new addition to our family—my child inspired a new development in my career, and I began photographing babies. They are full of so much life and emotion, and it's so special to capture babies learning and growing. Every day of life is new and exciting for a baby—they are insatiably curious and full of surprises, tears, smiles, and laughter.

Documenting babies' growth and experiences has become a huge part of my life and career. It has filled me with excitement as I strive to come up with creative ways to photograph babies in different environments, which never fail to evoke natural, genuine expressions of emotion from the precious beebsters.

Because I live so close to the ocean, I put my daughter, Poppy, in an infant swim class that teaches babies how to surface and float if they ever fall in. ISR (*Infant Swimming Resource*) provides the course. Thinking back to the fun I had with my first book, *Underwater Doggies*, I couldn't pass up the opportunity to put these three great things together: photography, babies, and underwater shoots! I started taking pictures of babies from the ISR class for an *Underwater Babies* series.

This is just one of the fun and creative ways that I have photographed babies. In reading this book, I hope that you will come up with your own unique, inventive ways to photograph beebsters! Happy shooting!

1

Preparing to Own a Business

Before you start a business, know that you have to *be* your business—year round, every day. You can't start a business and be present only half the year. If you aren't doing something great every day and doing something to stay ahead of the crowd, all the other people with cameras who are now "photographers" will take your business. You have to be marketing, networking, gaining publicity, and managing employees, vendors, and clients.

Sound daunting? It can be, but try focusing on the positive—what you *do* want, not what you *don't* want. Focus on solutions, not problems, and you'll find this daily work to be more manageable and fun. Create marketing strategies that excite you, and do one shoot a week that *you* want to do—a shoot that is only for you.

You need to be proactive, not reactive. If you are reactive, you wait until you see someone else doing something, and then you start doing the same thing or something similar just to help your business for the time being. Instead, you should always be thinking about how you can make a better business, grow your clientele, and offer new products. The business grows because of you and what you implement. Have goals that you're always working toward, and have marketing plans and ideas in place every few months, with a target time for when you want to reach them. If something comes up in the interim, you can always work on it—just be sure it fits your overall vision for your company.

In the slower months, it may be tempting to lower your prices, but doing so will change your clientele and your target market, thereby changing the products your clients want. Something that seems so small actually changes your whole business model, so it's better to stick to the goals you originally set and keep working toward those, even when business is a bit slower than usual.

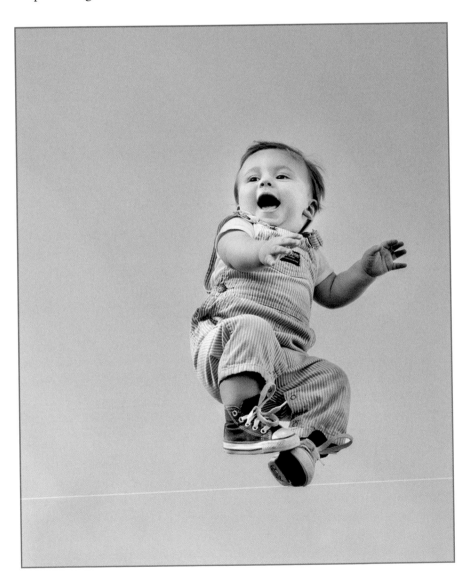

Set Goals: What Do You Want?

First things first: You need to know what you want out of your business. Set specific and realistic family, personal, and business goals that you want to happen within a specific timeframe—having a timeframe makes your goals easier to attain. Set daily, weekly, monthly, yearly, and five- or ten-year goals for yourself and your business. Then, for every business decision you make, ask yourself whether it's helping and working toward your ultimate goals.

From the beginning, this is *your* business, so make it what you want it to be and have it work for you, not the other way around. If your goal is to grow your business, write down by how much and by when. How many more clients do you need, or how much revenue do you need? Break down how much more money you need or want to make and then figure out how many more clients you need to have at that specific price point to reach your goals. Decide whether you need to raise your prices or increase how many new clients you need or how much they purchase from each session.

On the subject of pricing, it doesn't make sense to allow clients to haggle over prices. If you allow one to, then why not let everyone else? Well, in the end, it's not fair to you or your other clients. You have priced your services and products so that you know how many portrait sessions you need to book to have the income to support your family, pay your bills, save some money, and market yourself. Suppose you charge $500 for a portrait session, and you need to have 50 such session over the course of the year to make the salary you need. Then someone wants to pay you only $200. Now you have to hold an extra portrait session to make roughly the same amount. The person who wants the session for $200 is making you work harder, not smarter—all the while devaluing your art and brand. If you agree to this, you are now taking time away from your life and your family for your business.

In my experience, when I have adjusted the price for a particular client, those clients are often dissatisfied about something and much harder to work with. These types of clients are *not* your target market, so let them go. There is a perfect photographer for everyone, but you aren't going to be it for everyone. Give these types of clients a recommendation for another photographer, and everyone will be happier. Your clients are paying for your knowledge, professionalism, training, hard drives, computers, equipment, insurance, studio

space, and lifestyle, so when you set your prices and consider lowering them, think about this. Your clients aren't charity cases; you don't work for free. If you aren't making what you need to off of a session, then you are working for free—or at the very least, for less than you're worth.

Establishing a fair price for you and your clients is one goal, but there are many more goals in running a business. Follow these steps when determining your goals:

1. Figure out your goals and assign each one an importance.

2. Consider your options for attaining each goal. Ask yourself how likely each of the options is to help you meet your goals. Choose the option that will best help you meet your goals.

3. Later, use the consequences of your choice to modify your goals.

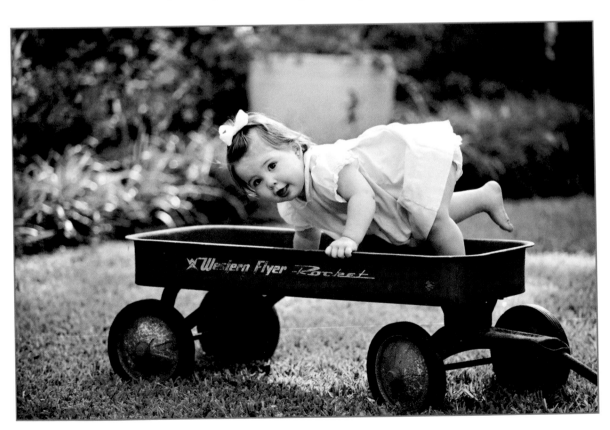

Create a Business Plan

Every business needs to have a business plan, and yours is no exception. A business plan can seem like a rather daunting task, but it doesn't have to be. There are countless books and online references you can use to research how to create a business plan. And, once your plan is complete, you can have friends and family go over it and make suggestions.

As I said, there are countless books and references on this subject, and explaining in depth how to create a business plan is far beyond the scope of this book. But here are a few general tips.

In your business plan, you will need to ask yourself some questions and establish solid answers now and as you go forward.

First, describe your company and your industry. You'll want to establish your company's legal name, the type of business, your slogan, your address, and where you will be doing business (if you're primarily shooting on location, mention that). Also, consider whether you need a business permit. List milestones, awards, clients, packages you have sold or would like to sell, and how are you funding your photography business. Use actual dollar amounts and say where the money came from. Include the services and products you would like to offer and any future services.

Also, you'll want to describe the photography business in general where you live. Talk about how you'll treat your customers and what your policies are.

Further, write down the serial numbers of any equipment you own or purchase—and while you're at it, make sure you have insurance on it.

Also consider your weaknesses and how you will fix them. Do you need more equipment? How much and what? How much will it cost and where will the money come from? When do you hope to have it by?

You'll also want to consider and discuss your target market. Will they allow you to be a boutique studio, photographing fewer sessions per year and charging more, or will your target market demand a higher-volume studio, where you shoot a ton of sessions a year and make less per shoot? What do the people in your market need? Where are they, and how will you reach them? Will you have to travel? If so, how far and how often? How will you pay for the travel costs? As the business owner and photographer, what are your responsibilities and how will you reach your market?

Describe what you're selling and how your clients will benefit from what you offer. Who are you, and what do you want your customers to know about you? How do you want them to feel about you?

Your business plan should also cover who your competition is and how you are different from them. What are their strengths and weaknesses? How are you better than them? What are *your* strengths?

In a similar vein, what are the risks in your business? For example, in the age of digital photography, everyone with a camera is a photographer—how will you compete with them? How will you handle changing media and file types?

Detail your weekly, monthly, yearly, and five- and ten-year goals. How will you reach those goals?

Last but not least, how will you leave your business when you're ready? Will you sell it, have someone else take over, or close your doors? How will you pay for retirement, and do you plan to retire?

Identify Your Target Market

After you've set your goals and created a business plan, you need to further identify your target market. To know who your clients are, sit down and really think about it. Who makes up your target audience, and how do you reach them? Ask yourself a few questions.

- Where do your potential clients live?
- Where do they work? Are they stay-at-home moms and dads? Do they work outside the home?

- Who are their kids? Are they in school or in daycare?

- Where do your potential clients shop?

- Where do they play?

- What is their income level?

- Did they attend college? Finish high school?

- What is their general age group?

- Where do they vacation and what style of vacation do they take?

- What kinds of clothes do they wear?

- What are their hobbies?

- What are their general attitudes and beliefs? What about their values?

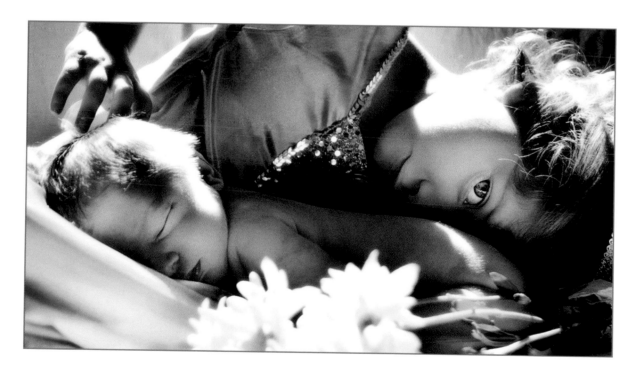

Some of these bits of information may seem irrelevant at first glance, but that couldn't be further from the truth. You need to know as much as possible about your target market so that you can reach them without being an outsider.

Knowing this information also helps you understand where and how to reach these potential clients. From where do they receive information? Newspaper, TV, the Web, friends? Do they go to certain events? If you know their hobbies and the places they shop, play, work, and vacation, you'll have insight into this.

You might wonder why you need to identify your target market instead of casting the net as wide as possible and trying to reach everyone. As I mentioned earlier, you can't be everything to everyone or assume that everyone needs your product. There are many reasons why you shouldn't simply try to market to everyone, including the following major reasons:

- Clients in your target market are going to identify with *you*. You are your brand, you create your images, and you own the business. So you want to work with likeminded people who have your vision and love your photography and products. If you change who *you* are to suit a client, then obviously it's not you—and you won't be happy with the shoot and with essentially working as someone else.

- Why waste tons of money marketing to everyone? A doctor's office is a great place to display images and leave your cards, but if that doctor's office primarily sees families in the lower income brackets, the potential clients most likely won't be able to afford luxury items, such as photography packages. So, now you have spent X amount on the photos for this particular doctor's office, and you won't receive any business from them. Why? Because the doctor's patients are not in your target market. In general, you should pass on accepting clients who obviously are not going to bring much income. I don't say this to sound snotty— if you really like the people and realize you are photographing them because you want to give your services to them, that is one thing, but doing this for everyone is another.

Only a limited number of people are going to buy your services and products; discovering who these people are to the best of your ability and marketing only to them will make your marketing dollars bring in much more business. Your business will be bigger, better, and more reputable if you are working with your target market. Doing so will help you become an expert in your field.

So how do you market to your target market? A good tip is to find someone in your target audience who is a connector. What's a connector? Someone who brings people together through their social network. A connector exists in any circle of people. Think about your own circle of friends and acquaintances, and undoubtedly you'll be able to identify at least one connector among them.

A connector is likely someone in his or her thirties or forties with a social job (such as a real estate agent, rather than, say, a computer tech). Such a person will likely know more potential clients for you than, say, a college student would. People of this age group and in such professions have had more chances to get out and meet people, and they're more likely to know people who would be interested in baby photography. Most likely, college students won't have the income for baby photography, even if they do have children.

When a connector uses you and loves your work, she will recommend you to others. And a personal recommendation is the best publicity you can have! (See Chapter 7, "Marketing and Sales" for more on the importance of referrals and publicity.) Connectors will talk about you to everyone they meet if they are happy with your work.

Always be sure to send the connector a thank-you letter. Never underestimate how important thank-you letters are—the real kind that go in the mail! In this age of texting and email, a personalized card or letter is more appreciated than ever.

Name Your Business

So, you've thought about your target market, but you need a strong business name that this audience will remember! You want it to convey who you are and what you do. It should be one-of-a-kind and catchy. And it should be able to expand with you. If your business name is Mountain Portraits, but you end up photographing more studio portraits or you move locations, you have already outgrown your name. Try something more general instead.

You could use your name for your business if it is short enough and catchy enough. But do you think you may one day expand and have other photographers shooting for you? If so, it might be harder to book your associates if the name of the business is your name. For example, everyone choosing Derek Smith Photography will want Derek Smith to do their portrait, and it

will be harder to book other photographers from this company. However, if the business is called Smith Photographers, booking associates will be much easier. I learned this the hard way. When I first got out of college, I never thought I would have other photographers shooting for me; however, years later, I was proven wrong. My business name outgrew my business, and I had to work extra hard to book my associates.

If you *do* want to use your name for your business, Google it and make sure you are the only one out there. If someone hears of your business and Googles your name, how will he know which one is you if there are multiple listings?

Also, make sure your name looks good when spelled out, either all together or with spaces. Does it form any "funny" words? Seymour Rassehes Photography could sound like See More Rashes Photography, for example.

Check to make sure your desired web address is available, too—if possible, you want to purchase the .com and .net version and all things similar to make sure that if someone else comes up with the same name for their photography business, you have all the web addresses so your clients don't get confused.

Another thing to keep in mind is that you don't want to have your name/web address have several of the same letters all together or numbers that could misread as letters. If someone reads the URL of such a site, they could get confused and never make it to your site. If the name of your business is 1lovephotographers, for example, would that be 1 or l or I? Upon first glance, they look the same. In a case such as this, you'd be best off to choose the URL onelovephotographers.com.

Establish Your Pricing

After you've determined your target market and come up with a strong business name, you need to make sure your potential clients can afford your services and products. They may *love* your photography (and you!), but if they can't afford your services, they won't use you.

It might surprise you to know that similar issues can arise if your prices are too low. Clients may not think your service is as good as another photographer's if it's priced significantly lower. People often associate higher prices with better products, so you want to make sure your services and products are priced high enough to suggest excellent quality, but not so high that your potential clients can't afford them.

Also, there is an inclination by new photographers to set their prices low as they try to establish a client base. But just because you're new, that doesn't mean you shouldn't charge what you're worth. It's hard to raise your prices and your perceived value if you are known as the "cheap" photographer—people will know you as the great monetary value but not as the great photographer, and that's not a role in which you want to be pigeonholed.

Also keep in mind that you are a creative and talented artist who has overhead expenses. Don't charge what you can afford; charge what you have to in order to pay your bills, make a profit, and save money. What if something happens to you, and you can't do all the shoots you've booked? You'll have to pay someone else to do them or refund their retainer, so you need this "what if" built into your pricing to ensure that you remain in business, even if you run into unplanned personal circumstances.

When pricing your services and products, make sure you account for your time (including travel) and your assistants' pay and gas, as well as the time you will spend blogging, corresponding with your clients before and after the shoot, retouching images, and uploading—and don't forget any other costs associated with the shoot.

Consider this: You charge $50 for an hour-long shoot. Your reprints are $10, and the client only orders one 8×10 for $10. You went to their house, which is 15 minutes away, for a total of 30 minutes of travel time. You spent an hour photographing their baby and three hours in post-processing, blogging, Facebooking, and uploading their images. You are using two external hard drives to back up their images, which take up 1 gigabyte of space, and you spent two hours in consultations before and after the shoot. You are now making less than minimum wage, as well as undercutting your competition. And you're probably shooting tons and tons of sessions per week to make ends meet—which you think is making you money, but you're actually losing money and burning out yourself and your equipment.

By undercutting other photographers, you are watering down the market and bringing down the quality of clientele and the perceived value of all the other photographers. Even if you don't care about that, know that other photographers will never recommend you when they are booked if you are shooting so cheaply.

Further, you may have 100 sessions per month, but you're not actually making any money. Make sure you price for profit, because everything costs much more than you think, and you still have to sell your products. Even though you're an artist, you still have to sell your art—or hire someone who can sell it for you if you can't sell it yourself.

When pricing your packages, it's wise to have a huge package that you think no one will purchase—something that includes everything and has a ton of profit built into it. As soon as someone purchases it, raise your prices. The fact that someone bought it means it is attainable to your market, and it could be your next "middle" package instead of the huge package. People tend to purchase the package that is in the middle pricewise, so if you put this once-huge one in the middle, it now seems as if it's the "best" one to choose—and your new huge package looks massive compared to this one. You can even raise your lowest package to be closer to this new middle package so it doesn't look so large.

Most clients will choose your middle package because they really want the top package, but they know they can't afford it, and the bottom package doesn't have everything they want. Your middle package should be priced to make you the most money and give the client all they think they want at the time, but still have room for you to upsell images, albums, discs, and other products or services.

The first thing you need to do when creating packages is figure out what your target market wants and then determine the best way to meet their needs and yours. Set up your programs so that clients can sign up for several sessions per year at a discounted rate. The sitting fee may be lower than your usual one, but you'll have more opportunities to sell to the clients. And although these are discounted sessions, you're building a lifelong relationship with the parents and the child. Who knows—maybe you'll be photographing the baby's wedding and *her* babies!

I suggest the following program: Start with birth, newborn, and 3-, 6-, 9-, and 12-month sessions, and then follow with a new program to go from 18 months to 5 years old. You can even include coming over on the morning of the child's first day of kindergarten—you can go to school with her, photograph her getting on the bus, shoot her lunch box and outfit…the possibilities are endless! Your relationship doesn't have to end at a year.

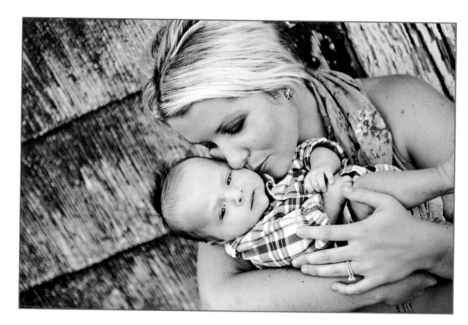

You can offer a package that includes birth, newborn, and 3-, 6-, 9-, and 12-month sessions.

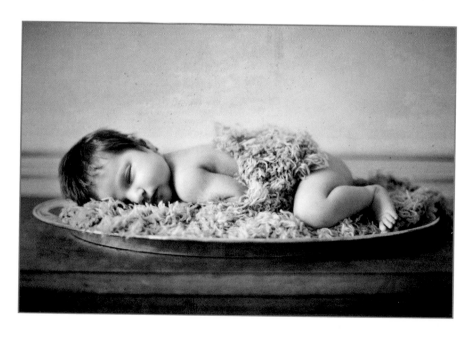

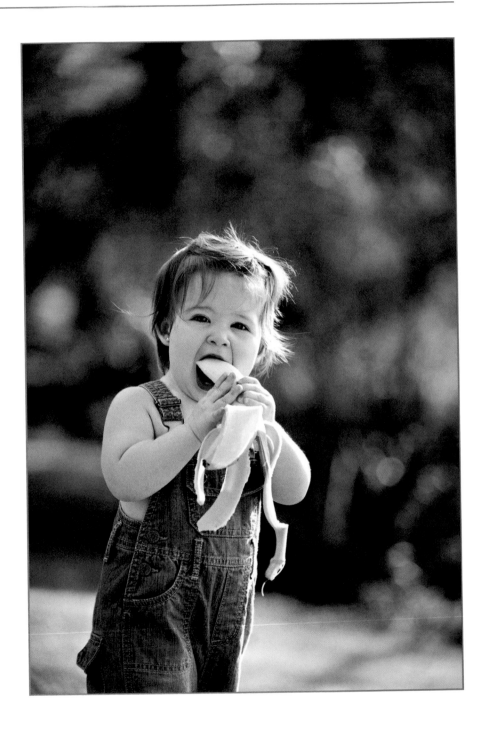

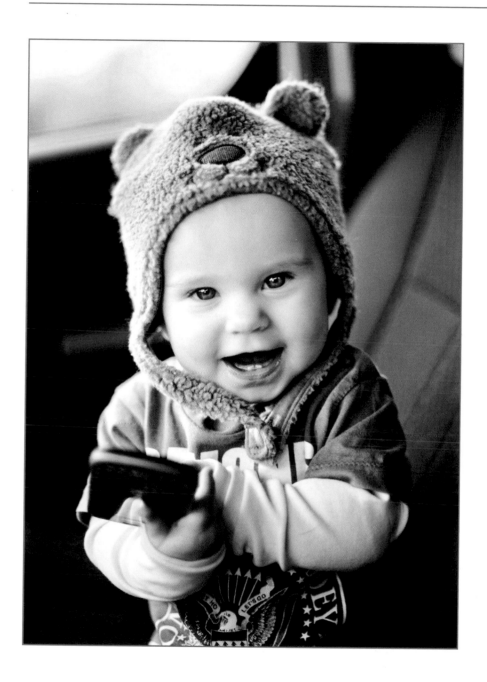

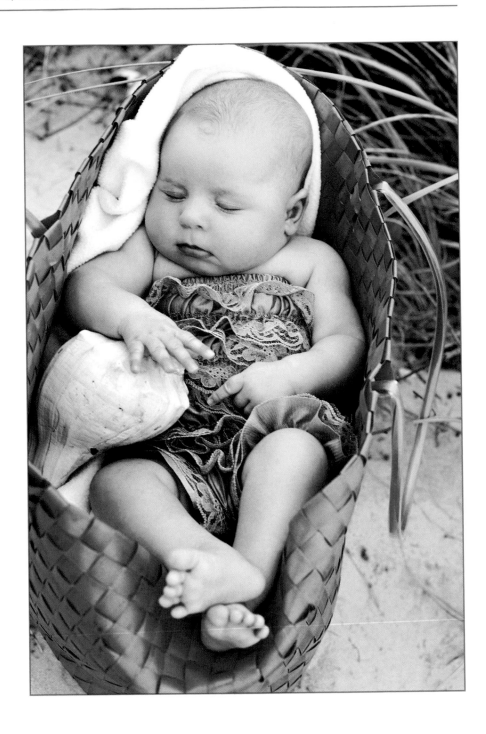

Think about what your goals are for your yearly packages. One of mine is to be able to document all the tiny moments of my clients' lives—just a few beautiful photos; it doesn't have to be a whole session, nor does it have to be posed. Here is some verbiage I use to explain why I do what I do and what I want to offer families.

> Now that we are expecting our first beebster, I find myself documenting every little thing about our lives before her and in anticipation of her arrival. I look back on my photos from when I was a kid, and there aren't many from before I was born to tell me what my parents' life was like without me. There are snapshots from when I was little and one professional before I was a teenager. I'm realizing how important it is to document our growing family as much as we can. I wish I had fun photos of my family doing the things we used to do—picnics, beach days, boating, crabbing—times I could look back on and also show my daughter what my life was like growing up. I think it would help her have a better understanding of who I am, other than "mom."
>
> To celebrate her arrival and motherhood, we are offering the See Me Grow Club. These sessions are meant to be flexible and to document your family at all stages. We can set up portrait times throughout the year, or if you are planning a family outing to the beach, boating, or teaching one of your munchkins how to surf or bake, I can be there to document that. I want you to remember the little steps your child makes throughout his or her life.

Other goals for packages are to have a chance for fun, creative shoots all year long with people who have already booked us and to generate income throughout the year. It's easier to have people who are already your clients book you for more shoots than it is to attract brand-new clients. Your past clients already trust you, and you don't have to spend anymore marketing dollars.

You might also want to consider offering shorter sessions during your slow season. These can generate great referrals from your client base for people who would like to meet you and have a small session without committing to a big investment upfront or who don't need a lot of photos. You can include a 10- to 15-minute session, somewhere that is convenient for you, include an 8×10 or wallets, and then up-sell the client. In cases like these, I always choose

the image for the 8×10 or wallets so that there's not a lot of back and forth after the shoot. If you do something similar, you can choose your favorite image (which you probably are already blogging about) so you don't make extra work for yourself by having to retouch another image. If you want to do mini-sessions like this, just make sure you set limits and that the clients know them. Always send them all the reprint/product pricing before you shoot. You want to be totally upfront about anything they may want to purchase.

When you're thinking about packages, keep in mind that you don't want to oversell. If the client signs up for a four-session-per-year package, you don't want to sell her a 30×40 of an image from the first session—if you do, she more than likely won't purchase any other canvases. Instead, try selling an 11×14 or a 16×20 from each session to display in a collage or in several places around the house.

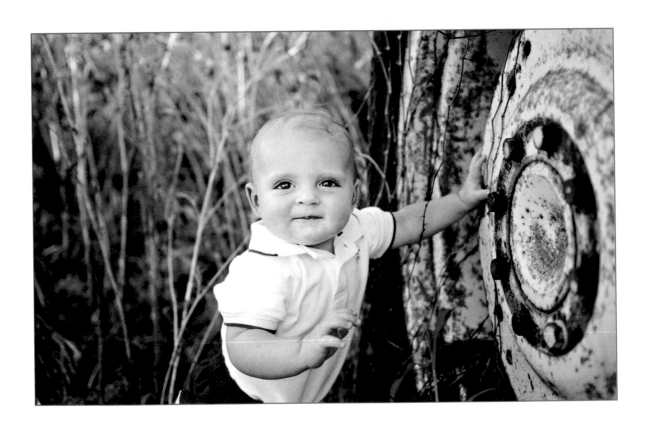

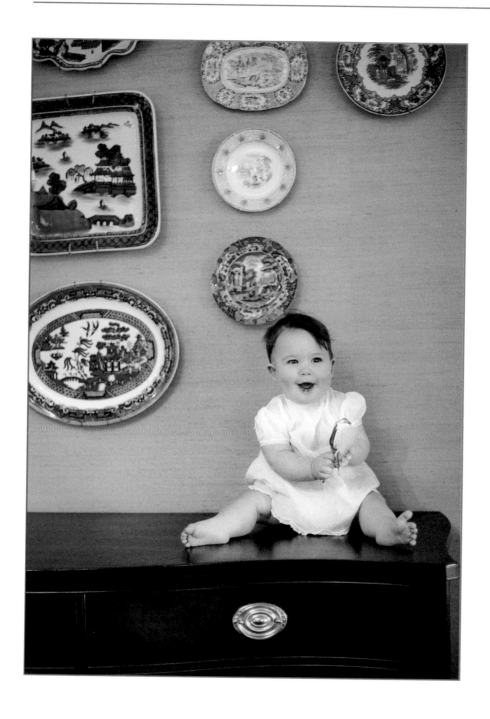

Some families will want holiday, birthday, and family photos, so why not have them commit to these at the beginning of the year? You can have them pay for everything upfront, monthly, or session by session. If the client wants to be on a payment plan, you can arrange to run his credit card on a certain day each month—this will help you through the slower months, too. Just make sure that you collect a nonrefundable retainer upfront; this reduces cancellations.

Have a contract that specifically says what package the client has and lists the reprint prices and product prices. The contract should also specify how long these prices are good for and when the prices may change. This way, the client will know everything upfront, and there are no surprises. See Chapter 4, "Be Prepared—and Prepare Your Clients, Too!" for more information on contracts.

A portion of reprints should be paid for upfront as well. Ideally, you'll require that clients pay in full before the products are ordered; however, if your client can't afford this, and you would like to set her up on a payment plan, make sure your costs (time finding and retouching images and the reprint prices and shipping) are covered in this initial retainer, so the second payment they make is all profit. That way, if they cancel their order or never pay you the second half, at least all your costs are covered.

When pricing your reprints, keep in mind that they don't cost you exactly what the lab charges you. Your client isn't just buying a photograph; they're buying a piece of art that you created specifically for them. You spend time locating the image on your hard drive, retouching it, and uploading or mailing it to your lab. When you receive it back, you have to safely package it with your branding and mail it to your client. Don't forget to factor in the gas and time to ship it, as well as the postage.

As surprising as it may sound, it's not unusual for an 8×12 or smaller print to cost quite a bit to produce, when you factor in all your time for shooting, importing, processing and retouching, uploading, backing up, shipping, and so on. See www.annmonteith.com/page27/page27.html for an interesting breakdown on pricing. You'll need to substitute your own rates for the data Ann Monteith provides, but her breakdown of pricing is eye-opening, to say the least. The term "cost of sales" describes how much it costs you to produce a product when you make the sale. All businesses incur expenses, even if they never have a sale or a shoot; however, cost of sales is how much you spend to create the product for your client.

Basically, you need to charge however much you have determined that it costs *you* for each product, multiplied by 3 (home studio) or 4 (retail studio), to make it profitable.

However, the lower the cost of sales the better. This means you get to keep more of the money you are generating from the prints, and less will go to the categories above. There are a few easy ways to do this. For example, you can shoot less so you have less to edit, cut your shipping-supplies costs, and/or only fully edit the images your client purchases or that you want to use for marketing. Why spend hours and hours retouching images that may or may not sell?

Here are two examples, based on a cost of sale of $91:

Home studio: $91 × 3 = $ 273

Retail location: $91 × 4 = $364

You may not be able to price an 8×12 at either of these prices, but you can build this cost into your sitting fee, package cost, and other reprint costs. You have to include your time into all your fees, or you will never be able to pay your bills and make a salary, even if you have tons and tons of business. It's like working for free. Time is money! It doesn't matter what other photographers charge; what matters is that you charge what you need to pay your bills, save for retirement, and live the lifestyle you want.

People do like to feel as if they're getting a deal, though. Reprints of the same image cut costs, since the image is already retouched and backed up. This is a good place to offer discounts.

One more bit of advice about pricing: If you give something away, say that it's a gift, not that it's complimentary. You don't want to devalue your work and what clients are willing to pay for the next time you work together. Generally, clients won't haggle over a "gift," and they'll appreciate it more. Gifts make people feel special.

Determine Your Type of Business

Will you be a sole proprietor, a freelancer, an LLC, or an incorporated business? This can change as your business grows, but you need to have a plan. All of these types of businesses have different tax laws, and you will need to check with your local small business bureau for additional assistance and support. Further, I highly suggest hiring an accountant and a lawyer. An accountant will know much more about all types of businesses, when tax laws change, what may and may not be written off, and what is going to work best for you financially. An accountant can lead you in the right direction on a monthly basis.

So, what are these types of businesses?

- **Sole proprietor.** This is the simplest business. It is owned and managed by one person, who is inseparable from the business. The owner has complete control over the legal and financial matters of the business and is legally responsible for all legal actions and debts the business may incur. Because the owner and the business are one and the same, they do not pay taxes separately.

 The scary thing about being a sole proprietor is if a client is unhappy and sues you, or if you run into financial hardship, the bank can take your home, car, and anything that you personally own. Also, because the business is *you*, if you retire or die, the business ceases. You can't sell it to anyone or have anyone take it over for you because it is *you*.

- **Freelancer.** A freelancer is self-employed and does not work for any one employer. Generally, this would be best for you if you did not want to own your own business, but you wanted to shoot for one or several photographers and be paid on a per-job basis. You would not be full time at any one job. This is best suited for those who want to make their own work schedule.

- **Limited liability company.** This form of business is well suited for a company with only one owner, as it separates the liability between you personally and your business. You can choose how you would like to be taxed, and you do not have to have a board of directors, as you do when you're a corporation. The income flows through the company to the owner, and you are not double-taxed. The income of the entity is treated as the income of the owners.

You might consider being an "S" Corp. You don't pay federal taxes; instead, the profits and losses are passed through to your personal income tax.

■ **Corporation.** This business is totally separate from the owner. It is a legal entity that is created under state laws, and it has its own liabilities and privileges separate from its members. This has much more limited liability than any of the other types of businesses. If a corporation fails, you can only lose your business investment and anything owned by the business. Any employees will lose their jobs, but you won't be held personally accountable. So, if your home is owned by you personally, it can't be taken if something happens to your business.

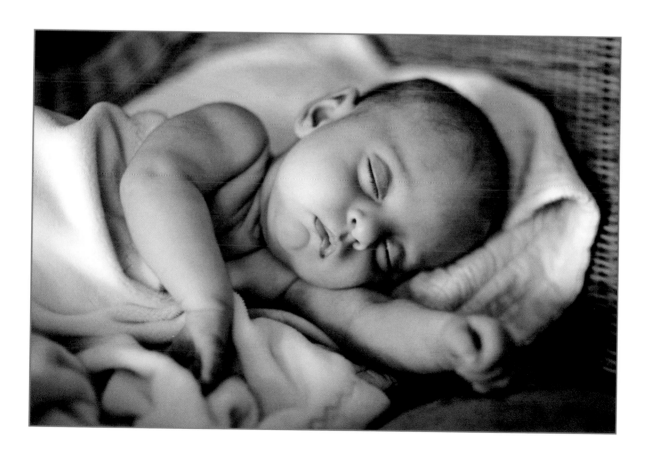

Handle Your Finances

The ins and outs of business types can get a bit confusing, so as I have stated before, you should hire an accountant. You probably started a photography business because you love documenting your life and the lives of those around you, and you have the necessary creativity, equipment, and clientele, but how can you stay in business if you don't keep up with your finances? And I don't just mean how much is coming in, but also how much you're spending on what and when—and is it tax deductible? If you're like me, crunching these numbers is not what you enjoy doing! You can do it yourself, or you can save yourself the trouble and hire an accountant to do varying degrees of it for you.

Accountants can also be invaluable when it comes to understanding tax laws. Find out all the sales-tax laws for your state and go over them in detail with your accountant. Although you may not have to pay sales tax on services, if your package includes products, it could be considered a gray area.

Keep Separate Accounts

Whether you choose to use an accountant or handle the finances yourself, you should have a separate business checking account from your personal checking account and use it accordingly. Keeping the accounts separate makes for much easier record-keeping at tax time, and it means you can pay yourself! It's easy to keep all your money in your business and never write yourself a paycheck, but this is not a way to keep yourself happy and in business.

Use Credit Cards: A Different and Fun Way to Pay

Credit cards sometimes get a bad rap, but they *can* be useful if used correctly. Only use credit cards when you have money in the bank to cover what you purchase. Pay off the balance each month to avoid paying interest charges.

Credit cards are not free money, but they can earn you cash back, free flights, and other rewards that you can turn into income. For example, if you have to fly somewhere for a shoot, you can still bill for travel, even if your sky miles are covering it.

When choosing a credit card, be sure to read the fine print that tells you about the hidden loopholes of the card. And review your statement each month to make sure there has been no fraudulent activity. Call the company immediately if something is incorrect.

Sales Tax

I'm no expert on taxes, so I will once again advise you to hire an accountant before you start your business!

That said, you need to think a bit about sales tax. Sales tax will vary in each state. In North Carolina, where I live, you can purchase a license to void you from having to pay sales tax for anything that is shipped out of state—however, my accountant advises me to pay sales tax on everything just to be safe. If you are audited and can't prove you sent a package out of state, then you will be subject to sales tax. In North Carolina, although services aren't subject to sales tax, I still pay sales tax on all of my packages. The packages include an album, prints, cards, and so on, and these are subject to sales tax, so I've been advised to pay tax on the whole package. You will need to work very closely with an accountant to make sure you are paying all the proper taxes and on time.

Save, Save, Save

You're a photographer because you want to be creative and capture moments, right? But don't you also want to make money and be able to take home a pay-check each week? And hopefully put something in savings? The best way to do this is to cut your costs—it's easier to cut your costs than to make more money.

So how do you cut costs? Take a hard look at everything before you purchase it. Do you *have* to have it? Will it make you money? A big way to make money is to stay out of debt. If you can't buy it with cash, don't buy it. If you purchase it and you don't have the money, you are going to be paying interest on your credit card or loan, and that's no fun!

Also, only have what you need! Don't purchase equipment and software because you want it—purchase it only if you have a real need for it.

Starting a business is expensive; there's no two ways about it. But you can save your business money in lots of ways. Think about what you use and how often you use it. Can you cancel your landline and only use your cell phone? Can you change your cell-phone plan so you save money each month? You shouldn't pay for what you don't need and aren't using.

Also, instead of paying for advertising, try networking. Meet as many people as you can, and offer to shoot a "connector's" family free of charge—they will know about you and tell anyone and everyone who will listen all about you! The more people who know about you and your services, the more recommendations you will get. Not only is word of mouth a more trusted source than almost anything, it's also proven to work better and be less expensive then advertising. You may spend money photographing the connector's family or ordering a print or printing images for a doctor's office or boutique, but it's still less expensive than running a half-page magazine ad among a bunch of other photographers—and you'll likely see more results.

Studio rent is another place where you can save big. I know having a studio is glamorous and fun, and it gives you a place away from home to work, but if your out-of-home studio doesn't make you four times what it costs you to pay for rent and utilities, it's a drain on your profits. By working from a home office and shooting on location, you'll save on gas, rent, and utilities, and you can make your own hours. You won't have to be open at certain times or hire an employee to keep hours so you can have walk-in traffic.

Depending on the size of your business and how many reprint orders you have coming in at a time, you can choose to post images online and have a company take the money, fulfill the reprint orders, and send you a monthly check. However, if you have the time to do this yourself, it is much more profitable. These companies don't retouch the images before they print and send them to your clients unless you pay an additional fee—and even then, is it retouched the way you want it? You will have to work with such companies to make sure they know exactly how you'd like your images to look when they are sent out. By fulfilling the orders yourself, you have total control over the look of the images and the money—no one is taking a percentage of your sale.

Another way to save money is to minimize your errors. By double- and triple-checking any albums or images that you order, you reduce the risk of making a spelling or retouching error and therefore having to take the time and money to reorder the same product you have already done once. And make sure to back up retouched files so that if they are reordered, you don't have to do the same work twice.

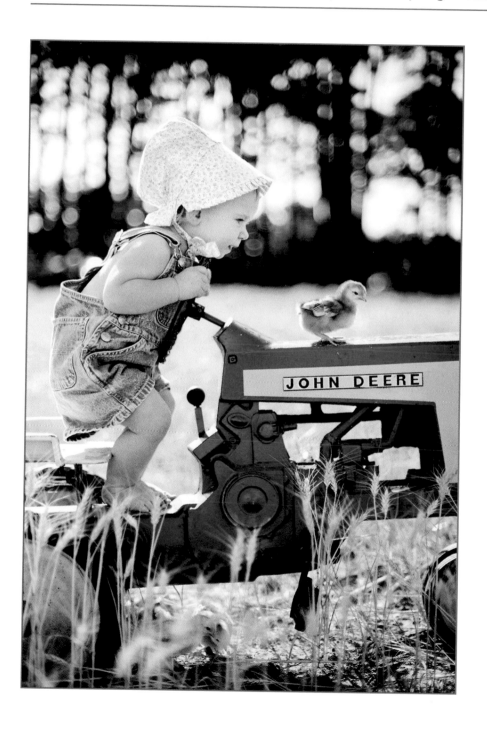

Manage Employees

Employees are a major factor of your business's finances. As a photographer, you may be used to shooting solo. But when you start a photography business, chances are you will at least have an assistant, if not more employees after you have made a profitable business.

How (and how much) do you pay your assistant? You can set up assistants as general contractors, meaning that you pay them for each shoot, and then you send them a 1099 at the end of the year. Or, your assistant can be an employee who you pay hourly or a salary—in that case, you pay employee taxes, Social Security, unemployment tax and insurance, and so on.

If your assistants are full- or part-time employees, work out whether you will be paying them one rate for in-studio/computer work and another set amount per shoot or whether you will pay them the same hourly wage no matter what they are doing. The same applies to salaried employees—if they are on salary, do they get paid above and beyond their salary for assisting at shoots? And what will you do about maternity leave? Paid vacation? Sick time? Benefits?

You should always talk things out with your employees if there is a disagreement—make sure their voices are heard and that you respect what they have to say. Pay them fairly and reward them for jobs well done. If you want loyal employees who respect you and your business, you need to show them mutual respect.

There are some things your employees don't need to worry about or think about, and only you, as the business owner, should be privy to. Employees are for making sure the day-to-day operations run smoothly and effectively and for helping to implement the plans you've made. As the business owner, you should spend the majority of your time making strategic plans, marketing, and growing the business. The point of having an employee is to give you more time to grow the business.

Full-Time Employee versus Outsourcing

One reason why many photographers hire an employee is for post-processing tasks. But before you hire an employee to do your post-processing, consider what it means to hire a full-time employee versus sending your files to an editing company.

If you send your files to an editing company:

- It may cost you more per session to have the images edited when you send them to a company, but you are saving money by not having to buy another computer/hard drive/workstation/software. And, you are saving money on employee costs.

- You don't have to train someone to do the tasks for you or manage an employee and keep him or her busy during the slow season.

- All the profits you make go directly to you. You aren't trying to support a whole other family; therefore, you may be able to afford to work less.

- You won't have to pay employee taxes.

If you hire a full-time employee to do your post-processing:

- You can closely manage his or her work.

- You can train that person to edit exactly how you want.

- You may have a quicker turnaround time, because you won't have to mail files or upload and download hundreds of files. Marketing this to your clients can be huge! Many photographers take weeks to show their clients the proofs, so a quick turnaround can be very appealing to clients.

- You have someone who sees your vision on a daily basis, which makes it easier to train that person to second shoot for you or to be an associate photographer.

If you *do* hire a full-time employee, that person needs to be able to make you more profitable than you were on your own. Consider how an employee can make your business more money. Is it by shooting? Selling? Helping you save money on other things you would outsource?

In theory, while your employee is working and making money for your business, you can be at home with your family or enjoying free time. However, having an employee who represents you and your business the same way you would requires extensive training. Such training even includes how they dress; speak to clients; shoot, pose, and work with the babies and families; and carry themselves in public on a personal level.

You don't necessarily need to bill as much for an associate's time as you bill for yours. If a client wants your style but can't afford you, offer them your associate with a similar style at a lower price. Assure the client that the associate's work will be top-quality—just at a slightly reduced price. Always praise your associates to your clients; this shows your clients that you trust and respect your employees.

Breeding Competition

One thing to keep in mind is that you are training these associates to shoot like you and represent you—but once they learn this, they can always open a business similar to yours and shoot like you. Instant competitor! You have to know that this is always a possibility, even if your employee says it won't happen.

I work with associates for years before I ever send them out on their own, so they are just as much a part of my business as I am. My associates edit my images for years so they can learn how I shoot, what settings I use, what poses, and what I'm looking for, as well as how I like the images to be presented to our clients. After all that training and time spent working together, you can see how it'd be disheartening to have an associate take all that he or she has learned and launch a business shooting the same types of images as you do!

There is no surefire way to keep your associate from becoming your competitor, but there are ways you can minimize the chances. Have associates sign a non-compete contract; this may be more expensive to enforce than it's worth, but it gives you something in writing.

Further, treat your associates with respect and show them that you value their ideas, images, and families. The more you respect your associates, work with their schedules, and give them creative freedom, the more they will want to continue working for and with you.

Motivate Your Employees

Everyone is different, and you have to go into having employees knowing this and knowing that they will be motivated to do a great job for different reasons than you are. We all have different lives, experiences, and personalities, and these all tie into what makes your employees happy and what makes them want to represent your brand.

You want your employees to be a part of your team—teams value and rely on each other, and being a team makes you work together to better both your lives and bank accounts.

Although people are motivated for many different reasons, two factors motivate almost everyone: money and happiness. How do you provide these for you and your staff? By providing motivation, communication, direction, and accountability. Your employees can't do a fabulous job if there is no direction and no timeline—they need to know what you expect and require and by when. They also need to understand why, because they need to know the consequences of not reaching the deadline.

As an example of providing direction, you might say something like, "Here are the files from the shoot today. They need to be processed, blogged by tomorrow, and ready for the client to view in one week for our sales session." Because you have spent extensive time training your employees, you won't have to show them each time how to download the cards, back up the images, and blog them. Your employees know how the images should look when they are blogged or put on social-networking sites.

Your employees need to know that if they don't have this done, not only are they letting *you* down, but they also are letting down the client. Letting down the client means the client won't recommend and trust you, which means less work for your company, which means less work for your employee.

Let employees see your vision for the company year to year or month to month so they know what is going on, what to expect, and where they fit in. Listen to their feedback and ideas, and consider their thoughts. Care about your employees, their families, and their careers. The more you care about them, the more they will care about you and your business.

Praise your employees and provide positive feedback for a job well done. They are taking pride in their work and in working for you, so let them know how much you appreciate it!

If you employ younger people, they tend to be motivated by constant learning and excitement. Once they feel they have learned all they can from you, they may move or start their own business. They may think they can do the job better than you and buck your decisions; they may want to go out on their own to make more money. This job may not be their number-one priority. After all, why should they be motivated to do their best for you?

You have to instill responsibility and accountability with consequences and rewards in order to motivate them to do their best work for you. For many young people who are eager to learn, praising good work and critiquing poor work can serve as motivation because they are working for you and, presumably, trying to please you with their work. Asking young individuals for their input on your decisions can also encourage them because it makes them feel that they matter in your business. Other employees may need more concrete forms of motivation.

Make sure you always have open lines of communication so you can talk to your employees and they can talk to you. If a problem arises, which it most certainly will with time, you have to express it and address it so that it doesn't fester or get worse. If this happens, not only is it bad for your relationship and business, but it could be bad for your clients. By talking about problems, it shows you both care. This needs to be open for new ideas to be executed as well as for conflict within your company or with clients.

Because there are so many different personalities, there are different ways to motivate your employees. The following sidebar, from a flyer by Francie Dalton, explains a bit more about this.

Francie Dalton, Dalton Alliances, Inc.
www.daltonalliances.com, 410-715-0484

The secret is to package what you want from each individual in a way that makes him/her want to deliver for you. There are seven classic work styles, each of which is motivated differently: Commanders, who need control; Drifters, who need flexibility; Attackers, who need respect; Pleasers, who need to be liked; Performers, who need recognition; Avoiders, who need security; and Analyticals, who need certainty. Now here's how to use this knowledge to better motivate your staff.

- **Commanders.** Results-oriented, aloof, bossy, and not terribly tactful, Commanders need to be in a position to take initiative. Delegate substantive assignments to them and employ a hands-off management style. Articulate the desired result and then stand aside and let them figure out the how-to's. To motivate the Commander, link what you want them to do to how doing so will improve order, control, or results. Most importantly, understand that the Commander wants to be valued and validated for their ability to overcome obstacles, to implement, and to achieve results.

■ **Drifters.** Free-spirited and easygoing, disorganized and impulsive, Drifters are virtually antithetical to Commanders. They have difficulty with structure of any kind, whether it relates to rules, work hours, details, or deadlines. To motivate the Drifter, delegate only short assignments and ensure assignments have lots of variety. Provide as much flexibility as possible, including what they work on, where they work, with whom they work, and the work schedule itself. Drifters want to be valued and validated for their innovation and creativity, their ability to improvise on a moment's notice, and their out-of-the-box thinking.

■ **Attackers.** Angry and hostile, cynical and grouchy, Attackers are often the most demoralizing influence in the workplace. They can be critical of others in public and often communicate using demeaning, condescending tones or biting sarcasm. Attackers view themselves as superior to others, conveying contempt and disgust for others. Granted, these folks aren't exactly the most lovable of employees, but you do need to be able to motivate them effectively. Start by identifying what they're really good at and then put them in positions of using or imparting that knowledge in ways that don't require much actual interaction with others. Value and validate the Attacker for their ability to take on the ugly, unpopular assignments no one else wants to touch and for their ability to work for long periods of time in isolation.

■ **Pleasers.** Thoughtful, pleasant, and helpful, Pleasers are easy to get along with. They view their work associates as extended family members and have a high need for socialization at work. Unable to handle conflict, Pleasers can't say no to the requests of others, developing instant migraines or stomach problems to escape having to deal with negativity. Motivating Pleasers is pretty simple and direct—just let them know how doing whatever it is you ask will make you happy. The more difficult thing is to manage their tendency to subordinate what's best for the company to the maintenance of relationships. To manage this, you'll need to continually stress the concept of the greater good. Value and validate Pleasers for the way they humanize the workplace and for their helpful, collaborative work style.

- **Performers.** Witty and charming, jovial and entertaining, Performers are often the most favorite personality in the workplace. They're the first to volunteer in public venues and the last to deliver on their promises. Performers can also be self-promoting hustlers who use others as stepping-stones on their path to stardom. They'll also avoid accountability for any negative outcomes by distorting the truth and blaming others. Motivating the Performer requires that you link recognition and other incentives, such as high-profile assignments, to improved teamsmanship. Value and validate your Performer for their ability to establish new relationships and for their persuasive and public speaking skills.

- **Avoiders.** Quiet and reserved, Avoiders are the wallflowers of the world. They create warm, cozy nest-like environments and prefer to work alone. They fear taking initiative and shun increased responsibility because of the attendant visibility and accountability. They'll do precisely what they're told—no more, it's true, but no less either. Avoiders will sacrifice money, position, growth, and new opportunities for the safety of status quo. Motivating the Avoider requires that you always provide detailed instructions, in which the Avoider will find safety, and don't expect to be successful in pushing this fear-based individual toward increased responsibility. Value and validate your Avoider for their reliability, for their meticulous attention to your instructions, and for getting the job done right the first time, every time.

- **Analyticals.** Cautious, precise, and diligent, Analyticals are the personification of procrastination. This sometimes incapacitates them in times of urgency. Their ability to multitask mentally results in poor eye contact and flat intonation; they scrutinize the ideas of others and anticipate all that could go wrong, which creates an inaccurate impression that they're negative. They're ill at ease socially and prefer that all communications be written or electronic—not in person. Motivating the Analytical requires that you give them time to complete each task before assigning another and that you demonstrate and articulate respect for data and for the analytical function. Value and validate your Analytical for their commitment to accuracy and for their ability to anticipate and evaluate risk far enough in advance to allow risks to be reduced.

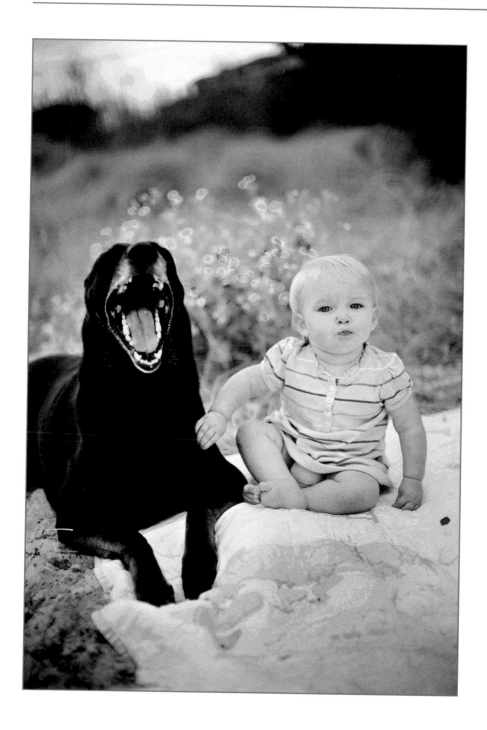

Choose Your Vendors

You've thought about your market, determined your pricing, considered your business model and employees, so what's next? Vendors! Your business is not just you, even if you don't have employees. You rely on other businesses to uphold your brand and expectations. And all the vendors you choose to work with represent *you*. So, it's extremely important to choose your vendors wisely.

As a photographer, you will probably have other companies print your images, host your images online, create your website/blog, and make your albums, canvases, frames, and other products. Let's face it: You can't do it all yourself, and it wouldn't be wise to try. The person who tries to do too many things well usually doesn't end up doing any of them very well!

You want to ensure that you have quality vendors, so before you choose them, test their services and products. It doesn't matter how beautiful of an image you created; if you and your printer aren't seeing the colors the same, that photograph could look awful! You are the quality control; have your lab send prints to you instead of to your clients. Before you send them to your clients, you can look at the images to make sure they are cropped properly and the color is correct. If you have prints drop-shipped to your clients, you could be shipping them something that looks horrible. (Not to mention you'll miss valuable branding and marketing opportunities.) Your clients won't understand that it was the printer's fault the image was cyan; they deal with you and trust you. It is your fault, and they may not give you a chance to fix it. Worse, they may no longer trust you.

Before choosing your vendors, especially labs, request samples and make sure your monitors are calibrated the same. This means the color you see on your computer screen is the same color they see on theirs. Request samples on each of their different types of paper—black and white, color, and sepia. Make sure they aren't blowing out your whites or that your blacks aren't too dark. You are the customer when dealing with vendors, and you should be treated as such.

You may have different labs for cards, prints, and canvases, as well as metal prints. An online hosting company, a website company/designer/host, a graphic designer, an album company—you should have a relationship built with each one so you can call them to check on your order or speak to someone who knows you and your work if there is a problem. They should be willing to fix it immediately.

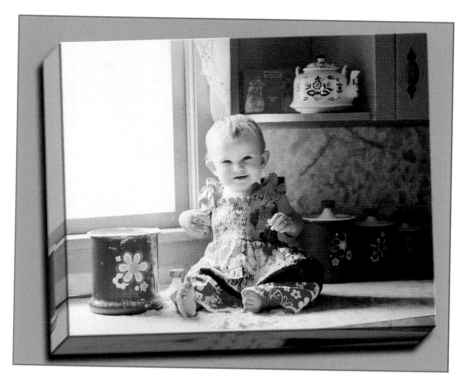

Make sure you're happy with your lab's processing. There's a huge difference between good and bad processing, as you can see in these images.

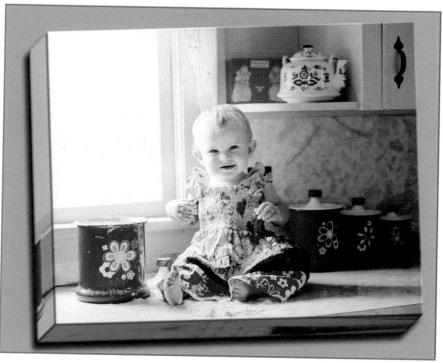

Gain Clients in Your Market

Now that you've established your target market and your pricing and you've chosen your vendors, it's time to earn the business of potential clients in that market. Think about who your current clients are and why they use you. Presumably, you want to reach other clients similar to the ones you have. This is again where your knowledge of your target market comes in handy. If you know where your current clients live, work, shop, and play, you know where to start looking for other similar clients.

But your ability to gain clients doesn't stop there. Look at who your competitors are targeting—can you target similar clients? Don't go after the same market, but look for a niche in that market where you will fit. Chances are, there's a niche that your competitors haven't quite reached.

What is a niche market? It's a spot in the market that you carve out just for yourself. The smaller the niche, the fewer people you will have to sell to, but because it's so pinpointed, they're likely to be eager buyers if you offer what they want. For example, I photograph dogs, but so do a lot of people. So, I began photographing dogs underwater. That is a small market that isn't going to appeal to everyone, but it can really appeal to certain people.

You can't be all things to all people. It pays to focus on what you love doing and what you're great at! I know how to use studio lighting, but I don't enjoy it. That niche is better left to someone who loves that work environment and loves having control over everything. So find a niche that you love and that you're good at—that's the niche that will gain you clients.

Think again about who your direct competitors are and what they offer. How can you be different from them? What can you provide that they don't? If you can answer these questions, you stand a good chance of finding a niche you can fill.

Always be sure to interview your clients before you take them. That way, you'll know whether they are in your target market and whether they're looking for your style and what you offer. By doing this, you'll reduce the likelihood of them being unhappy with your service or product.

Establish Your Style

When you're starting a photography business, it's crucial to establish a consistent style. If your photographs are all over the place in terms of style, you won't be able to draw in a strong client base as easily. Think about it: If a potential client is looking for a specific type of image of their baby—say, an Anne Geddes type of shot—and your website shows a couple of these shots mixed with a bunch of edgy, fashion-photography types of shots, the client isn't likely to be drawn to your work. That client is looking for a photographer whose work clearly shows expertise in that style—not just a few random shots here and there.

So how do you define your style? Shoot in a way that is true to you! There are clients out there who want all sorts of styles; you just have to find the right ones in your target market. For example, there is nothing wrong with either a traditional or a modern style—you just have to make sure you market to these types of clients so you can shoot the way you want. Take pride in who you are and what you do, and be true to your style.

Your style and design have to appeal to your target market. And, your style should remain consistent in general—that is, you don't want to jump abruptly from shooting, say, softly lit, ethereal portraits of cherubic babies to shooting edgy, avant-garde fashion photography. Obviously, you'd lose your target market if you did that. However, even though your style should remain consistent, you don't want it to be stagnant. Keep evolving your style and your business to continue growing—you don't have to follow the current trends, but you should evolve your style in terms of who you are and how you see the world.

There is a market for all kinds of images; you just have to make sure you are marketing to the people who want your style. It's one thing for someone to bring in clippings from a magazine that they want to use as inspiration, as long as they trust you to put your spin on it. But if people are constantly asking you for a style that isn't yours, you're not reaching your target market. The worst thing is to have a client say, "I want to hire you, but here are pictures from another photographer that I want you to re-create." That client doesn't want you or your style, even though she might think she does. Be honest with these types of clients and suggest another photographer in the area.

Tell the client it's been wonderful meeting her, but you feel that another photographer will see her vision perhaps better than you can, and it will be a perfect fit! Make sure to also call that photographer and give them a heads up that you're referring someone to them.

Be you, and be different from everyone else. Your style, design, and brand are emotional and factual extensions of you. They are evident in everything you do, how you dress, what food you like, what your hobbies are, how you speak, and so on. But even though you already have a style, describing it and being true to it photographically isn't always easy. It's about what you see and what others may not, as well as your response to what you see.

> **NOTE**
>
> Don't plagiarize other photographers' work. You want to have your own defining look, not take on the look of someone else. When you find inspiration in someone else's work, be introspective and see how their ideas trigger new ideas for you—independent of what inspired them.

Ask yourself questions such as, "If I were an animal, which one would I be and why?" Questions such as these will help you think outside the box. Focus on yourself to find the answers. Look at what you like and don't like, what you're drawn to in magazines and stores, how you decorate your home, what you enjoy doing, and how you view the world. This will give you a firm idea of what your style is, even though the answers will change as your relationship to the world around you evolves.

Taking the Myers-Briggs Type Indicator test will tell you much about your personality and how you think, which will in turn inform your style. Look at your childhood, your present, and where you see yourself in the future. Pull photos and quotes from magazines, newspapers, and websites and make an inspiration book. You can refer to it when you need some creativity; it may help you to conceptualize the style you like and see whether it fits the style you shoot.

Why is establishing a style so important? Because your style is a window into you. People should be able to look at your website and portfolio and feel as if they know you. You can photograph all types of subjects in your style, because your style shows a piece of you. When people see your work, you want it to stand out and be memorable. You don't want someone to think, "Oh, I saw her work; it looked like so-and-so's."

Style is not all about the intangibles, though. By choosing to use specific cameras, lenses, software, actions, ISOs, f-stops, and shutter speeds, you are creating a style for yourself. Just as important as what you're using is how you're using it. You're using light, but how? And why? Are you methodical and logical about how you capture your subject, or do you shoot more spontaneously, capturing what happens next? Look at several shoots. What orientation do you tend to shoot? Do you tend to see things as a portrait or a landscape? Do you tend to show the whole subject or part of it?

After you've been shooting for a while, you will come to have favorite settings and equipment and to look for or create a particular quality of light. This won't happen overnight; you have to grow into it. Because you're always growing and things happen in your life, your style is always evolving. Be honest with your clients; when your style evolves, change the design of your website and marketing materials to represent you. You don't want to have a misrepresentation, as it will keep you from reaching your target market. Accept and embrace your style, and make it known to your clients!

Showcase your particular style in your portfolio and on your website.

You need to have a style agenda. Even though you *love* that new Photoshop action and the hot new backgrounds that all the photographers are using, do they fit who you are? Every style you embrace has to fit your brand and agenda. Trying out each new one that comes along isn't being true to yourself, and it will water down your brand.

You can still try new processing techniques and update your style, but be consistent. And remember that your clients will want you to shoot what you show on your website. So as you try new things and your style slowly evolves, remember to update your website, blog, and Facebook page to show some of the fresh new things you're working on.

Often, your style may evolve while you are shooting for fun and are willing to take more risks. It's easy to shoot "safe" shots when you are shooting for a client, but what happens when you aren't safe, and you try something that you haven't done before? You get excited, regardless of whether it works. There is nothing wrong with failure; it's simply a way of learning.

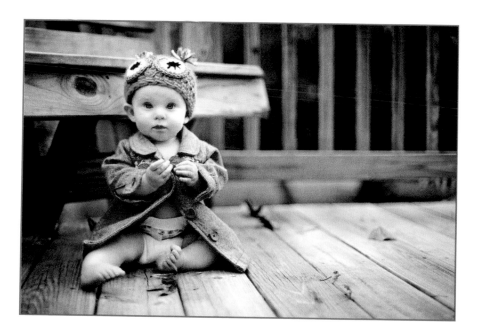

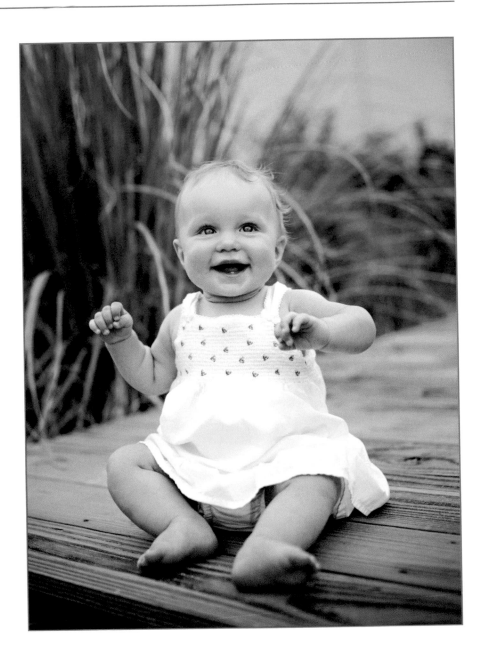

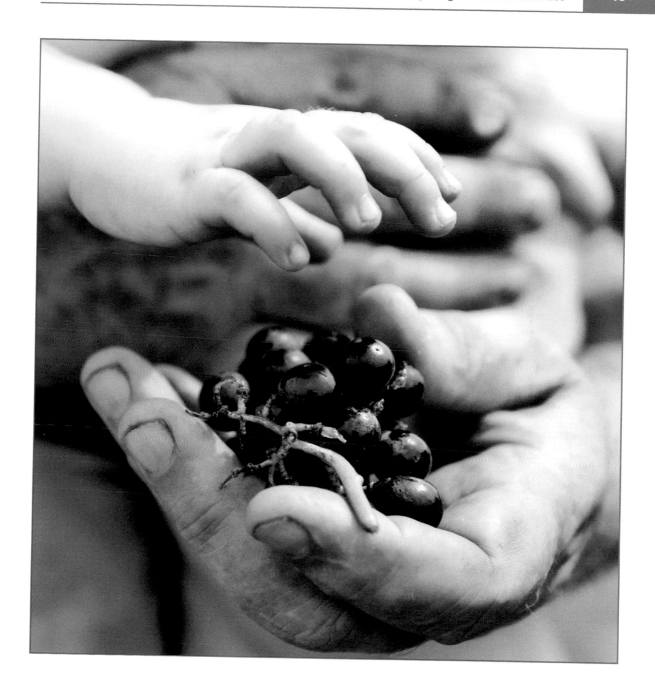

Create Your Marketing Materials

Once you've established your style, you can use it to brand yourself and your work. For example, consider your logo. What will it look like? Your logo—perhaps the most important piece of branding you have—can reflect your overall style. Just be sure that your branding helps you stand out from all the other photographers in your area. For example, if your style is very natural and you want to brand yourself with birds, consider how many photographers in your area also use birds in their branding. How can yours be different and *you*?

Your logo isn't the only part of your branding and marketing materials that should reflect your style, though. All of your marketing materials should reflect your style, but they should also be simple. Make your price lists, website, and other marketing materials easy to understand, not overly wordy or complicated. You want your clients to be able to figure out easily who you are and what you offer. Make sure the message (and branding, logos, and so on) you are sending is consistent with your goals throughout all your communication. The message should support your brand, and your brand should support the message.

To help establish your style in your marketing materials, use powerful images that get your viewers' attention—pictures that they will remember and that are unlike any they have seen before.

People hire you for your vision and your outlook on life, so let your personality come through in all of your marketing, blogging, meetings, and photographs. Your clients want to know who you are; you're sharing your vision with them, and they need to know what that is. Stand apart from the others by being yourself. See Chapter 7 for much more information on marketing.

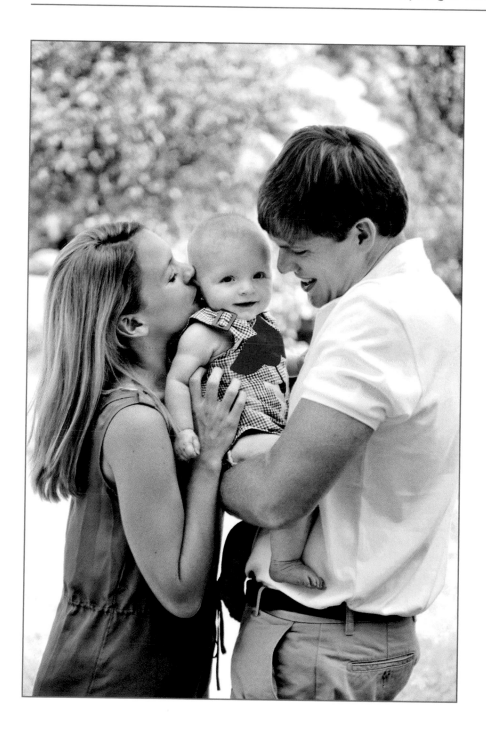

Create a Web Presence

To have a successful business in this day and age, it's almost required that you have a website, a blog, a Facebook page, and a Twitter account. Install a statistics counter so you can keep up with who is visiting your page, when, where they are coming from, and how long they stay. You can use Facebook Insights, Google Analytics, or a stat counter for your website.

Facebook pages and Twitter accounts are simple to set up, and there are easy-to-use free tools you can utilize to create a blog. Websites are a bit trickier. If you're tech-savvy, you can build your website yourself. There are basic programs that will help you create a simple site. But you're a photographer—your business is all about the visual! So really, you want a knockout site—and if you don't feel comfortable trying to create one, then consider hiring a web designer to do it for you. There are several companies that offer photography-specific website templates—Into the Darkroom and Blu Domain are just a couple.

When choosing a web designer (or any vendor!), look for positive feedback from others. Do you know another photographer with a site you think looks really sharp? Ask him or her who designed it. Also, look at potential web designers' portfolios. Are the businesses featured in it successful? Visit the sites and see how they rank in search engines and whether all of the functions work.

Many people are choosing to include music on their website these days. If you use music on your site, just make sure it's not copyrighted. Here are a number of sites where you can purchase and license music for this purposes of putting it on your website:

- musicforphotography.com
- brokenjoeyrecords.com
- songfreedom.com
- musicbakery.com
- jewelbeat.com
- earcandydigital.com
- triplescoopmusic.com

Remember that not everyone wants to listen to music when they visit your website, and they may already be listening to Pandora or other music on their computer, so make the music easy to turn on and off.

Naturally, you'll need an email address, too. Make it something easy to remember. Janedoephotography95678@confusingaddress.com isn't going to be easy for clients to remember. Pick something simple and memorable.

Make sure your email address and phone number are visible on the landing page of your website and at the bottom of any email correspondence. You can even add a signature to your emails with a link to your website/blog/Facebook and Twitter accounts and any recent awards you have won—just don't make it too long!

Emails can take over your life. The more you send out, the more you receive. If you have a lot of emails that ask for the same information, create a standard email and make it a signature so that when you answer the email requesting that information, all you have to do is hit Reply, choose your signature, and customize it to that person's specific requests.

Chapter 7 will go into much more detail about how your online presence will help you market your business. For now, just know that an online presence is essential in this business.

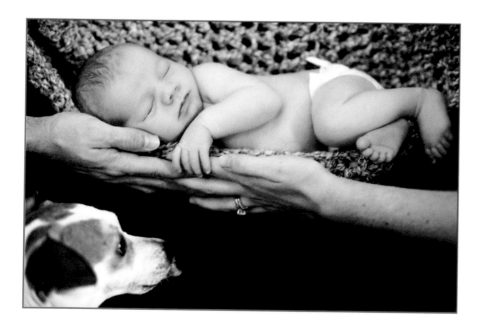

Establish a Schedule

Because it's your business, you can make your own schedule. It doesn't have to be 9:00 a.m. to 5:00 p.m. or, worse, 8:00 a.m. to 10:00 p.m. Maybe you want to shoot a few nights a week—have your days free and work at night. As long as you're available to answer phone calls, you can shoot at any time—just let your clients know what to expect and deliver on time or before.

Whatever your schedule, it pays to be consistent. You'll find that a consistent balance of business-related activities from week to week will help you stay focused and organized.

Here is an example of a typical workweek:

- **Saturday and Sunday.** Shooting! This may not be optimal to you, but if families are working during the week, it may be best for them.
- **Monday.** Blog about your weekend sessions and process images.
- **Tuesday.** Work on your marketing in the morning and meet with your clients in the afternoon to show them their images.
- **Wednesday.** Process their orders.
- **Thursday and Friday.** Your days off!

In your times of slower shooting, you can create blog posts for the month or year and schedule when you want them to post. That way, in your busy months, when you will be posting lots of photos, you can fill in with other types of blog posts without taking more time from your already busy schedule. Also, set certain times of day to Tweet/Facebook. I'm really working on getting better at this part!

Just Say No

You have to be willing to say no. If you get a bad feeling from a client, if you feel you can't handle another client that week or year, or if you already have something planned with your family, say no. It's your business, and you make your own schedule. Don't let your schedule rule you—take time off with your family. It will help you enjoy your work more, and you'll have a great time doing it!

Organizing and Prioritizing

As I mentioned, keeping a consistent schedule will help you stay organized. But you'll still find that owning your own business comes with a mountain of tasks. Make to-do lists for each day; just remember that there are only so many hours in a day, so you should make your list of goals realistic.

Most people are more productive in the morning, when they've had a good night's rest. If this is the case for you, prioritize your day and do the most challenging tasks first. Save easier things that you enjoy doing until later, when you aren't as sharp or when you're distracted.

Speaking of distractions, email is a huge one for many people—me included. Try not to check your email throughout the day. If you check it only once or twice a day, you'll be more productive at your other tasks. How many times have you had a list of twenty things to get done in a day, and then you opened your email, had ten people requesting information for your services, two album orders, three print orders, and a request for something you didn't have a price list for? Major distraction—it's hard to focus on your current list of 20 things when you feel you need to get back to everyone in your inbox right away. You don't want to ignore your email for long periods of time, but answering once a day and getting back to people within 24 hours is certainly acceptable!

Before you leave the office for the day (if you work in your house, close the door until the morning), prepare anything you need for what you want to get done in the morning. This will save you time in the morning and let you get the most important things done first, as you won't be wasting time searching for things. You can leave files uploading to back them up, pull files from the hard drive to edit in the morning, or have all your bills together in a pile so you can go through them quickly. Better yet, set up your bills on auto-pay. It takes a while to do it, but when it's done, you'll save five to ten minutes per bill, per month—that time adds up!

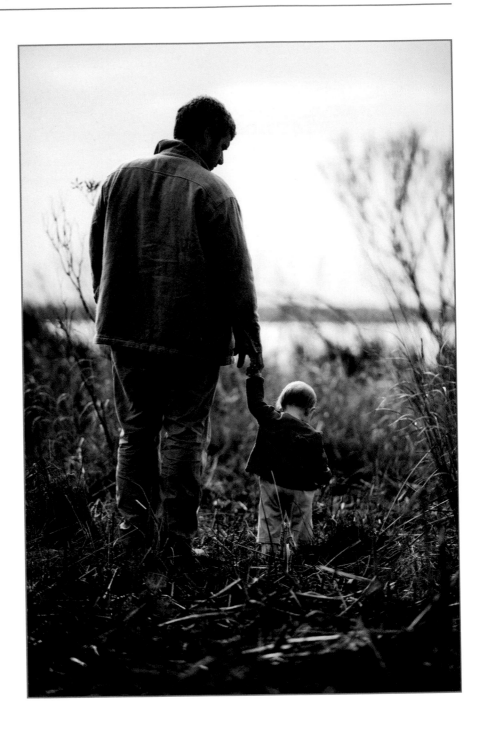

Outsource

Your business can completely take over your life, so how do you find balance? Once you have a successful business running, begin outsourcing—you can't do everything and do it well. What are you good at and what do you enjoy doing? I choose to outsource my housecleaning; I can get much more work done that I enjoy and that I'm good at by hiring someone to take care of my home for me. The same is true for accounting. I can gain more clients and generate more income by hiring an accountant to file my taxes, categorize my expenses, track my income, and do my payroll taxes, leaving me free to do what I do best—take pictures and run my business! And, I have an associate photographer who is not only an amazing shooter, but also a lifesaver on Photoshop. She processes all of our files and uploads them to the galleries, so my big job is to shoot, choose my favorites, blog, and market them.

Owning your own business is way more than picking up a camera and calling yourself a photographer. Make sure you have a plan together before you ever take your first client—and if you've been in business for a while, take time to stand back, look at your business, and make sure it's still working for you and not the other way around. There are so many little pieces of a photography business that are all essential to its success, and you don't want to get ahead of yourself and begin something without taking time to consider everything you will need to do. You have to be ready to market yourself and be responsible for everything that needs to be taken care of, which means getting organized and learning how to find and satisfy clients. You need not only talent, but also motivation, preparation, business smarts, and a positive attitude.

2

Equipment

Equipment is a huge part of a photography business, from cameras and lenses to compact flash cards, computers, hard drives, software, and lights…. But all equipment is not created equal. Knowing your style and how you like to shoot is a must before you ever purchase equipment. Certainly, most equipment will work for general purposes, but your equipment is what gives you the ability to shoot the way *you* want to. For example, if you shoot primarily natural light, you don't need to invest money in strobes, even if you find them for a really good deal. They won't make you money back as quickly as purchasing another piece of equipment you really need.

That said, there are certain pieces of equipment you need, without question. You must have a professional camera. Period. Do your research to choose which brand you want to go with: What meets your needs and budget? Most professional cameras are great, but for different reasons. One brand may be known for their low noise at higher ISOs, whereas another is known more for their glass, and still another kind may be less expensive than the rest but still meet your particular needs. When choosing your equipment, keep in mind that it makes sense to stick with one brand. For example, if you already have Nikon equipment, it's better to stay with Nikon, because Nikon lenses don't fit on Canon bodies and vice versa.

Further, most professional photographers shoot with dSLRs, but film is still an option. Consider carefully which option is right for you. Some may think that digital is cheaper, but because you are doing all the processing yourself, it is actually much more expensive. When shooting film, you send it to the lab, and they process it for you—you don't have to sit in front of your computer for hours or pay someone else to do it. You also don't have to own terabytes of hard drives on which to back up everything. There are definitely benefits to both film and digital.

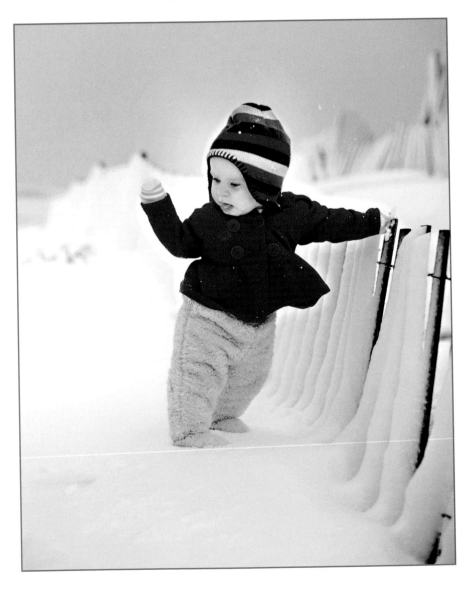

Choosing Your Equipment: Test before You Buy

After you've chosen the brand, it's time to get your equipment. I suggest getting one high-quality body and one that's a step down as your backup. However, don't go into a lot of debt to get these right off the bat! You can rent them for a few sessions so you make sure they're what you really want. Then, hopefully you can afford to buy them in cash, without taking out a loan or using a credit card. This is especially important if you have a limited budget (and who doesn't?).

Don't buy equipment because you *think* you need it. Make sure that you know how you'll use a piece of equipment before you buy it—know *why* you're making the purchase. Again, this is where renting comes in handy: You can rent or borrow the equipment before you make a purchase to make sure it's exactly what you need. Plus, it allows you to try out the equipment and make sure you're satisfied with it before you spend a lot of money on it. That zoom lens might *sound* great on paper, but if you try it out, you might discover that the image quality at high levels of zoom isn't great, and you'd rather wait, save up some more money, and buy a higher-quality zoom lens when you can afford it. In the meantime, you can rent.

Renting a piece of equipment for a full year isn't economical, because by that time you would've paid enough in rental fees to buy the item, but renting for a few shoots to determine whether you like it is ideal.

ISO, Shutter Speed, and Aperture

When choosing your camera and lenses, ISO, shutter speed, and aperture are all factors to consider.

ISO

ISO is the speed of your film or digital sensor. It determines how sensitive your sensor is to light, and it affects the shutter speed and aperture you need to use to get the correct exposure.

The higher the ISO, the more sensitive the sensor is to light. High ISO—for example, 1600—settings allow you to take photos in less light. The downside of this is that higher ISOs also create *grain* or *noise* in the image. This noise may not be terribly apparent in small prints, but it can be pretty obvious in larger prints.

The noise is virtually nonexistent in these next two images, shown at a low ISO.

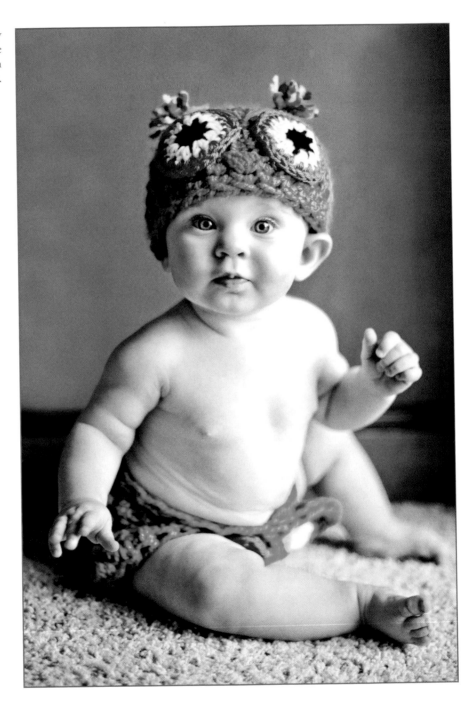

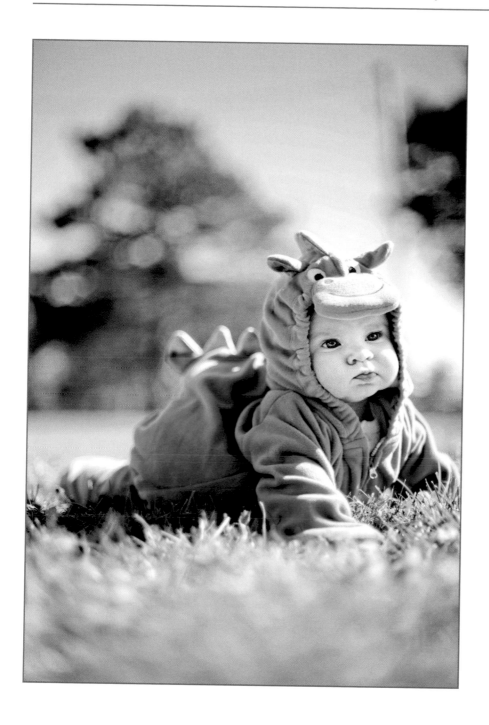

Here you can see a
bit more noise.

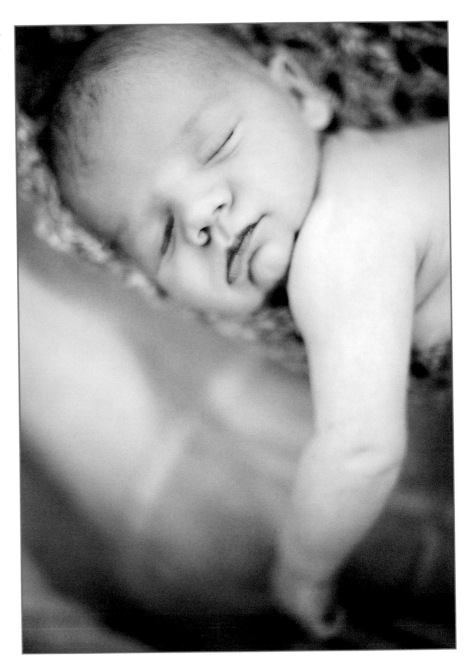

A "noisy" shot done at high ISO—but turning it black and white at least makes it look like "artistic" noise!

If you are shooting primarily in a studio, you won't necessarily need a camera that has low noise at high ISOs, because you will have control of the light, and you'll be able to use low ISO settings to avoid the noise. However, if you'll be shooting indoors in locations where you *don't* necessarily have control over the light, you'll need a camera that can shoot at high ISOs with low noise, so that you won't end up with grainy images.

Some cameras now have ISOs that go up to 6400 and higher; however, when shooting at that high of an ISO, you will have a lot of grain. But, if the camera goes up that high, you will have considerably less grain at 1600 than you would with a camera whose ISO only goes up to 1600. In other words, these two cameras may have the same amount of grain—but one will show it at 1600 the other will show it at 400.

Shutter Speed

Shutter speed is the amount of time your shutter is open and is measured in seconds or fractions of a second. The longer the shutter is open (for example, 1/10), the more light it lets in; the shorter it is open (for example, 1/1000), the less light it lets in. Each full stop in shutter speed doubles the amount of light (stopping down to slower speeds) or halves it (stopping up to faster speeds). If a subject is moving quickly, you usually will want to shoot at a faster shutter speed to stop the movement; if you want to blur the subject, shoot at a slower shutter speed.

As an example, if you are shooting a baby sleeping in a shaded outdoor setting, a shutter speed of 1/60 would probably be high enough to not blur the subject and still let in enough light. But if you're photographing a one-year-old running outdoors, you may need to use a shutter speed of 1/500 to avoid blur. Then again, if you *want* to show some blur of the child running, you may want to use a slow shutter speed, such as 1/30.

A slower shutter speed (and thus a long exposure) can allow you to capture flashes of light and the ambient light.

This image was shot at a shutter speed of 1/100, aperture of f/1.6, and ISO 1200. The shutter was fast enough to stop the people's movement but still slow enough to blur the fountain in the background.

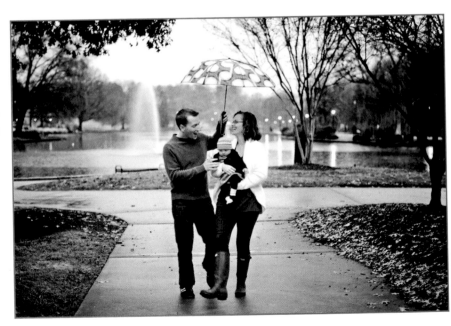

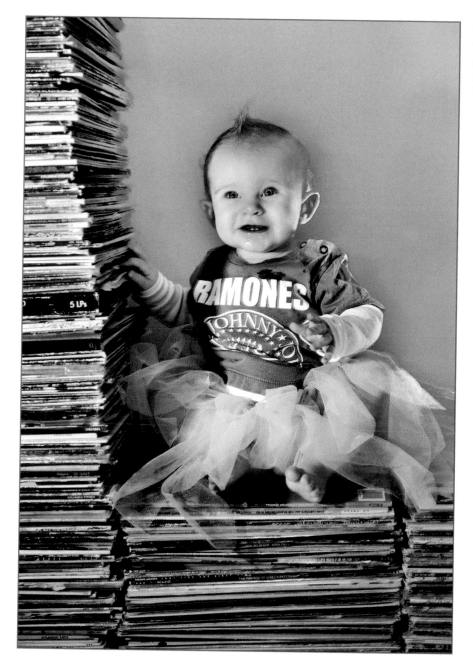

Figure 2.1

This image was shot at a shutter speed of 1/25, aperture of f/2.8, and ISO 800.

Generally, shutter speeds are the same from camera to camera; however, some cameras will sync with flash at higher shutter speeds than others. This is not a big determining factor when purchasing equipment, but just something to keep in mind if you do a lot of shooting with flash.

Some cameras may include two settings for very long exposures:

- B (for bulb) keeps the shutter open as long as you are holding the shutter release.

- T (for time) keeps the shutter open until you press the shutter release again.

These settings are not common for portrait photography; however, they're very handy for creative options, such as capturing fireworks at night with your camera on a tripod or firing a flash to capture a child holding a sparkler.

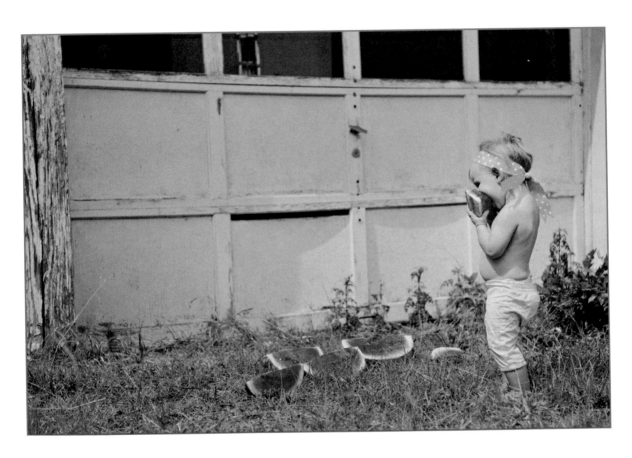

Aperture

Aperture, also known as *f-stop*, controls the depth of field. The depth of field indicates how much the objects are in focus in front of and behind your subject. It controls the size of the hole in the lens that allows light to come through to hit the sensor or film. The larger the hole, the more light it lets in and the shallower the depth of field. The smaller the hole, the less light it lets in and the greater depth of field. So if you are shooting at f/1.4, there is going to be a very narrow field of focus on your subject. If it's a portrait, the baby's eyes may be in focus, but his nose may not. If you are shooting at f/22, everything in front of and behind the baby will be in focus.

When shooting with your f-stop wide open (for example, f/1.4), you can separate your subject from your background and blur out most of the background if it's distracting. The lower the aperture number, the larger the hole; and the larger the number (such as f/22), the smaller the hole.

When shooting a baby, you might think, "Yes! I want the background blurred!" But keep in mind that if the baby's hand is in front of her face, and you focus on her face, the hand will be out of focus if you shoot at f/1.4, making the hand a very distracting part of the image. So you might choose f/4 if the light allows. Also, if you are shooting in the baby's nursery, and you want the baby's name above her crib to be readable while you have the focus on the mom holding the baby, you will want to shoot at f/4 or higher as well. If you shoot at f/1.4, it will blur the background so that you can't read the name. If you're shooting on the beach and you want multiple people in focus or you want the ocean in focus, you will want a deeper depth of field—perhaps f/8.

When purchasing a lens, the speed of the lens refers to the widest aperture diameter. Bear in mind that like the shutter speeds, aperture stops work in fractions. This means that while f/4 appears to be a smaller number than f/22, they are in fact 1/4 and 1/22 of the diameter, respectively, thus making the smallest number in your lens the widest possible aperture and dictating the lens speed with relation to its capacity for capturing light.

Aperture is dependent on the lens, not on the camera body. So if you want to be able to stop down to f/1.2, you need to purchase a lens that allows you to do that. These lenses are considerably more expensive, so make sure you need this feature before you purchase it. Often f/2.8 is sufficient to get creamy skin texture and a blurred background.

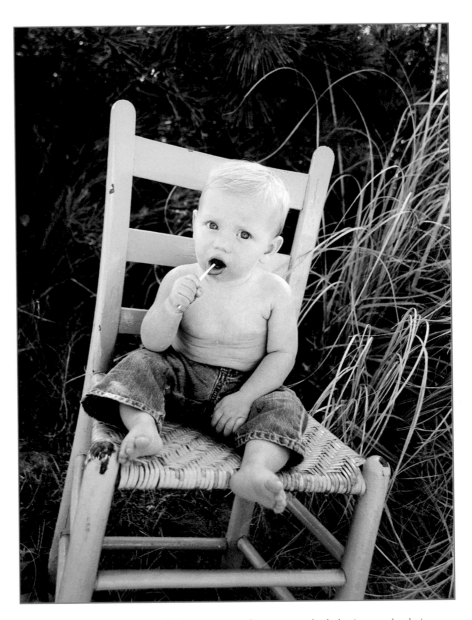

It's a careful balancing act to find an aperture that ensures the baby is completely in focus, but the background is blurred.

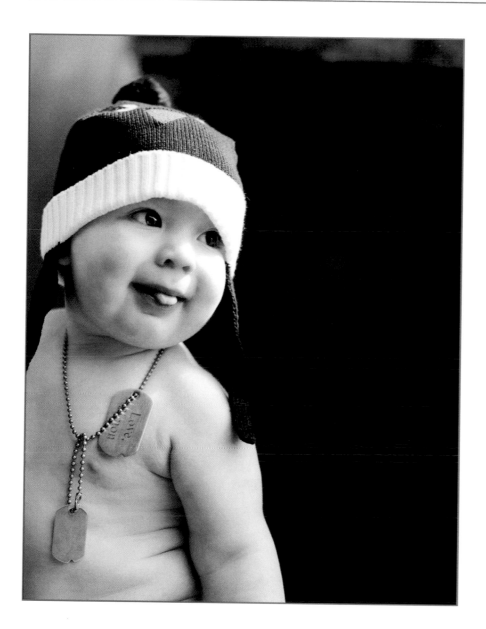

Lenses

You can get by with a body that perhaps isn't as top-of-the-line as you'd like, but you should get the best lenses you can afford. After all, the most important part of taking great photos is the glass.

More about Aperture

Lenses with an aperture of f/1.2, f/1.4, and f/1.8 are more expensive but absolutely worth the cost if this is a feature you need. They let you shoot in lower, natural light and blur the background of your images, allowing you to focus on one part of the baby and have the rest be out of focus. Because of the shallow depth of field, these lenses can smooth out babies' skin, which often is red or flaky.

However, if you won't be shooting at f/1.2 often, there's no need to spend the extra thousands of dollars to get such a fast lens. And if you're shooting with strobes, you'll have plenty of light, so you won't need this feature unless you want it because it fits your style of shooting.

Fixed Lenses

I primarily use fixed lenses for photographing babies. They provide a much sharper image and generally have a wider aperture option. Fixed lenses are lenses that don't zoom—you have 16mm, 24mm, 35mm, 50mm, and 85mm, to name a few.

Zoom lenses, on the other hand, let you stay in one place and use your lens to zoom closer to or farther away from your subject. An example of this is the 24–70mm lens. You can stay in one spot and get a wide variety of angles. If you were using a fixed lens, you would need to walk closer to or father away from the baby to zoom in or out on him.

50mm f/1.4 or f/1.8

My 50mm lens is my favorite, as well as the most affordable one I have! It allows me to blur the background so I can shoot almost anywhere, even if the background isn't beautiful. Although it isn't a wide-angle lens, it shoots wide enough that even in a small room or space, I can fit the whole subject in my frame.

The 50mm f/1.8 lens is incredibly affordable, and the f/1.4 isn't much more expensive. If you use this lens, keep in mind that when you're shooting at wide-open f-stops, the lens will blur everything you're not focusing on. So if there is a blanket in front of the baby's face, it will be out of focus if you're focusing on her face. This can be distracting, as it puts an unfocused blob in front of the baby's face. When you're shooting with this type of lens, be careful to make sure you know what will be in focus and what won't—and why.

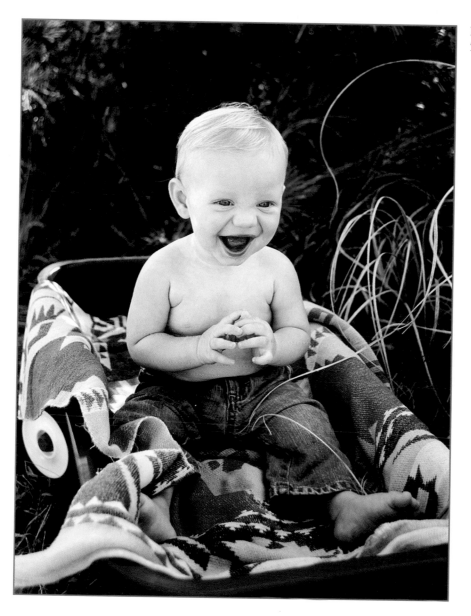

I love, love, *love* my 50mm lens!

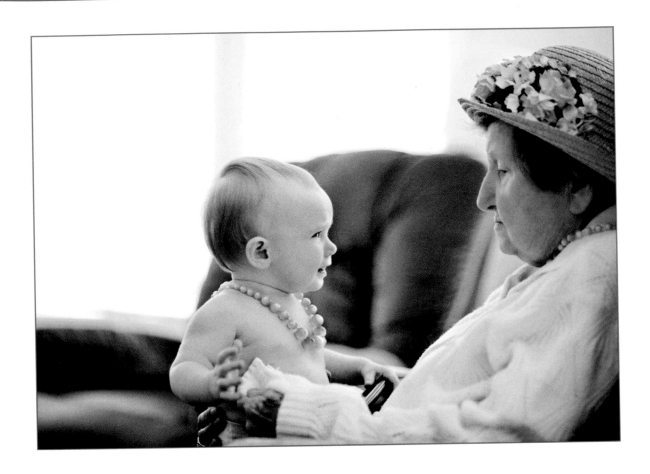

85mm f/1.4

The 85mm lens is my second-favorite one for photographing babies. In fact, if I always had the room to use this lens, it would be my all-time favorite! It's perfect for framing different parts of the baby. The wide-open aperture blurs the background and makes it ideal for shooting indoors.

Zoom Lenses

Zoom lenses are more convenient in that you can stand in one place and get a variety of angles and focal lengths. They are great all-purpose lenses, because you can get zoom lenses that go from wide to telephoto all in one! However, they don't take as sharp of an image as fixed (prime) lenses do. And generally, they don't have as wide of an aperture as a fixed lens does. (Or if they do, they're very expensive and very heavy!)

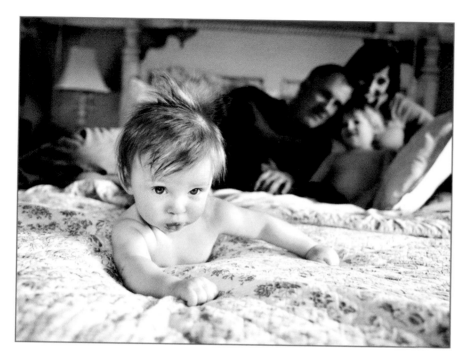

This lens usually works best outdoors, but it can allow you to get some interesting inside shots, too.

24–70mm f/2.8

This lens works best when used outdoors, because it doesn't have as wide of an aperture as a fixed lens, so it doesn't let in as much natural light. It's a great lens to use if the baby is moving—it allows you to stay in the same place and get several different angles of the baby. If he is crawling toward you, you can zoom out as he gets closer for a distorted and interesting view.

70–200mm f/2.8 VR

This is my favorite zoom lens, even though it's heavy. I've had it for years and only recently began using it as my primary outdoor lens. It allows you to take a step back from your subject and just watch her. Because you aren't very close to the baby while you're photographing her, you'll tend to get more natural expressions while she's playing. Zooming to 200mm also allows you to crop in really close to the subject's face to show the emotion while not interfering with the moment.

My favorite zoom lens!

Generally, I don't use this lens indoors unless I'm in a huge house where I can really step away from the baby. However, I love standing on the top of a dune, watching a baby crawl in the sand or play with his parents without noticing I'm there.

This lens has vibration reduction that is really quiet, so if you're shooting in lower light, you don't need a tripod, but it's not loud, so it won't scare the baby. Sometimes I find just clicking the shutter will startle the little ones, so I have someone continuously click the shutter as the baby is falling asleep so he gets accustomed to the sound. That way, when we start shooting, it doesn't startle him.

Because this lens has an f/2.8 aperture, you can really focus on your subjects and blur your background.

Macro Lenses

Macro lenses are great for shooting up close to babies' hands, feet, ears, or hair—and having *only* that part in the photo. If the image is printed as a 4×6, it will be life size or larger.

You can use a macro lens to shoot close-ups of babies' tiny body parts.

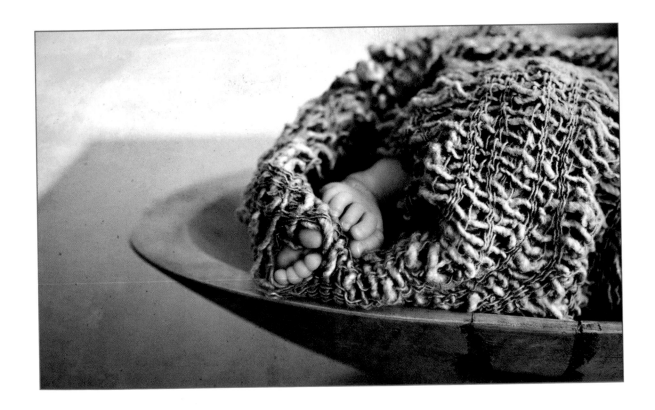

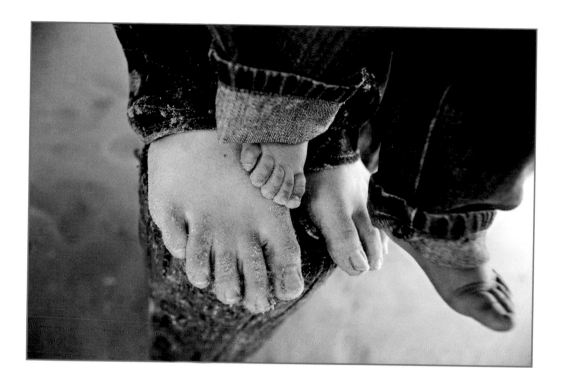

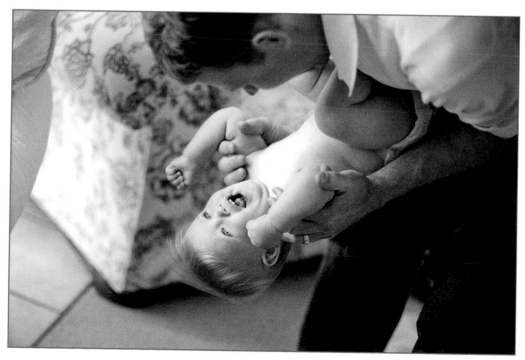

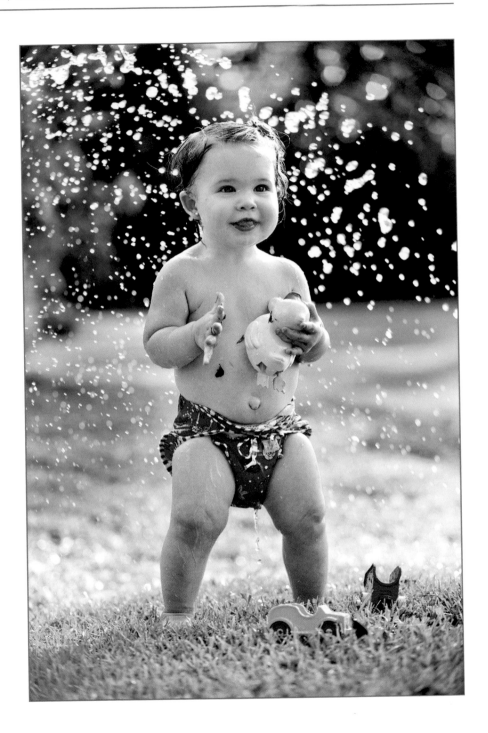

Sometimes when you're shooting macro images, the front of your lens may almost touch the child, but this doesn't allow room for you to light your subject. To avoid this, you can use a telephoto macro lens so that your lens is farther away from the subject, but you can still use the macro capability. If you already have a lens where this happens, you can always crop afterwards, but I suggest getting it right in the camera first. It makes post-production *so* much easier!

Wide-Angle Lenses

Generally, you won't shoot portraits with wide-angle lenses; they distort the subject and make him look larger, and they curve the edges. Portraits are best shot with portrait lenses of 50mm to 200mm. Like any rule, this one is meant to be broken at times—but make sure that when you break it (or any others), you know *why* you're doing it and you get the desired result.

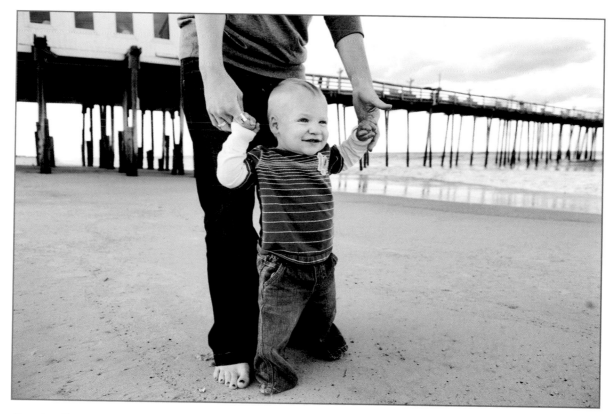

Occasionally, you can break the "rule" and use a wide-angle lens for portraits.

Computer

Are you going to go with a Mac or PC? Each one has plusses and minuses, and it really is a matter of personal preference. However, regardless of which one you choose, get the fastest possible machine with the most memory you can afford. You will spend a bit more on a fast machine, but you will quickly make up the difference with the time you save while editing your images.

Software

Image-editing and -managing software packages abound. Which will you use? Photoshop is a must, but will you also use Lightroom or Aperture? Something else entirely? Again, this is purely a matter of personal preference. Some people love Lightroom; others swear by Aperture, for example.

Most people have heard of Photoshop—it is the big-name program for editing your images from RAW to your desired file format or for heavy editing on the final file type. With Photoshop, you can retouch skin, change colors in the photo, add or subtract people or objects, apply other special effects—it's the Big Daddy of image-editing and -manipulation programs.

Lightroom and Aperture are used for photo organizing and some manipulation. You can use presets for when you convert images from one file type to another and for doing some types of manipulation, but you cannot do all you can in Photoshop. Some digital photographers use both programs together, because they like the way programs other than Photoshop organize and make basic tweaks to their images.

Most of these software packages don't come cheaply. If you're still in school, purchase them while you get your student discount—it will make a *big* difference in the final price.

Hard Drives

Your hard drives are just as important as your camera equipment, computer, and software. Many companies make hard drives, and which one you choose is really up to you. However, regardless of what brand of hard drive you choose to go with, back up, back up, back up! Use at least two external hard drives to back up your edited and unedited images, RAW and/or JPG.

In addition, consider backing up your images online so you can access them from anywhere. This also ensures that they are stored offsite in case of a fire or theft. You might even consider storing a hard drive in a safe-deposit box.

Cloud storage is an option more photographers ought to consider. This is where you upload your images to a server, and they are redundantly stored offsite. With cloud storage, you can access your files from anywhere you have an Internet connection, simply by logging in and choosing the images you want to download or ordering a disc of your images. They are backed up multiple times offsite in case one of the storage system's computers goes down.

You can also back up Photoshop and other programs offsite and use them from any computer. If you have an older and slower computer, you can log in to the server and run Photoshop from this offsite storage system, and it will run very fast because it's not taking up space on your computer's hard drive.

There are a couple of online hosting companies that will back up your images, and you can order the ones you want via FTP, or they can send you a high-resolution disc. Pictage.com provides a place where you can upload your high-res files and have your clients view and order them, as well as a lab. You can offer albums, back up your files, and access them over the Internet. Collages.net offers a similar service, but you pay an additional fee/event.

You can use RAID (*Redundant Array of Independent Disks*) drives to back up your images. These are multiple hard drives in one unit. The more drives, the greater the RAID protection. Digital media is written in binary numbers, composed of only zeros and ones. The RAID drive splits this data across each drive: 0, 1, 0, 1, and so on. This is beneficial because if one of the multiple drives fails, you can swap it out with a clean new drive, and the RAID will rebuild itself, inserting the missing 0 or 1. No data will be compromised! It divides and duplicates data over several drives in one unit.

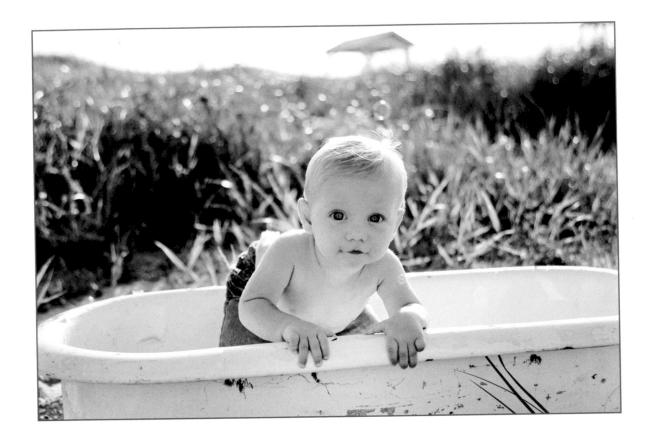

Additional Items

This chapter has covered the basics you'll need, but there are a few peripherals as well. You will need CompactFlash/SD/memory cards. The size of your memory cards is variable—decide how many gigs you need based on how much you shoot per session. Also look at how fast the card is—you will want to get one that writes data quickly so that if you begin shooting quickly, you don't have to wait for your card to catch up and write the data before you keep shooting, or worse, not capture some of the images you are taking.

Some cameras have dual CompactFlash slots and back one card up to another while you're shooting. If this isn't the case on your camera, you'll want to use smaller CompactFlash cards. If your card gets corrupted or lost, it's much better to lose what's on a 1-GB card than what's on a 16-GB card.

This one should be obvious, but if you're shooting anyplace other than your studio, you'll want to take an on-camera flash or other lighting with you—you never know when you'll need it! If you are shooting in a studio, you'll need lights, stands, modifiers, and a light meter, as well as an assortment of backdrops or sets. We'll talk more about lighting specifics in Chapter 3, "Seeing the Light."

Also on the obvious side of things, you'll need plenty of backup batteries and chargers on hand for each type of battery you are using. You don't want to be left with a dead battery in the middle of a shoot.

I also suggest having a smartphone on which you can answer emails and view attachments when you aren't at your computer. Having a reasonably quick response time for your clients is important. You can set up an automated email response telling them that you answer emails once or twice a day—say, at 9:00 a.m. and 5:00 p.m. That way, you don't have to check your phone every time a message comes in. However, if you're out and about and you have a few spare minutes midday, a smartphone is handy so you can catch up on some quick emails here and there.

You can do the same for phone calls—on your voicemail greet, you can say that all calls will be returned after 4:00 p.m. That way, you aren't distracted by calls while you're shooting or trying to get your editing or marketing done.

Some smartphones even allow you to run credit cards, which keeps you from having to purchase a separate credit-card terminal. And, many have GPS systems built into them, which saves you from having to purchase a separate GPS system.

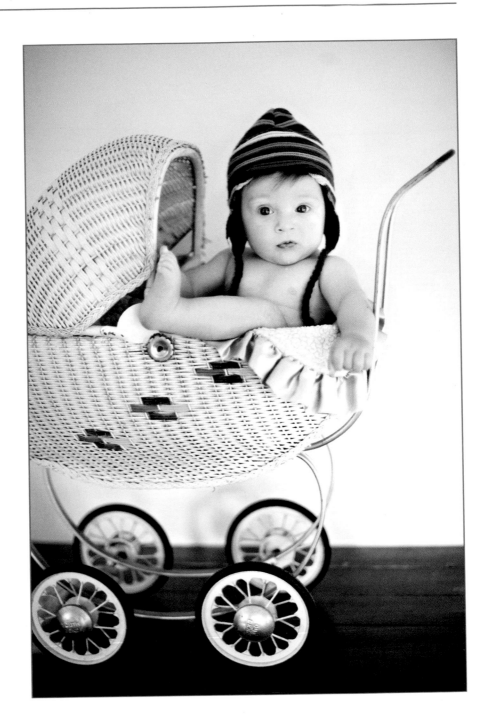

Make sure you get a smartphone with the capacity to store files. A Bluetooth-enabled smartphone will allow you to transfer files wirelessly, a feature that can be useful. Also, consider a smartphone with video options so that you can do video conferencing with your clients.

Card readers are also good to have. There are many types and brands of card readers available; I suggest getting the fastest one you can afford and the kind that tethers together so you can download more than one card at a time. This will save you time and money.

A Word to the Wise

No matter how well you take care of your equipment, you never know what can happen and when. If a camera or lens breaks, you don't want the client to know or worry about it. Make sure you always have backup equipment handy and you have liability and theft insurance. The backup equipment will let you keep shooting, and the insurance will give you peace of mind that you can replace your equipment and avoid being sued for any accidents that may occur. If someone trips over your light or camera, can you handle a million-dollar lawsuit? I didn't think so....

3

Seeing the Light

When you're a photographer, you learn to see the light—how it falls on your subject, what areas are lighter and darker, how the subject stands out from the background, and so on. You learn to look at your subject and know whether you need to overexpose, underexpose, or shoot what the meter tells you in order to get the correct exposure. In this chapter, we'll talk all about light and how you use it when photographing babies.

What Light Is Best?

No one particular type of light will work in all scenarios. When choosing the lighting to use, consider what mood you want to convey, where you'll be shooting, and what the theme of the shoot is. Natural light tends to look the most real when it's available, but there will be plenty of times when it won't be available or sufficient, and you'll need to supplement with lamps, flashes, flashlights, studio lighting, or LED video lights. Be creative! I have a deer light over which I have put several layers of white tissue paper to diffuse it and to soften the yellow light of the tungsten bulb. I take it with me everywhere I go because I never know what I might need.

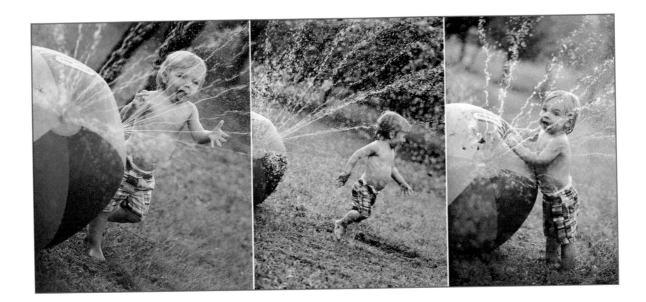

If you have sufficient light on the baby but the background is going dark, you can always turn on a light in the background, move a lamp, open a door or window, or set up an off-camera flash to light the scene. You can use an on-camera flash and bounce it from the ceiling or wall—just keep in mind that whatever color you bounce it off will cast onto your subject, too. So, if you bounce your light off a red wall, it will give your subject a red cast.

If you're shooting outdoors and it's starting to get dark, you can always use the car's headlights for light. Keep tissue paper or a sheet on hand to tape in front of them to cut down the brightness, and it could create an interesting effect! (Just be sure not to kill your car battery in the process!) In short, any light will work once you learn how to see and manipulate it.

The Basics of Light in Portrait Photography

Light is what makes photography; you can use and create any type of light. Have fun with it and don't always stick with what's safe. Learn the rules so you can break them!

Quality, Intensity, and Direction

Generally, when photographing portraits, you want to use soft light. Harsh light doesn't do anyone any favors—no matter how adorable the baby is! So, wherever you're shooting, you want to look for bounced, soft light.

If you're shooting indoors and the room light comes from a window, you don't want the light streaming in directly on your subject; instead, look for another room where the window is facing a different direction and the light is coming in softly. Ideally, you can have the window in front of your subject or find a room with two windows—one in front of the subject and one beside—so you have fill light.

If you're shooting outdoors, noon light provides harsh, crisp shadows as it comes from directly overhead. It will cast strong, dark shadows below the subject's eyes. However, if you have to shoot in bright light, you can put a diffuser between the sun and the baby or bounce light into the shadowed areas on the baby.

Direct frontal lighting results in shadows, flattens your subject, and doesn't give depth. Instead, look for slightly directional light that isn't too harsh. However, if direct frontal lighting is all you have to work with, you can modify it by holding a sheet in front of the window for the light to filter through or by using a reflector and bouncing the light back onto your subject.

Figures 3.1 through 3.3 show examples of different lighting I had based on the camera angle. The shot in Figure 3.1 was front lit—I was standing directly in front of the sliding-glass doors, and the baby was lying on the bed looking at me. The lighting was flat and harsh—you can see the harsh shadows it produced, the hotspots on his forehead and cheeks, and how his face is much brighter than his bottom. Also notice how I lost detail in his eyes and face. This lighting mimics that of an on-camera flash that is not bounced but instead is facing straight toward your subject. It's flat and harsh with hot spots and deep shadows.

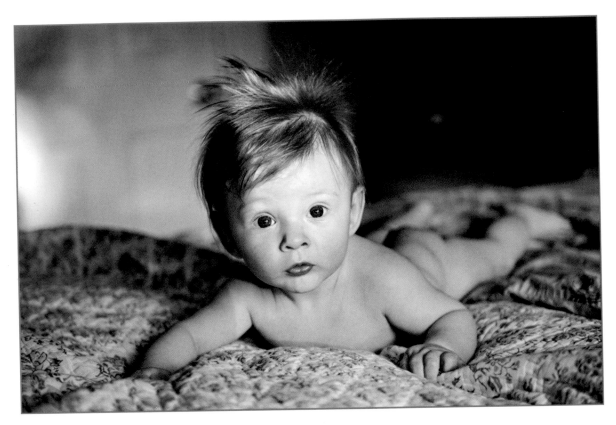

Figure 3.1

My first front-lit shot has some problems.

This lighting was not working, so I moved to the corner of the bed, where the baby was being side lit. You still can see the harsh shadows and how one side is much brighter and more washed out than the other. In a case like this, you can add a fill light to the shadow side with a white card, reflector, or flash.

Because I didn't have time to do this, I quickly changed my camera angle again so he was more backlit but yet still side lit. Although not perfect, the lighting is more even, his eyes still pop, he has the light coming through his hair, and his bottom and face are evenly lit. Ideally, time allowing, you could hang a sheet or white sheer curtain over the doors to diffuse the light so it would be softer and easier to work with, or you could go to another room that has softer light.

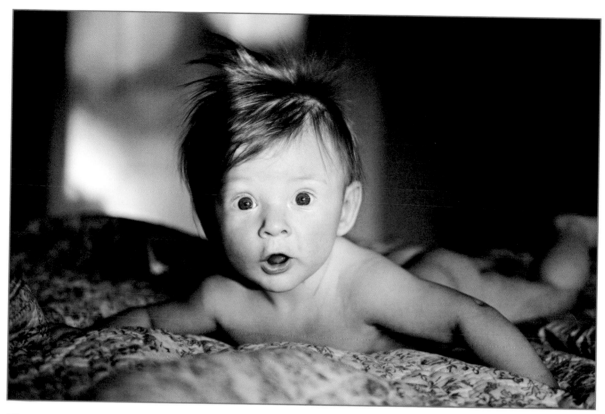

Figure 3.2
My second attempt.

When you're using a reflector, the white side will bounce soft light, the silver side will provide harsh highlights (often used in fashion photography), and the gold side will bounce warm light.

In general, bright backlight is preferred over harsh frontal light. A concern with photographing your subject backlit, or shooting into the light, is that you may get sunspots (lens flare) or haze from direct light hitting the lens and scattering within the lens' optics. Zoom lenses, in particular, have several layers of glass and have a greater tendency to flare. To control lens flare, use a lens hood. Or, if you angle your lens a certain way, it can provide a beautiful hair light—where the light hits the back of your subject and separates him from his background. However, this technique can make the baby's hair and ears glow, so be careful when using it.

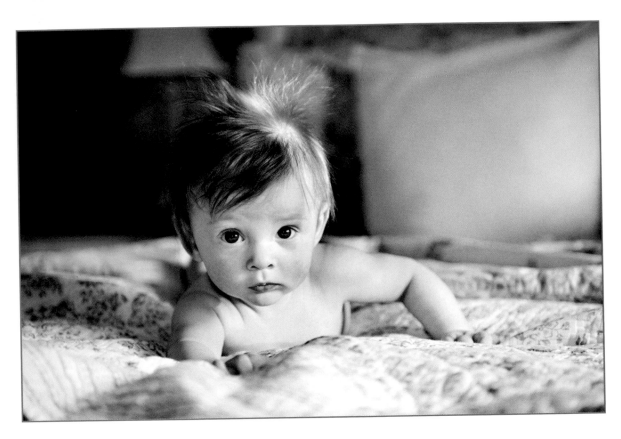

Figure 3.3
The third, best attempt.

Color

The light's color, also known as *color temperature*, depends largely on the shooting conditions. If you're shooting on an overcast day, the light tends to be cool, cyan or blue, whereas if you're shooting on a sunny day, the light tends to be warmer. Open shade also tends to provide bluer light. Sunsets will provide warm light but may also be very backlit, depending on the angle you are shooting and how low the sun is.

Remember, too, that if you're shooting in a colored room or on grass, or if there's light bouncing off of an article of clothing, the subject's skin will pick up the color of the light bouncing onto it.

You can use fill light or filters on your lens to warm up or cool down light, or you can adjust this in post-production. In general, you want babies to have warm skin tones so they don't look washed out. In some instances, the color of the light is mixed, and the image might look best in black and white.

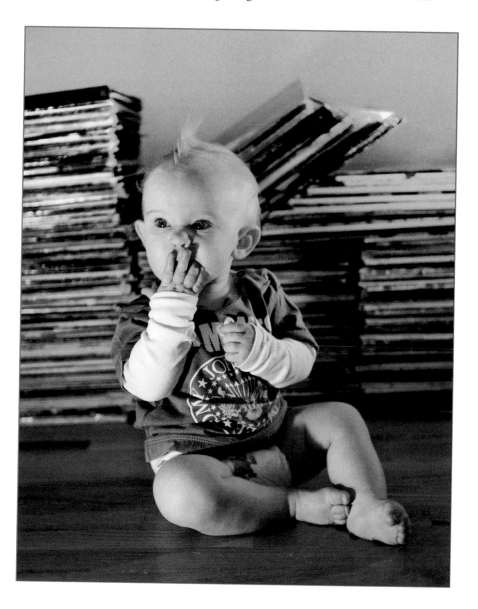

Consistency

If you're shooting on a day when the clouds are constantly moving to cover and reveal the sun, the conditions will provide very inconsistent lighting. You have to be prepared for this and know when to change your camera settings and when to move your subject. While the sun is behind the clouds, the light will be cooler; when the sun is out, the light is much warmer. To accommodate this, you can manually adjust the camera's white balance or set it on auto.

If your subject is mobile, he might be moving all over the place anyway, so you won't be able to trust the consistency of the light. You might need to move your rambunctious one-year-old subject to open shade or to a place where the light is more consistent. You could capture the cutest expression, but if the sun just popped out and is hitting him the wrong way, you could have awful shadows and a squinting kiddo.

To Overexpose or to Underexpose

First, a quick definition. In the photography world, to *overexpose* means to add more light. To *underexpose* means to take away light.

If your subject is darker than her background, you have a couple of options. You can expose for the baby, thus overexposing and blowing out the background, or you can expose for your background and light the baby with flash or video light so she's the same exposure as your background. You can shoot in Manual mode or use your exposure compensation button while you're in Aperture Priority mode.

If the baby you're photographing is moving around, you often can't plan the exact light, as it will change if you're outdoors. So, you must learn to see the light and instinctively know how many stops you will need to overexpose or underexpose.

Just playing with the exposure compensation and seeing what you will get is okay some of the time, but it's best to *know* what you'll get. Know why you're using the settings you are using. Practice makes perfect—the more you adjust your exposure compensation for the available lighting, the more aware you'll become of how many stops you'll need to go in a given lighting situation. A good way to learn this is to play with a light meter; you can meter different lighting situations and see how the light is different at various stops. Once you get the hang of this, you can learn to "see" it without a light meter.

In Figure 3.4, the baby's highchair was right in front of a window. The light that was coming through the window was one stop brighter than the child eating the cake. The camera automatically wants to expose for the brightest part of the photo; however, had I allowed it, we would have seen the green grass, dogs, and fence outside, and the little boy would have gone in shadow. Instead, I put my camera on Aperture Priority mode and set my exposure compensation at +1 so that I was tricking the camera and exposing for the child and not outside.

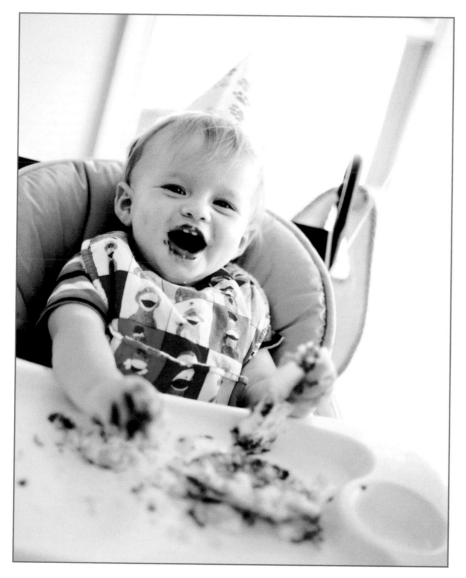

Figure 3.4

I forced the camera to overexpose by one stop to get the lighting right on the little boy.

I didn't think this was the best lighting, so I moved my camera angle to his side, where I had a window behind me acting as a natural fill light on the shadowed side of his face. I could have stayed where I was and used a bounced flash LED light, but instead I changed my camera angle. See Figure 3.5.

Figure 3.5

I decided to change my angle to get better lighting.

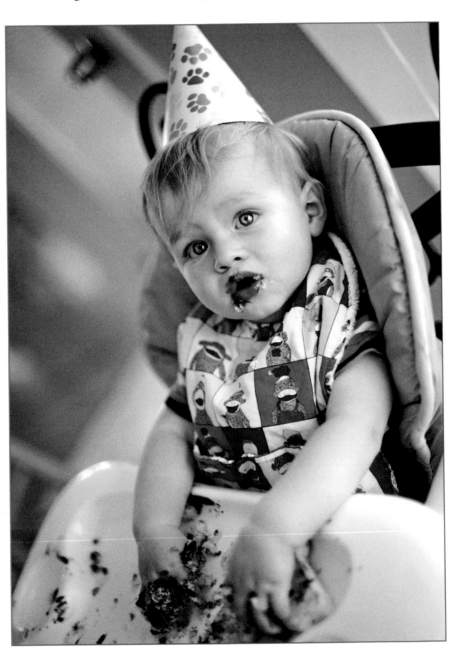

Tips for Shooting Outdoors

If the child is running around outside on a sunny day, you're likely shooting with natural light. You'll use a lower ISO, and you'll need a faster shutter speed to stop the action. An open aperture will blur the background if you're just shooting one subject, but if you have other family members in the shoot, you'll need a narrower aperture. You can't shoot at f/1.8 and have all the faces in focus unless they are on the exact same plane. In situations such as this, try shooting at f/8 or f/16. Keep in mind that if you are farther away from the subject, more will be in focus, even when you're using an open aperture.

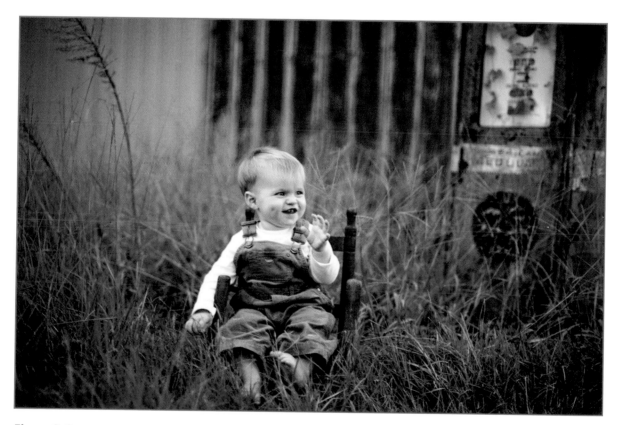

Figure 3.6

I shot this at f/1.8 to keep the boy's face in focus but blur the barn behind him.

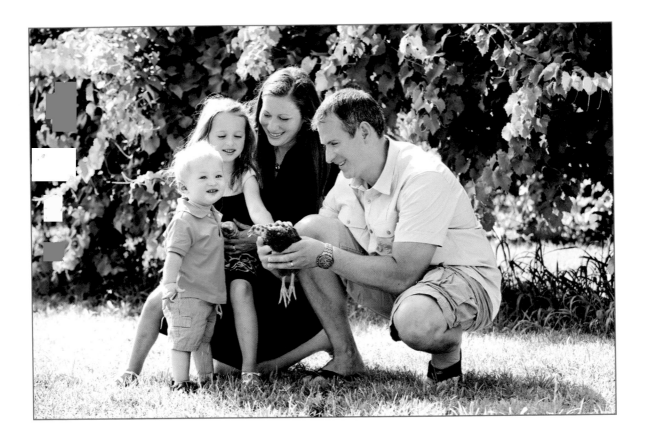

Tips for Shooting Indoors

If you know the child will be indoors and not moving much, and you'll be shooting with available light, you'll need to shoot at a higher ISO, a wider aperture, and a shutter speed of 1/60 or higher to avoid blur.

If you need to add light but you don't want to use direct flash, you can use a reflector to bounce light into the desired location instead. Keep in mind that a reflector doesn't have to be a purchased piece of equipment; it can be a wall, a ceiling, a sheet, a bedspread, a piece of white paper—whatever you have

available. Just remember that the color of the reflector will bounce back into the image. For example, if you're shooting a baby on a red couch, her skin will be tinted red or pink because of the couch. The same is true if you're shooting a child under a blue parasol—the blue will reflect on him and give him a bluish cast, so you'll have to warm up his skin in post-production.

In Figures 3.7 and 3.8, the baby was photographed on blue fabric, and it's bouncing back on her skin. Had I not intended to convert the image to black and white, I would not have chosen this material.

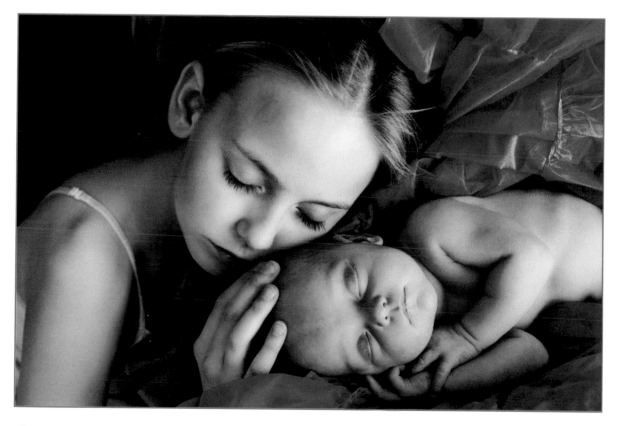

Figure 3.7

The blue fabric is reflecting onto the baby's skin.

Figure 3.8

In black and white, the image works.

Types of Artificial Lighting

Particularly if you're shooting indoors a lot, you'll need to understand the types of artificial lighting. This section will discuss the two main types of artificial light that you will encounter.

Tungsten Light

Tungsten lights are the lights that are usually inside homes, such as lamps and overhead lights. They're the traditional light bulbs we grew up with, as opposed to the energy-saving fluorescent lights that many people use in their homes today. Tungsten lights give a yellow tinge to photographs (unless they are daylight-balanced bulbs—the ones with a blue tint on the glass bulb). You will want to compensate for this by custom setting your white balance, using a filter, or adjusting for it in post-production. If you're shooting inside a house and you don't have enough natural light available, you may use tungsten as fill light. Note that there will be inconsistencies in the two light sources: window-lit daylight (cool) and tungsten interior lights (warm). You may want to balance the color temperature in post-production.

Fluorescent Light

Fluorescent lights cast a green light, and although they generally produce *more* light than tungsten light, if you are using them, your images often will be best rendered in black and white.

Using Flash

The benefit of flash is that it allows you to shoot in low light, to stop motion, and to add daylight-balanced light to a low-ambient-light environment. However, while photographing babies during the first year, you generally can control the lighting by choosing the time of day and location so that you don't need to use flash. This is desirable because if you don't know how to use flash correctly, you'll find that it can provide some harsh, unattractive lighting. But that doesn't have to be the case. Learn how to use on-camera and off-camera flash in Manual mode and TTL (*through the lens*).

There are several different flash types available:

- **Built-in or pop-up.** This describes an on-camera flash that is built into the camera body. This type of flash can be harsh, but you can use diffusion to control harshness of the light. For example, take a notecard and rubber band and put the notecard in front of the flash, held in place by the rubber band around the flash. When the flash fires, it will bounce onto the card and then up to the ceiling or wall and will provide softer light. Keep in mind that you will have to shoot in Manual mode to get the correct exposure with this type of flash. The downfall of these types of flashes is that they don't recycle as quickly as off-camera flashes. You have to wait longer between photos for the flash to work—often the camera won't even let you shoot without the flash unless you pop it down. These flashes are stationary on the camera, and you push a button to get it to come up and then you push it down to close it. These flashes are not very versatile and can't be moved or rotated.

- **Hot shoe or shoe-mounted.** These flashes are secondary components that can be attached to the camera body through the hot-shoe mount. You can use diffusion to control harness of light, and some models can swivel and rotate to bounce light. These flashes can be used on camera or off camera in slave mode, and you can use them in conjunction with other flashes to create dynamic lighting scenarios. When using flash in TTL mode, it is through the lens metering and generally gives you a desirable result. It fires a pre-flash to determine how far away the subject is so it's not too bright; however, you may have to manually compensate to add more or less flash if you're bouncing it off ceilings or doors.

- **Flash sync.** This describes off-camera lighting, which syncs to camera's shutter through either a trigger slave or a wired slave.

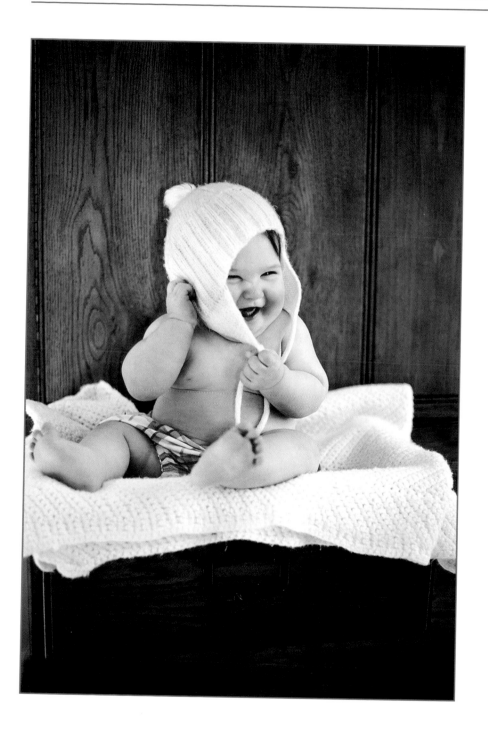

On-camera flash directed right onto your subject will wash her out and provide flat lighting, shiny spots on her face and harsh shadows. Instead, turn the flash up or to the side to bounce it off the ceiling or the wall so it's not as harsh. This can provide interesting directional light.

If you have a video light or an LED light on your camera, or if you have your pop-up flash or an off-camera flash mounted to the hot shoe of your camera not rotated facing your subject, it can act as fill flash and make the subject's eyes pop, but it will also add shadows. So, make sure if you turn your camera to take a vertical photo, you consider where the shadow will fall.

If you have any light mounted directly on your hot shoe, when shooting a horizontal (landscape) photo, the light is directly inline with your subject, and the light will be flat and will put shadows directly behind the baby that you may not see unless the baby is really close to a wall. If the baby isn't close to a wall, the shadows will just fall right behind him.

When you turn your camera one way or the other to take a vertical (portrait) photo and you have the light mounted on your hot shoe and haven't turned it to bounce it off a ceiling or wall, the light will hit your subject from one side or the other and throw a shadow off to the side. It will put more light on one side of the subject or another, making that side darker.

Ring Flash

Ring flashes are best known in fashion photography—they create an almost shadowless image. These flashes were originally created for people shooting with macro lenses, who wanted to illuminate the image with as few shadows as possible. However, they are now widely used in fashion photography as well. You can best capture the desired effect from a ring flash by photographing your subject up close—that way, you can soften the shadows and evenly infuse the light. The three images on the next couple of pages were taken with a ring flash, but rather than having it around my lens and using it as a flash, I took it off and used it as a continuous light source.

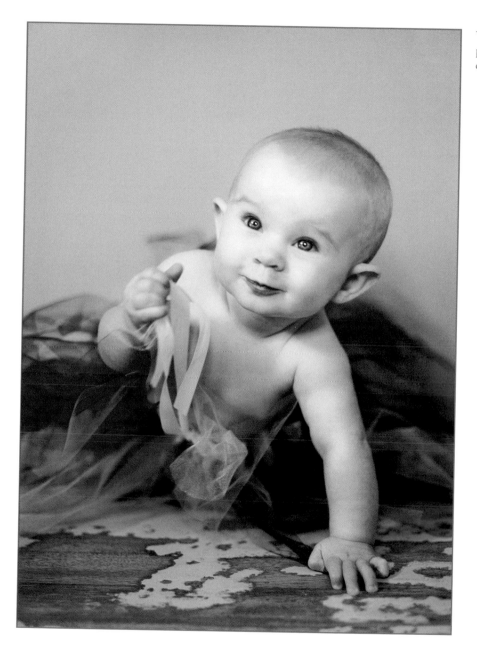

When you use a ring flash, photograph the baby up close.

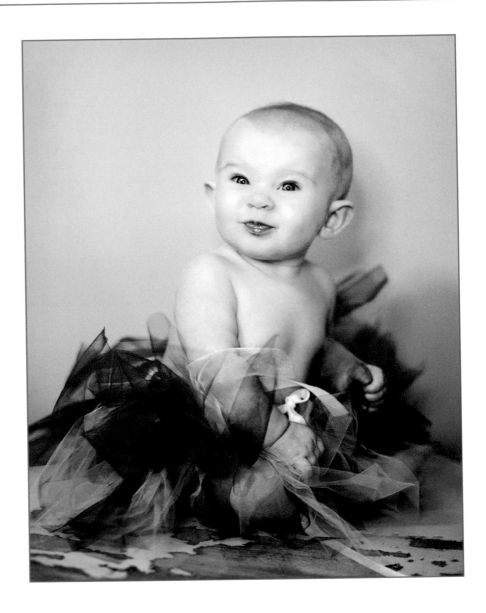

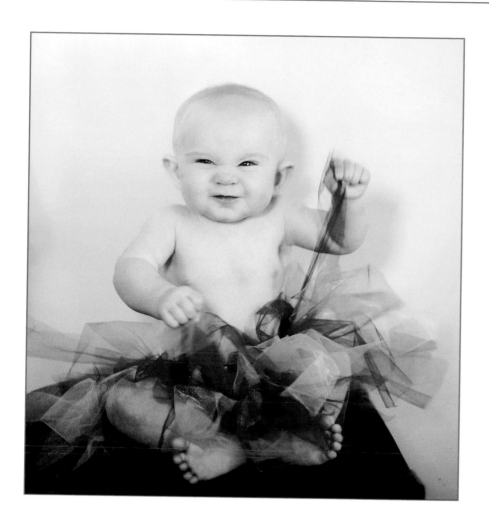

Using Continuous Lighting

Because flash can be so intrusive, you might try video lights and continuous light sources. Some of these also flash and come with warming and cooling filters. Although they might look slightly intimidating, babies get used to them quickly, and they also can provide warmth. Be careful when using them, though—some get very hot. Make sure they're far enough away that the baby won't be able to reach them and that they can't fall on the child.

These types of lights are best used for fill light when you're using natural light from a large window or an ambient light source.

There are several types of continuous lights:

- **Fluorescent lamps.** You can use these with corresponding light modifiers for on- and off-camera kits. They generate little heat.

- **Tungsten halogen lamps.** You can use these with corresponding light modifiers for on- and off-camera kits. They generate heat and pose a burn and/or fire hazard when handled unsafely.

- **HMI.** You can use these for movies and professional studio photography. They are an off-camera light source only. They generate heat and present a burn and/or fire hazard when handled unsafely.

- **Hot lights.** These are used for movies and professional studio photography. They are an off-camera light source only. They generate heat and pose a burn and/or fire hazard when handled unsafely.

So ends our brief look at lighting. There is a wealth of information available on the subject—entire books have been written on it. It would be outside the scope of this book to try to provide a complete reference on lighting, but do research some more to gain more knowledge about the subject. For now, we'll move on to being prepared…and preparing your clients!

4

Be Prepared—and
Prepare Your Clients,
Too!

Always be prepared! Take care of everything you possibly can before the shoot so that the shoot itself can go as smoothly as possible. Photography is already somewhat unpredictable, and shoots can have bumps along the way. Making sure that you and your client are on the same page and arriving to the shoot completely prepared will ensure that things go as smoothly as possible. If you do your homework, the client's experience will be better because you can concentrate on them and their shoot without being preoccupied. Remember, in the time you spend with your client, you want to be completely focused on them and create a positive environment; lack of preparation has the potential to add unnecessary stress to your experience with the client.

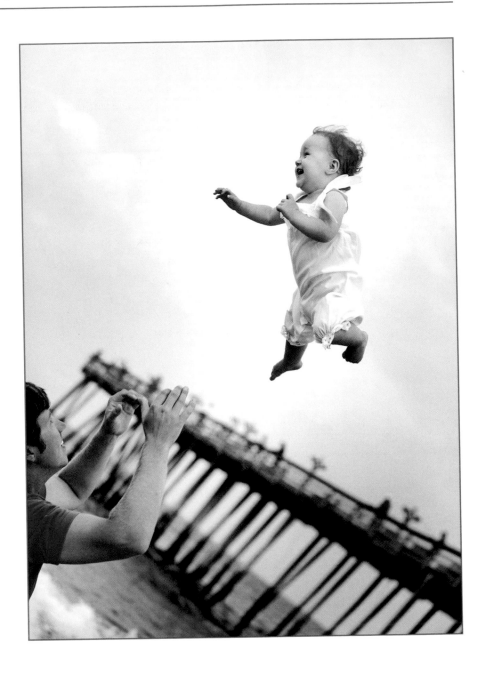

Present Yourself Well

This may go without saying, but you should have good hygiene and look presentable when you meet your clients or even leave the house. You don't have to wear a business suit, but you should look casually well put together. You are your brand, and you don't want to look like a slob. Your clients will translate that into you not caring about their images—if you don't care about how you look, how can you possibly care about their images?

In addition to a neat appearance, bring an open mind and a good attitude to all your shoots. No matter what happened that day or what is going on in your life, you need to remain pleasant and professional. You want to give your clients a positive experience from the first moment they talk to you and then carry that through every interaction you have with them. Not only do you want to photograph their baby's first year, but you also want to photograph their children through their weddings and their own babies. Being pleasant and professional at all times is the only way you'll make that happen.

Prepare Your Props

If you're shooting in your studio, it's easy to know the props and lighting you want to use. But if you're going to a client's home or another location, you must make sure you have all the props you need packed in your car. Although you can always improvise if necessary, it's a whole lot easier to have what you need on hand when you get to your location. Often I bring a ton of props, only to use what the clients already have at their home. However, the one time I didn't bring any, I had a hard time finding ones at the home to use!

Pack your props the night before so you don't forget anything the day of the shoot. Also include any paperwork you might need to bring, a GPS, your equipment, a heater, a noise machine, water, and treats for older kids.

Props make photos more interesting and believable—and as an added bonus, they give babies something to do with their hands. Your props don't have to be expensive. You can add to your bag of props when you go to consignment stores or flea markets. Most decent consignment stores have standards for what they'll accept, so you'll usually find good-quality products in such stores—but for a fraction of the retail cost. Make sure to clean and disinfect all props when you purchase them and again before and after you use them. Parents won't appreciate it if their child is well before the shoot and sick afterward. Babies tend to put everything in their mouth, so germs spread easily!

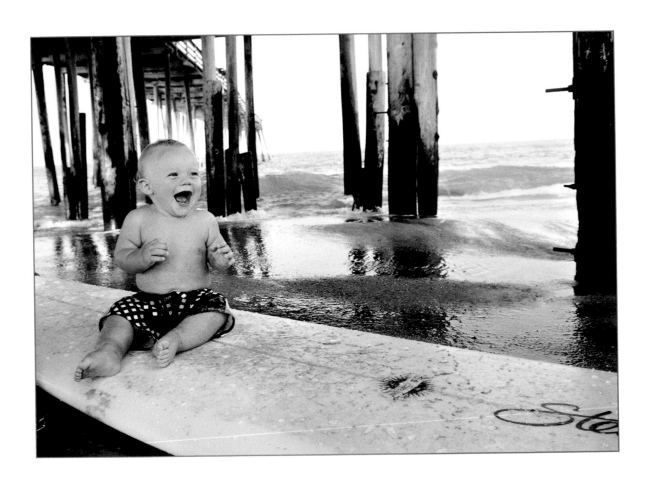

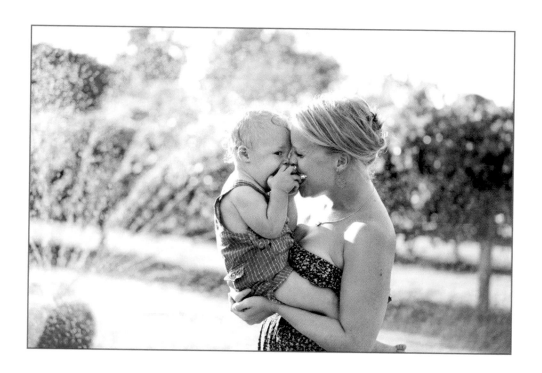

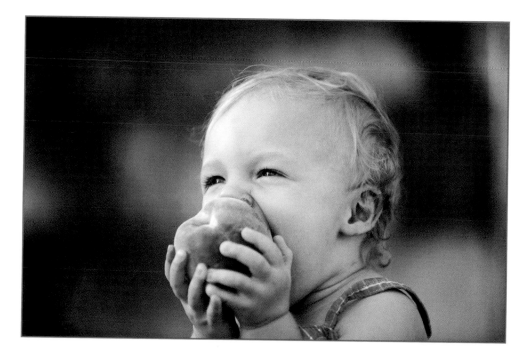

For each shoot, plan props that will match your client's home and décor. If your client lives in a sleek, ultramodern home, for example, that rustic, hand-painted wagon of flowers isn't really going to fit the scene. You'd want something more spare and minimalist. But that wagon of flowers would look great in a cozy, country-style home.

If figuring out prop aesthetics isn't your thing, think about whether you want to hire a prop or baby stylist. If you do, tell your clients and have the cost built into your fee. No one wants to be nickel-and-dimed, so you should have these things built into your packages. That way, your clients can see the total for everything—and they can always add onto it if they decide they'd like more services.

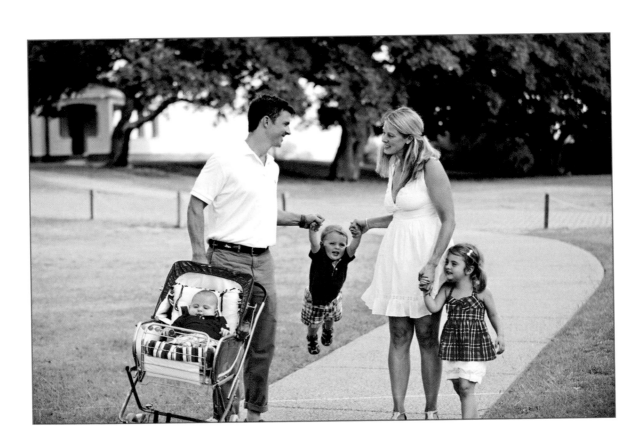

Location Basics

This, too, may go without saying, but be sure to call or email your client the day before the shoot to confirm times and locations. And remember, if you're shooting in a public location, make sure you don't need permission to shoot there—or if you *do* need permission, that you've secured it ahead of time.

Have a spreadsheet of your clients' names, numbers, and addresses; what package they have secured; what is included in the package; when their payments are due; the names of their kids; the style of their home; whether you have photographed them before; and, if you *have* worked with them before, what they tend to order.

If you're shooting on location, make sure you have an address and directions and that you leave with plenty of time to get there early. Being right on time is equivalent to being late. You should always be at least 10 minutes early so you can prepare yourself and look at the location before you begin shooting. If you arrive exactly on time, you still have to park, bring in your equipment, scout the house, and make sure you have the correct lens on your camera. And if it's a newborn session, you have to find plugs so you can heat the area and turn on the noisemaker.

There are many locations you can shoot; my clients often request the beach. And although it is gorgeous, there is no shade, and the best times of day (6:30 a.m. or 7 p.m.) aren't always best for babies' (or parents') schedules. If you shoot during the day on the beach, it's often hot—not only is everyone sweaty, but they look it in the pictures, too. The sun creates shiny spots on people's faces—they look greasy, they're squinty, and it's likely that there are more people on the beach than in the early morning or the evening.

It can also be really windy on the beach, with sand flying everywhere. Not only will flying sand get in the babies' eyes and faces, it will get in your equipment. For that reason, I have my equipment cleaned monthly and replaced yearly. So, while the beach *is* pretty, it may be better for older kiddos than for baby shoots.

One of my favorite places to shoot is on our farm. We have tons of different backdrops that can work at different times of day and in different lighting conditions. There is a lot of variety, and it's interesting to the kids. Trucks, tractors, barns, water, vineyards, long dusty roads, fields full of fun crops— it's a child's paradise!

When looking for a location, I look for a place that has several areas where we could shoot. That way, if the child gets bored in one location, we can go to the next, and it's like a brand-new adventure!

Parks are a great location, because they usually have a swing set, trees, and open areas. You can scoot around as if it's a play date! Do watch out, though, as there tends to be a lot of photographers in parks, and you don't want your photos to look the same as everyone else's. If you find a lot of photographers in one place, go to another one if possible.

Often shooting at your client's home is easiest for everyone. They have the kiddo's toys and snacks there, so they don't have to pack a ton, and the baby is used to her surroundings. Not to mention, if the baby soils her clothes, it's much easier to clean and change her at home!

Equipment Basics

Bring a reflector to bounce light, flashes, and video lights. Even if you know where you'll be shooting, you never know what idea may pop into your head at the last second, and you'll want to have the equipment there to execute your idea.

You should take a variety of lenses and at least two bodies, in case one breaks at the shoot. Also, don't forget to bring extra charged batteries and the battery charger.

Always test your equipment before each shoot. Make sure your batteries are charged, your CompactFlash cards are formatted (and that you have several with you), your camera is set to the desired settings, your clock is set on your camera, and your lenses and sensors are clean. The last thing you want is to do a shoot, come back and begin editing, and see dust spots all over your images because you have a dirty sensor. That means hours and hours spent retouching images, and if the client purchases a disc of his or her high-resolution images, you'll have to retouch each image. In short, the added time spent on post-production will cut into or fully consume your profits.

Prepare Your Clients

Make sure to set expectations so you can exceed them! You can have a pre-shoot consultation at the client's home, in your studio, over the phone, or over the Internet via Skype.

Your clients are the most important part of your business. Without them, you wouldn't *have* a business. So it's important to prepare them for the shoot, so that everything goes as smoothly as possible.

Pre-Consultation Basics

When you meet with your clients at the pre-consultation, give them a book-let with everything they should expect and how the process works. Let them know how many images they can expect to see based on each package, how they will view the images, how much they cost to purchase, and when they'll be available after the shoot.

If you have a Facebook presence, you can ask your clients whether they would like you to post some fully retouched proofs on Facebook for them. If so, decide whether they get to choose the ones you post or whether you'll post the same ones from your blog. Also, let them know whether you charge for this. I personally suggest that you don't charge and that you choose your favorites to post, as it's free advertising. Many parents with younger children have friends with young kids as well or are members of a mommy or parent group. Posting their images on Facebook with your logo allows all their friends to see your work, and the parents love having these low-res digital files of their kids to use as wallpaper on their cellphone or as their profile picture. If they have an image with your logo on their cellphone, it's another form of advertising!

When you have the first conversation with the family, find out what images they're looking for. Do they want to shoot in their home, at your studio, out-doors, or a mixture of places? Would they like pictures of the baby only, or do they want to include siblings or the whole family? Are they looking for a hori-zontal image to go above their fireplace? If so, would they prefer it to be of the whole family or just the baby? Finding out information such as this will help you know whether you need to shoot more vertical or horizontal images or a series.

Make sure you shoot tons of each scene or setup. Give the parents a choice of images with the same background. They may adore their child's expression in one photo but want more of the background to show, so make sure you have as many options as possible.

Also, you don't have to shoot anything you don't want to, but make sure your client knows what you will and won't be shooting. For example, some photographers won't photograph staged family portraits; they prefer to shoot in a more photojournalistic style. If you have a preference of this nature, be sure to convey it to your clients. By setting expectations for your clients, there won't be any awkward moments during the shoot when they ask for something you don't typically do. This also goes back to reaching your target market.

If something like this *does* come up, instead of making a stink about it, just photograph what the client asks you to. It is better for business to take the posed family portrait of them than to not. Or, if you're focused on one child playing on the grass, and their older one is off running through the park and they ask you to grab a photo of that, graciously do so. They aren't telling you you're doing a bad job, but you *are* missing a moment while concentrating on another moment, and capturing both moments is ideal. After all, you can't be in two places at once!

Getting Model Releases and Contracts

The pre-consultation meeting is also when you should get a signed contract and model releases. Give your clients a contract and an informational sheet that explains exactly what they can expect in terms of the shoot, the products, and what they'll pay.

In the contract, you should include:

- The client's contact info (name/phone number/address/email).

- The date contract is signed.

- The shoot location and date.

- A description of your packages/services.

- Fees, including sales tax and total.

- The amount of your retainer and the date it's due.

- The date the balance is due.

- What to expect during and after the shoot (when and how images will be available to view, when to expect what is included in the package, for how long additional images can be ordered, and so on).

- Terms and conditions.

- Postponement terms—what happens if you have to postpone the shoot?

- Cancellation terms—what happens if one of you cancels?

- Copyright information—who owns the copyright? What can and can't the client do with the images and any high- or low-res files? Without this language, people could potentially try to sell the files to a stock agency to make money. Even if you sell your clients their files, make sure you also have them sign a contract stating that they understand that you, the photographer, still own the copyright, even though they may print them however large and wherever they would like. You should also educate them on the retouching/ordering process so they understand the difference in professionally retouched, finished images and the proof images that they take to their local drugstore to be printed.

- Details about arbitration.

Following is a sample of our Client Services Agreement.

Client Services Agreement

Agreement Date	Client	
Mailing Address		
Phone		
Email		

If you are on Facebook, may we add you as a friend and post a few of our favorite images?
(circle one) Yes No

Shoot Location		Date	/ /

Description of Photography Services

Subtotal of Fees		
Sales Tax (6.75%)		
Total Due		

	Due Date	Amount Due	
Retainer (50% of total)	Upon Signing	$	
Second Payment	Day of Session	$	

Following the shoot, YOUR STUDIO. ("Studio") will make the above described images available online for viewing and purchasing for X AMOUNT OF DAYS/WEEKS/MONTHS. If you need your gallery to be reposted for ordering purposes, there is a ____ repost fee/month. Only images ordered within the allotted days will be archived, all others will be purged.

- Once Studio has completed a client's order by exchanging images for full payment, Studio shall not be liable for storing those images for Client. Images that are ordered within the ordering period (while images are online) will be archived for one year from date of portrait sitting.

- Due to the custom nature of the work, no refunds will be provided for any orders resulting from this Assignment for prints or other photographic products once any work has commenced on the order.

- All images remain copyright YOUR STUDIO and may not be reproduced without written permission of the Studio.

Terms and Conditions

This Client Services Agreement ("Agreement") is entered into, and is effective as of the Agreement Date (as defined on page 1) by and between YOUR STUDIO. ("Studio") and the person(s) identified as the Client on page 1 of this Agreement.

Definitions:

- "Assignment" refers to the portrait session and any related photography services described that the Client is specifically commissioning Photographer to perform.

- "Cancellation" means that the Assignment is canceled by client and not rescheduled.

- "Postponement" is the rescheduling of the Assignment by the Client at least ____ days prior to the Assignment to a mutually agreeable date, and no more than ____ calendar days after the original Assignment date.

- "Photographer" means the photographer identified on page 1 of the Agreement and the Studio.

- "Work" means all photographic images, negatives, digital files, prints or other materials created by Photographer while performing the Assignment.

1. PAYMENT SCHEDULE. The first payment is due with contract to hold the date and the second and final payment is due the day of the portrait session.

2. POSTPONEMENT, CANCELLATION & LIQUIDATED DAMAGES:

- *TERMINATION BY CLIENT:* Client acknowledges that in the event that there is a Cancellation of the Assignment the Studio will incur expenses and financial loss. Therefore, there will be no refund in the case of cancellation unless the cancellation is due to inclement weather and the Studio is unable to reschedule your portrait session. Due to the custom assignment and inability of studio to perform other sessions during time reserved for Client, if Studio has received payment for a scheduled Assignment, Client will not be entitled to a refund if he or she cancels the Assignment.

- *TERMINATION BY COMPANY:* In the event that YOUR STUDIO cannot perform this agreement due to strike, casualty, fire, act of god, or any other event beyond its control, or due to the illness of Company's designated photographer Company may terminate this agreement at any time by returning Clients retainer. In such case, Company shall have no further liability to Client with respect to this agreement.

- *SUBSTITUTION:* In the event the Designated Photographer cannot perform due to illness, injury, acts of God, or other unforeseen circumstances beyond Photographer's control, then another photographer in the Studio shall perform the assignment.

3. COPYRIGHT AND CLIENT'S USAGE: YOUR STUDIO (Company) shall own the copyright in all works created hereunder. Client acknowledges and accepts that photographs taken hereunder may be freely reprinted and utilized by Company in its promotional book, website, in advertising material, art exhibits, or for editorial or any other purposes, whether for display within or outside of Company's offices. Photographs provided to Client hereunder shall be for Client's personal use only. Client shall not sell photographs, enter them in contests or have the images published in any magazine, website or other printed material for anything other than personal use.

4. ARBITRATION: Any controversy or claim arising out of or relating to this agreement, or breach thereof, shall be settled by arbitration, and judgment upon the award by the arbitrator(s) may be entered in any court having jurisdiction thereof. The parties wave trail by jury, to the extent permitted by law, and expressly agree to mediation in any, proceedings or counter claim brought by either party against other, or any other matter what so ever arising out of, or in any way connected with this agreement.

5. NO WARRANTY OF LONGEVITY. Studio does not warrant the longevity in quality of any digital media or files delivered to Client. Client bears the sole responsibility for backing up, archiving, and maintaining the integrity of the files.

6. MISCELLANY: YOUR STUDIO and Client mutually agree to the terms and conditions of this contract. A firm and binding agreement exists between studio and client only after this agreement has been properly executed and all fees paid. This agreement supersedes and replaces any previous document, correspondence, conversation or other written or oral understanding.

Agreed to and Accepted:

_____ _____
YOUR STUDIO Date

_____ _____
Client Signature Date

In addition to a signed contract, you should have model releases for each person being photographed. Having one person in the family sign the model release isn't enough—you need everyone in the photograph to sign the release for each session they are photographed. So if you photograph a family of four three times over the year, you would need three model releases, and on each model release, you'd need to have each member of the family's name.

It's easy to go to a shoot and forget your paperwork and then think you'll get to it later, but if you post images on your website or Facebook page without a written model release, you can get in trouble. It's easier to dot your I's and cross your T's before the shoot than after.

If you don't have a face-to-face pre-consultation and your clients will be signing contracts and releases without you present, there will be a lag time in your client printing the paperwork, filling it out, and mailing it to you; and you receiving it, copying it, signing it, and returning it. To avoid this back-and-forth time, use e-signatures so you'll have the contracts signed and returned in minutes. For clients who can provide an e-signature, this makes working with your company as easy and cost-effective as possible—no postage fees and time spent running to the post office!

Timing the Shoot

Be sure to schedule the shoot with the baby's schedule if possible. Instead of having a fixed time, have the parent call you when the baby wakes up. This gives mom or dad time to change and feed the baby and keeps them from stressing about an exact schedule. You can say something like, "I plan to shoot between about 1:00 and 3:00, so call me sometime during then when the baby is ready." This makes everyone's job easier. You want to photograph a happy baby, and you want the parents relaxed and not stressed about their baby not being in a good mood because he missed his nap. Everything you do should work around the baby.

Also, let your clients know how long they should expect the shoot to take so they can plan accordingly.

Clothing

Let the family know what to wear. For example, if one person wears a pattern, have others coordinate with that person but not match exactly. Let them know not to have people in the shoot wear lots of different patterns, as it will distract from the faces.

Consider where you're shooting, and suggest that participants have their clothing match the background—whether it be their home, your studio, or a different location. Suggest that they have additional outfits set out so they can change quickly if one gets soiled. I have a detailed PDF of information that I send to clients; it includes, among other things, what to wear and what *not* to wear.

Let parents know to keep the baby's diaper loose so that it doesn't leave red marks on her skin. This will make for less retouching later if you photograph the baby naked!

Coordinating outfits are good—but not *too* matchy-match!

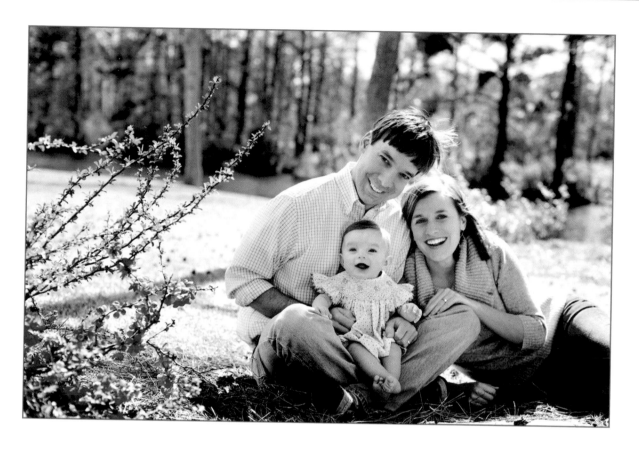

Charges

Be upfront about all charges so your clients aren't surprised by any additional charges for time or products. Tell them your hourly rate if you're charging per hour for the shoot. Make sure they know during the shoot when it's going over the allotted time, so they aren't surprised by a bill after the fact.

If they book an hour session and it goes over by 15 minutes, I don't charge for that—not only do I feel that's nickel-and-diming the client, but I also have spent time talking, posing, moving about, and walking that shouldn't count toward the hour anyway. It's your call what sort of limits you want to set, but I advise being somewhat flexible—after all, flexibility is key when dealing with babies!

When photographing newborns, I suggest that the client book at least an hour session, but I know full well that it will take between two to three hours total. I may only be shooting for an hour, but it takes times to get the baby to sleep, pose the baby, and change props and outfits, and this time shouldn't be charged as overtime. However, you should set your sitting fee knowing that each session will take a bit more time than allotted—that will help you recoup some time costs.

During the Shoot

Let parents know that you might ask them to leave the room while you're photographing their child because they could be a distraction. Kids behave differently when they're around their parents versus a friend. Especially if the mom is breastfeeding, the child may find comfort in nursing even if she isn't hungry. If mom says no, it may upset the baby—or if she says yes, the baby could end up nursing for quite some time.

Be wary when scheduling sessions close to sunset or super early in the morning, when the light is perfect and then abruptly changes to super bright or dark. Clients being late, nursing, or needing to have a "time out" can drastically change your light. This is one more reason why I suggest shooting in a place that has multiple locations—that way, you can start earlier or shoot later based on the lighting.

Also, if you'll be bringing an assistant to the shoot, let the parents know ahead of time so they aren't overwhelmed by more people than they expected coming over.

Preparation is the key to a successful photography business. Know before you open your doors that 90 percent of your time will be spent working on the computer, educating your clients, working with vendors, and marketing—and the other 10 percent will be spent shooting.

5

Photographing the Miracle of Life: Birth through the First Year

Photographing babies and children is hard work. You have to understand and connect with them, as well as manage the parents while on the shoot. One good way to do this is to incorporate the parents as a whole or in part. You can incorporate the parents holding the child, the baby sleeping on the parents, the parents' hands or toes, or even the parents' baby photos. Connect with the child and parent(s). The more they enjoy your company, the more they will open up to you and show their personality. This is what they buy.

Connecting with Children

Get down on the child's level; it shows her that she is important. It also makes you less intimidating to little ones. If they see you on their level, they're more likely to open up and show their true personality.

That personality is exactly what you want at a shoot! Parents want to see who their child is, not just what he looks like. Any funny expressions you can capture are sure to sell. Show who the child is that day; show what she is good at and capture her new tricks. If the baby has teeth, show them. If he can push up on his arms from his belly, show that. Capture babies standing, sitting, and so on.

If you can, show the child's relationship to each parent or pet—not just in a formal pose. You're staging the photos in the best light and with props, but you still want to shoot journalistically to capture emotions and relationships.

Photograph from all different angles, and don't forget to document how tiny babies are—put them in bowls and baskets or on tables. Show their hands or fingers next to their parents' to show how small they are. Or, rest the baby on the parents' arms/forearms/hands to show her size.

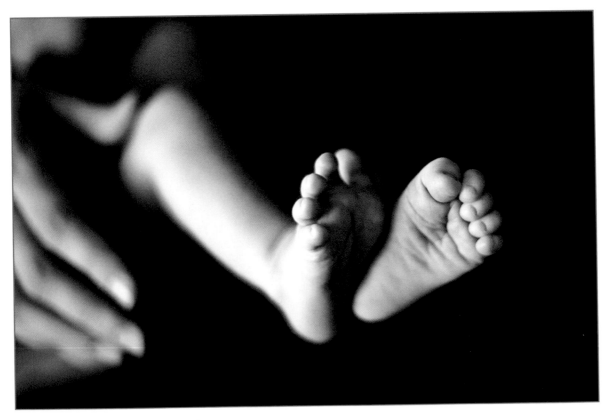

Don't forget to photograph the tiny bits!

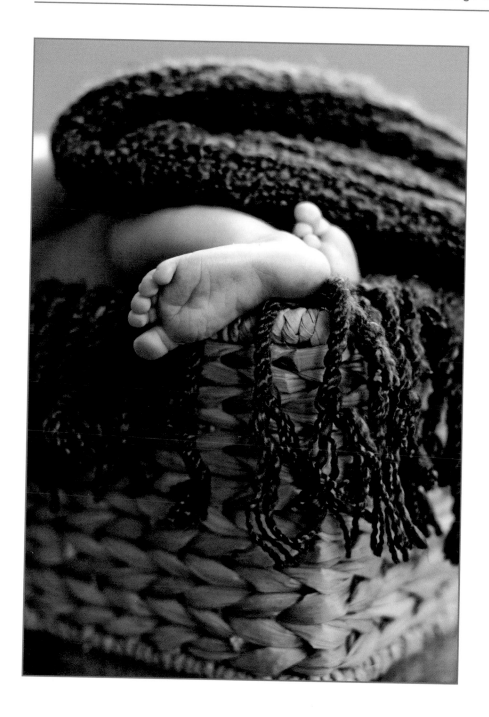

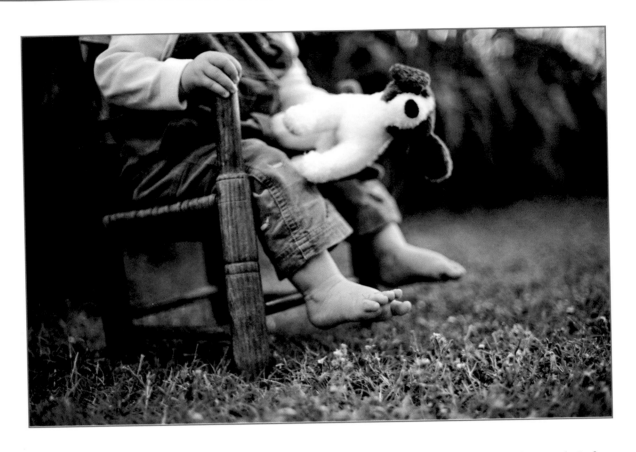

Now let's talk some specifics about photographing babies during their first year.

Happy BIRTH Day!

It's easy to say that you want to photograph a birth, but how do you do this when they are so unpredictable? It takes a bit of planning, but photographing a birth doesn't *have* to be as daunting as it might seem.

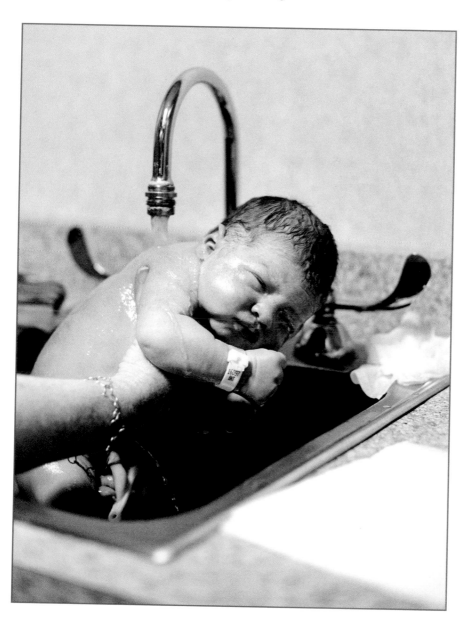

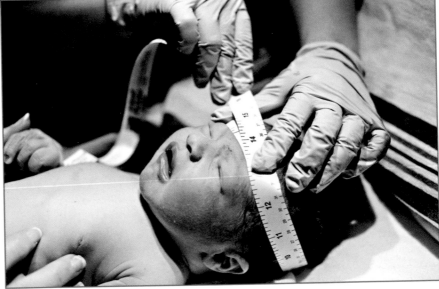

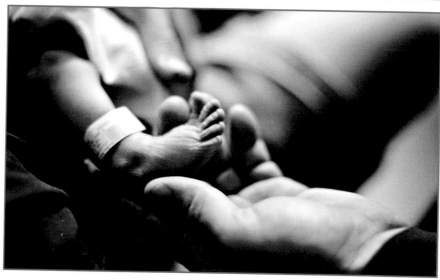

Planning

To photograph a birth, you will need to get permission from the hospital and/or the doctor/midwife. Ask the expectant parents to inform the appropriate parties that you will be there and to investigate any rules that may apply. You may not be allowed in the room when the baby is actually being born, or you may not be able to go with the mom when she's having a C-section. The hospital may not allow flash or allow you to publish which hospital you're in. You may not be allowed to photograph any of the doctors' or nurses' faces.

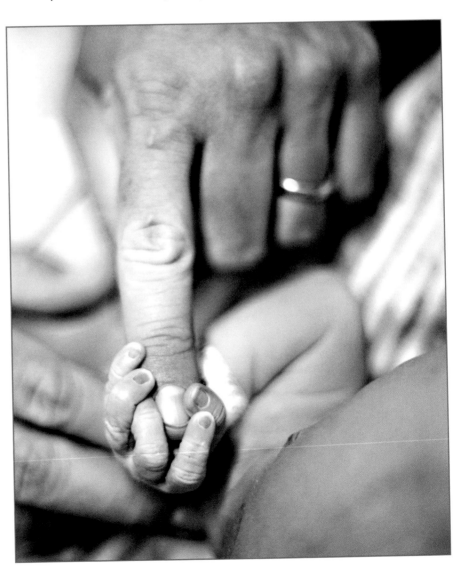

When the big event happens, be completely unobtrusive and always say thank you to every doctor and nurse you encounter; after all, they are allowing you access to document this new life.

Payment Options and Packages

You may want to have all of your other shoots paid for up front, but this one should be the exception. If there is a scheduling conflict or the birth happens very quickly, you may not be able to be there, and you don't want to have to deal with a refund.

You should also have a set fee for this type of shoot rather than charging per hour, because it is impossible to accurately determine when the baby will arrive. Labors can last from a few hours to several days; it's impossible to predict.

People will want prints of a lot of baby photographs. However, when photographing a birth, you'll tend to sell albums instead, as many don't want to display birth images on their walls for everyone to see.

In your birth package (as in any package), you can include all the digital files if you choose. However, if you do so, make sure that you are being well compensated for them, as you probably will not make more money from that shoot after you give the files to the clients. You want to work smarter, not harder, and shoot fewer sessions but make more money.

When to Arrive

Determine the best time to arrive for the birth by talking to the father and any other family members. You don't want to be waiting for hours for the birth, but you don't want to miss it, either. Depending on how far you are from the birthing location, ask a family member to call you when the attending practitioner believes that the mother will begin pushing in one to two hours. Remember that second and third babies tend to come more quickly than first ones! If the birth is a scheduled C-section, you should go to the hospital when the parents do.

Photography Style and What to Capture

So what exactly do you shoot during a birth, given that it's a very intimate experience? Discuss everything with both parents and the doctor before the birth. Be sure to clarify how much of the event the clients actually want documented and learn the doctor's rules in advance.

Hospital photos look best in black and white because the lighting is less than optimal, and you don't want to use flash and distract from the moment and energy. So that you don't have to use flash, shoot at f/1.2–2.8 at a high ISO. This allows as much natural light in as possible and blurs the background to draw attention to the subject.

Doctors often use spotlights during the birth. This makes the lighting difficult, as it's very bright and contrasty and leaves the rest of the subject dark. In this situation, you may want to use a video light or open a window. Discuss this with the couple before the birth to make sure they don't mind you opening the blinds or using additional light. While mom is pushing, you don't want to distract her by asking questions!

Shoot wide angles and up close—the details make the shot! Don't forget to photograph the outside of the hospital, the name of the hospital, the room number, clocks, the arm bands, and the oh-so-delicious food—ha! Don't forget the little moments (dad's hands holding mom's, him wiping her forehead, and so on), the scan of contractions, the heart-rate monitor, any texts that are sent out, and even the parents' Facebook and Twitter updates once they announce the birth. And naturally, don't forget the people: mom, dad, grandparents, doctor or midwife, and so on.

Getting close-up shots is crucial. Take macro shots of feet, hands, bends, folds, lips, slobber, noses, ears, and hair. Some children are born with hair all over their bodies and lose it in the upcoming weeks, and they are covered in a white film to protect them from getting "pruny" while in the womb. Don't be alarmed—this is all normal and should be captured.

Always stay out of the way and be respectful of everyone at every moment—especially if something goes wrong. You want to capture each moment without altering it or being invasive, which may require you to use a longer lens or stand on a chair so you are above the scene and not in anyone's way.

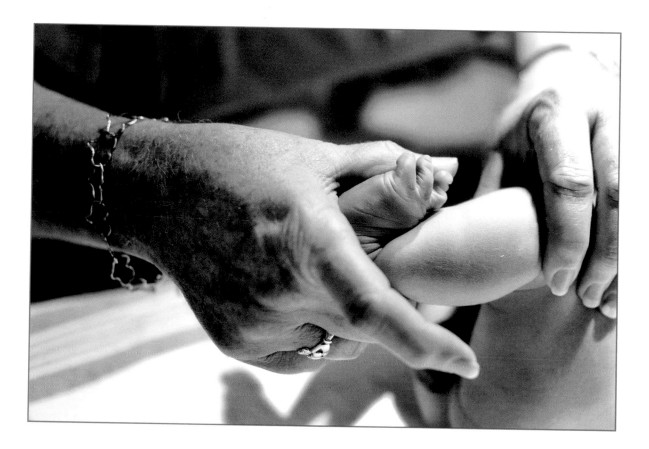

If there is an emergency C-section, document everything other than the birth (unless they allow you in the operating room), such as dad putting on his scrubs, dad holding the baby—whatever you, the doctors, and the parents are comfortable with. This is a very emotional time for everyone, so be courteous and keep your distance.

While shooting, if you and the father are the only ones in the room, you also may have to act as a doula, encouraging mom and dad, holding mom's hand, helping to hold her feet while she pushes—your job can extend out of documenting the birth and into participating!

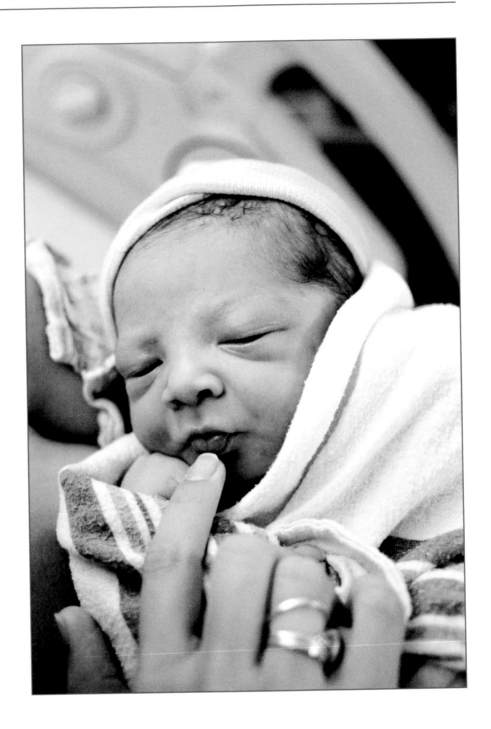

After the baby is born, capture the height, weight, length, footprints, first bath, and feeding—these are some of the most precious moments. Try to do it in a creative manner. Keep in mind that you want to shoot for profit and shoot images the couple will love and want to relive and share with their child. You are documenting the first few hours of this child's life, so tell the baby's story and the parents' story—shoot it from an insider's perspective. If the parents trust you enough to allow you in the room for the birth of their child, they trust your perspective and relate to you. You want to see it through the mother's, father's, and baby's eyes. What do you think the baby sees and feels when she first enters the world? Get on the baby's level and try to imagine what he sees.

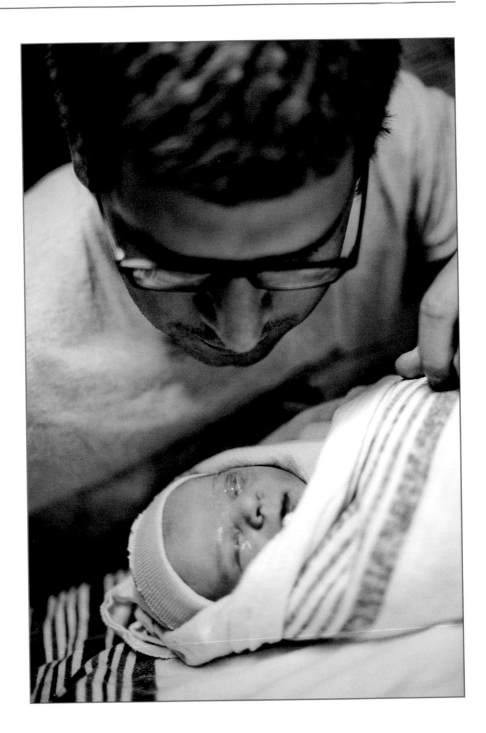

Newborns

Many think newborns are the hardest babies to photograph, even though they seem like the easiest. Yes, it's a sleeping baby, but getting the baby asleep and keeping her asleep isn't as easy as it looks.

The Location

Consider shooting newborn pictures at the parents' house. Often dad isn't available, and it's hard for a new mom to get out of the house with her newborn and any props she wants to use. If you come to them, mom and baby stay comfortable, and you have the flexibility to use any baby props they have lying around.

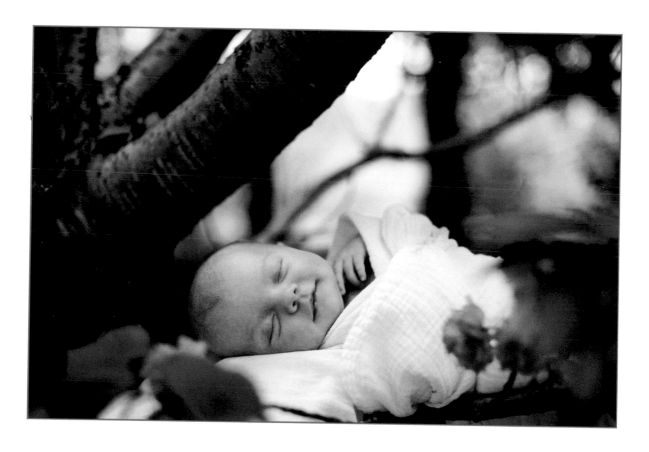

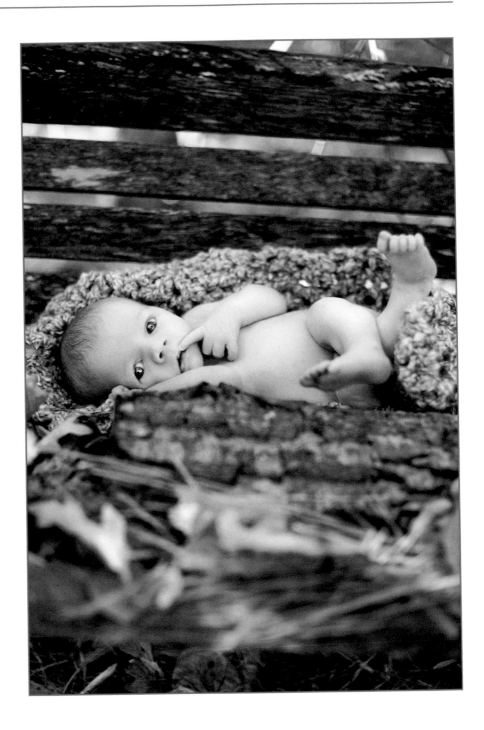

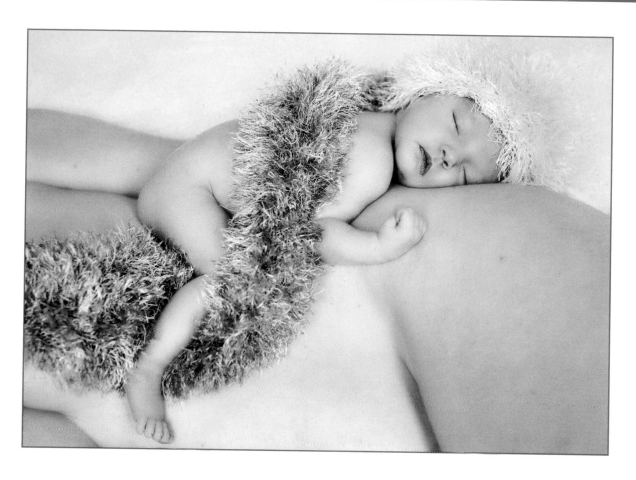

Look for soft, natural light for the shoot. If you are shooting indoors, look for large windows that have indirect sunlight or white sheer blinds you can shoot in front of. Try opening a door to let in more light.

If it's warm enough, move the shoot outside. You can take any furniture outside you'd like, assuming you can move it and the parents don't mind! Once you're outdoors, look for open shade or a backlit area. If you shoot with the sun hitting the baby directly, you'll get harsh shadows, shiny skin, and squinty eyes—images that will be hard to sell. Even more important, babies have very sensitive skin, and you don't want the child to get sunburned. Also be wary of bugs.

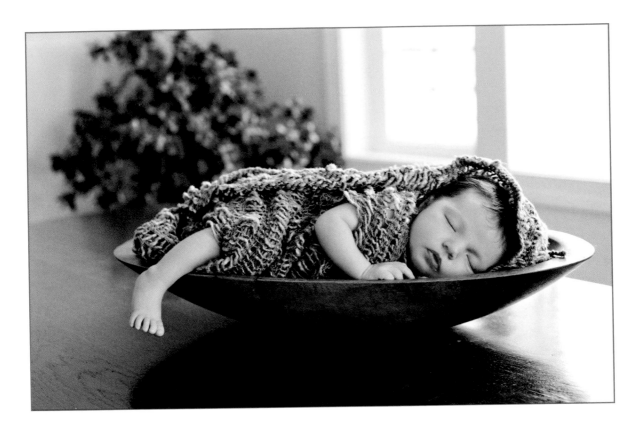

The Shoot

Photographing babies during the first two weeks of life, while they are super sleepy and bendable, is optimal. After that, they begin to wake up more and come out of the shape they were in while in their mommy's tummy.

Photograph the baby's ears, feet, and fingers with and without the parents for a spread in their album or a storyboard, as well as wedding bands with the baby's fingers or toes and the parents snuggling the baby. Photographing the baby's tiny parts along with the parents' larger parts gives a sense of scale and shows just how tiny these little fingers are when they're born! However, these shots have been overdone at times, so think of creative ways to do this.

Try to capture the child nursing without showing the breast; this is such an intimate and special time for both mother and child that most parents want it documented. Shoot it from the mom's point of view, looking down over her shoulder. Having the baby look up at her from this position is the perspective no one else can have but mom.

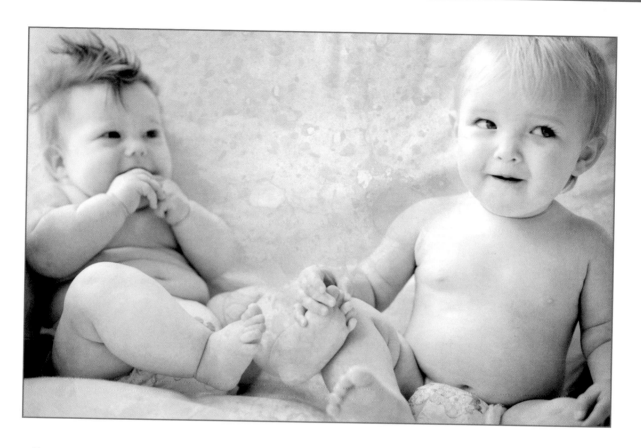

Allow several hours per shoot. It might sound like a lot, but between the baby sleeping, posing, pooping, peeing, and eating, you will need it! When you arrive, bring mom a gift. The baby gets tons of gifts, but once the baby has arrived, mom gets somewhat forgotten. She is tired and sore, and her life has changed more than anyone can imagine. Give her something for *her*— bubble bath, lotion, an eye mask, or any small token to let her know that *she* is special, too.

If you haven't had a pre-consultation meeting at the parents' home, then when you arrive for the shoot, walk around to each room with the parents and look at the lighting. Take 15 to 20 minutes to talk to the parents about their vision before you even meet the baby. Talk to the parents about what they envision for the shoot and whether there's anything special they would like to incorporate.

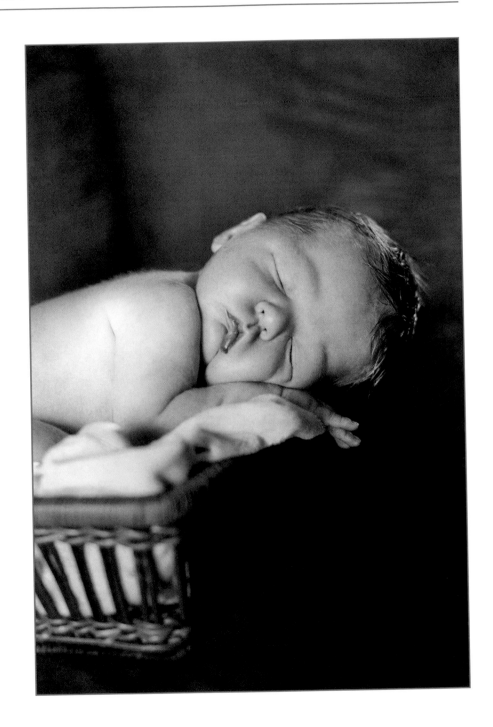

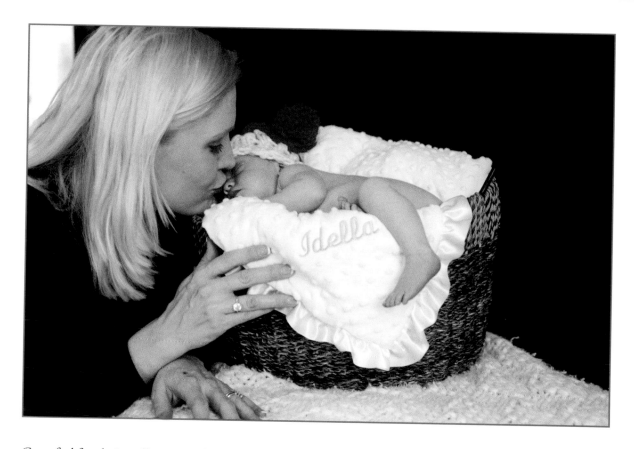

Get a feel for their wall space and where they would like to display the images. If they say they think they would like a few 5×7s or 8×10s, show them what those sizes would look like on the wall.

Ask that the baby be fed and in only her diaper when you arrive. Have the heat set high and bring a space heater and a sound machine (a hairdryer set on cool will work, too) into the room in which you are shooting. This will help the baby stay warm and sleepy, as the white noise or hairdryer mimics the sounds babies hear in the womb.

When you're photographing the baby on his own, have mom sitting in the room with you but not by the baby. He may smell milk and want to eat or just be by mom if she's close by.

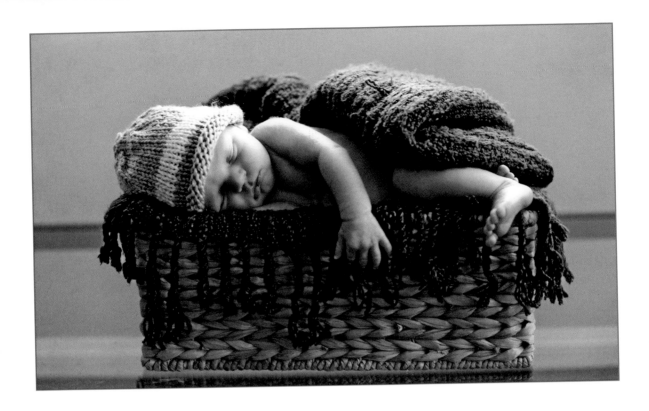

Props

Have any props ready when you begin shooting, and have a vision. You should have an idea of what you want to shoot, but be ready for the unexpected. Often this is what *makes* the image—a brief smile, a pout, or any expression that the parents love.

When the baby is super small, sleepy, and bendable, you can put her in tiny areas, such as in drawers or baskets or hanging in a blanket, and in unexpected places that emphasize how small she is. If the family has a pet, try to capture the baby and the pet together.

You can use items such as hammocks, blankets, hats, scarves, and diaper covers for props. Try to show the personality of the parents as well as the baby—be creative! If dad hunts, for example, you might put the sleeping baby on a taxidermy animal. If mom rides horses, have the baby sleeping in a saddle. If the parents enjoy Sunday mornings reading the paper, have the baby snuggled between a bunch of sections of *The New York Times*. The best images show who they all are.

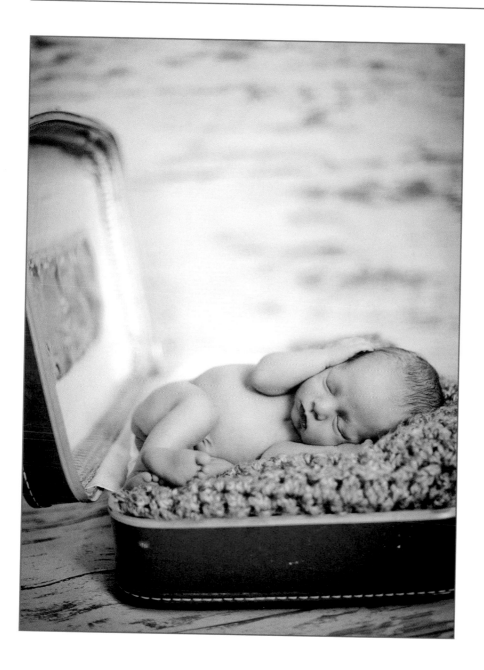

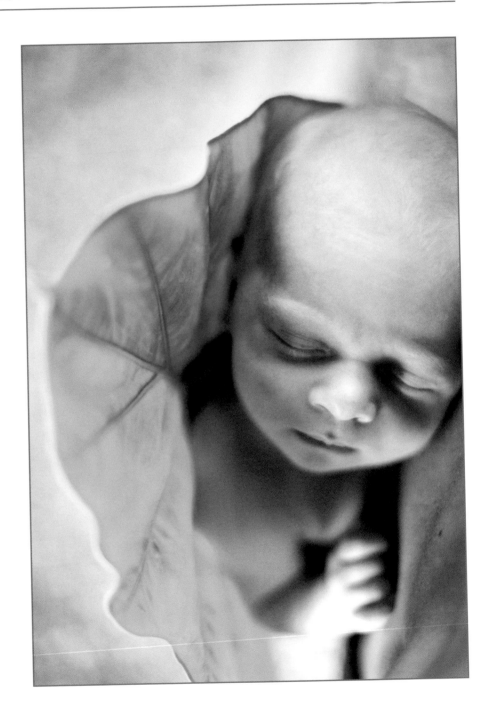

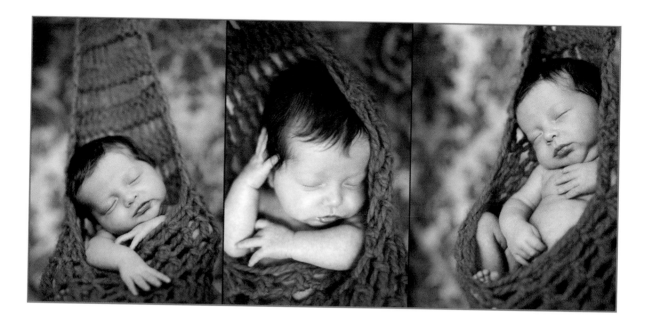

You don't have to spend a ton on props; you can purchase them on Etsy.com, in baby stores, or at consignment stores. You can even make them yourself or use what the parents have in their home.

Soothing Strategies and Safety

The baby will probably wake up, but once you get him in the position you want (belly/back/side) in the desired location, use the five "S's" from Dr. Harvey Karp and the book *The Happiest Baby on the Block* to get the baby back to sleep. (If the parents aren't familiar with these techniques, they'll think you're a genius baby-whisperer when you haul them out!) If the baby takes a pacifier, give it to him and then whisper "Shhhhhhhhhhhh" close to his ear. Cover him with a blanket and put one hand on his head and one on his bottom. Gently vibrate him back to sleep. Basically, you want to mimic one of those vibrating chairs newborns sit in. Obviously, be gentle—you certainly don't want to shake the baby! But steady vibration can soothe newborns back to sleep.

If the baby takes a pacifier, it can be a good way to soothe him back to sleep.

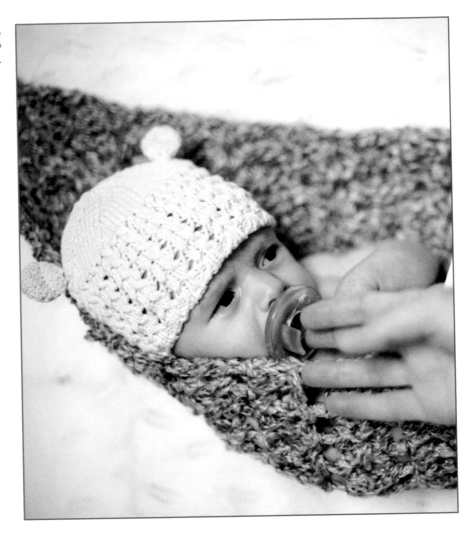

If you're not familiar with Dr. Karp's method and book, the following information taken from www.colichelp.com/shop/happiestbabyontheblock.html will give you the basic idea:

- **Swaddling.** Tight swaddling provides the continuous touching and support the fetus experienced while still in mom's womb.

- **Side/stomach position.** You place your baby, while holding her, either on her left side to assist in digestion or on her stomach to provide reassuring support. Once your baby is happily asleep, you can safely put her in her crib, on her back.

- **Shushing sounds.** These sounds imitate the continual whooshing sound made by the blood flowing through arteries near the womb. This white noise can be in the form of a vacuum cleaner, a hairdryer, a fan, and so on. The good news is that you can easily save the motors on your household appliances and get a white-noise CD that can be played over and over again with no worries.

- **Swinging.** Newborns are used to the swinging motions that were present when they were still in mom's womb. Every step mom took, every movement, caused a swinging motion for your baby. After your baby is born, this calming motion, which was so comforting and familiar, is abruptly taken away. Your baby misses the motion and has a difficult time getting used to it not being there. "It's disorienting and unnatural," says Karp. Rocking, car rides, and other swinging movements all can help.

- **Sucking.** "Sucking has its effects deep within the nervous system," notes Karp, "and triggers the calming reflex and releases natural chemicals within the brain." This "S" can be accomplished with bottle, breast, pacifier, or even a finger.

Photograph the baby on her own first, and then include the parents in some shots. By that point, the baby may want to nurse or need cuddling. If the baby gets fussy during the shoot, let mom feed her if the other "S" techniques don't work. Don't make mom feel rushed or awkward; give her plenty of time and space so she feels comfortable. Photographing babies is as much about building lasting relationships with the family as it is about creating lasting images.

You may need to bring an assistant to help with positions/styling so mom can relax. This may be the first time she hasn't had to care for the baby since he was born, so let her know that she can take a nap, read a book, or do whatever she'd like while you're there. Tell her she can just relax until it's time for her to be in pictures.

Safety first! Whether you are suspending the baby in a hammock or swing, shooting outdoors or in your studio, make sure the baby and any other children are safe. If you are working with a baby and an older sibling, and you are focusing on the baby, the older child could run off into water, pull something off a table, put something in her mouth—the possibilities are endless. Make sure you have a second pair of eyes and ears to help you avoid disaster.

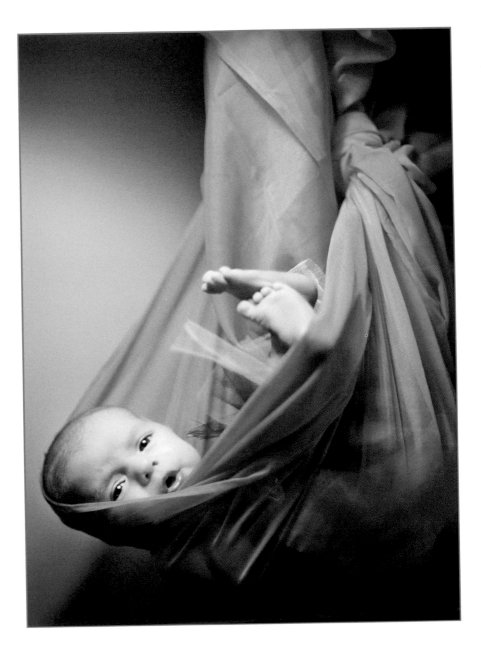

This brings up insurance. You need liability insurance. Many insurance companies will provide this, but if you are a member of PPA (*Professional Photographers of America*), you may already be covered. Check with them to find out the details. You should also insure your equipment. If anything happens to it, you don't want to have a huge out-of-pocket expense.

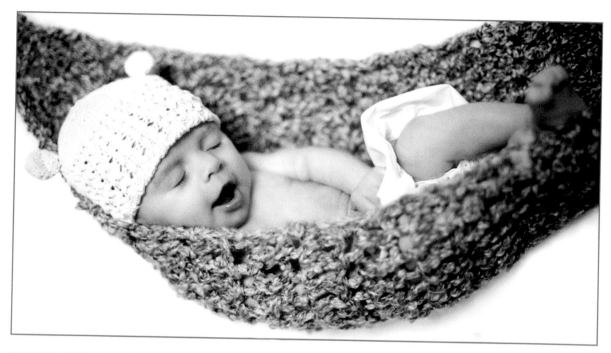

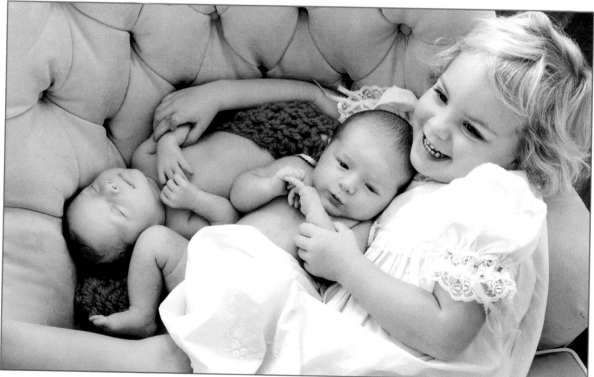

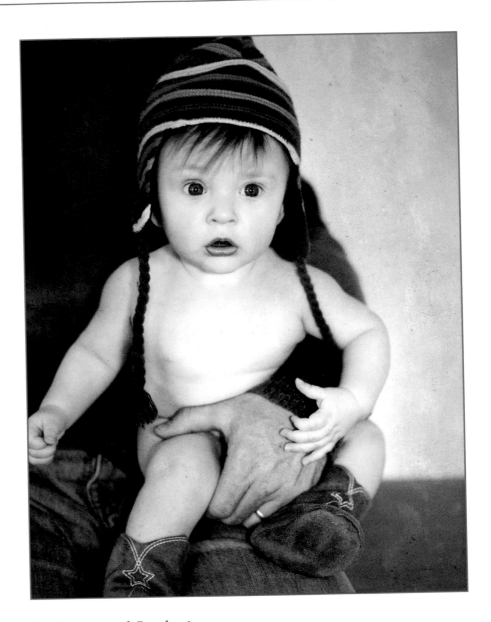

Packages and Products

As the kiddos grow up, they will pull on everything—and I mean *everything*. Even though a photograph may be framed with glass and hung on the wall in a stud, there is still the chance that it could fall and the glass could shatter on top of the child or leave shards for the child to cut himself on and eat. (Yes, I had this happen!) Fine-art canvas prints are much safer; if they fall, they won't break and aren't dangerous. For this reason, I always recommend fine-art canvases.

If the parents don't come to your studio, bring samples of canvases, albums, cards, birth announcements, and prints of different sizes for the parents to look through while you're photographing their baby. This will help them envision what they would like to order while they see their child in the pose.

Although birth announcements and cards aren't incredibly profitable, they are a huge source of trusted marketing. The family will send these cards with your images and website out to all their friends and family, and voilà—instant referrals!

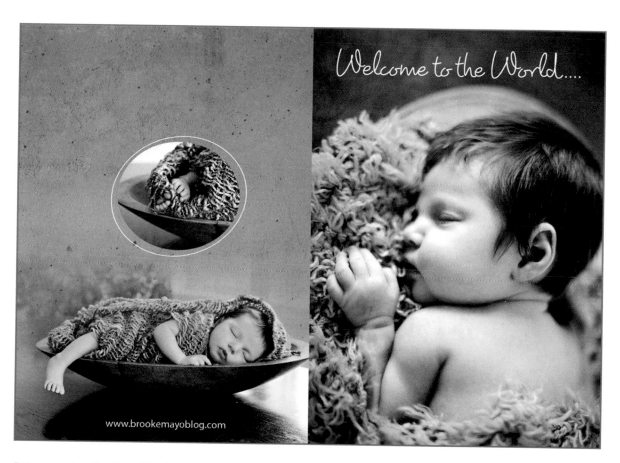

Bring samples of cards and birth announcements so your clients can see what they would be getting.

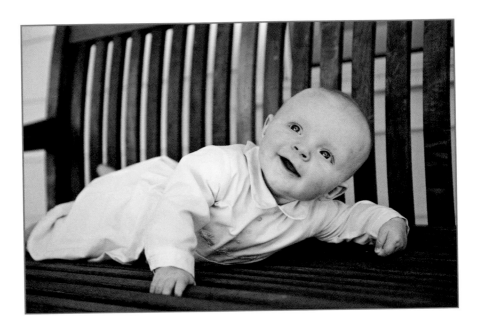

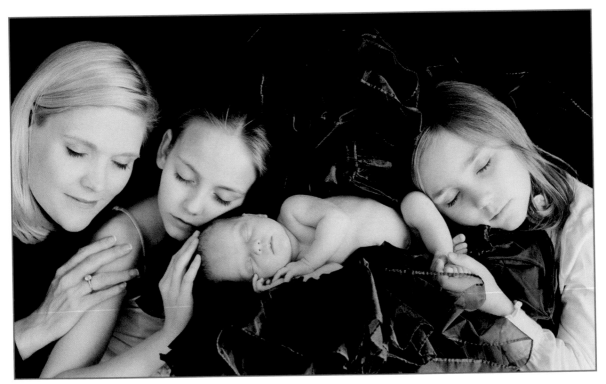

Three Months

Hopefully, your client has hired you to document her baby's whole first year. During this year, you'll want to capture what the baby does best at each stage.

The Shoot

At the three-month shoot, the baby may be smiling or able to lie on his tummy and push up with his arms. Three-month-olds are more aware of their surroundings and may even be on a loose schedule, which can make scheduling the time for the shoot easier. Babies at this age may be able to pick up and shake a rattle, so bring along some small toys as potential props.

Ask that the baby be fed and changed right before you arrive and in just her diaper. That way, you'll have fewer interruptions during the shoot, and you won't have to change the baby's outfit more times than necessary.

It's easy to get caught up in the moment and how cute the baby is, but be sure to watch your background and exposure! It's easier to get the shot right in camera than to fix it in post-production. Having to do excessive retouching or cropping that you could have done in camera cuts into your profits. When you have to spend additional time fixing your mistakes, that's time you could've spent doing something else to build your business.

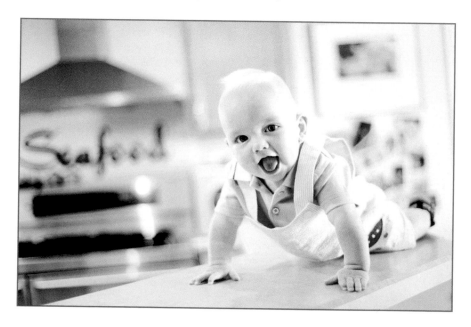

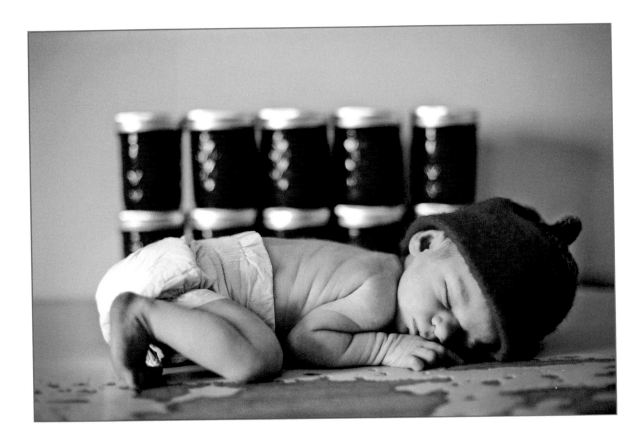

Pricing

You probably want to price three-month shoots hourly unless it's included in a first-year package. This cuts down on the parents wanting to push the baby past his naptime for more photos, which introduces a crabby baby. Although some of these cranky images are cute, a whole hour of crying doesn't add to your photographs or to how the parents view you as their photographer. Also, if you don't charge hourly, parents may expect you to stay through the baby's nap to finish the shoot when she's awake, which can take several hours. Make sure you set expectations and limits.

Six Months

When the baby is six months or older, you may not get more than an hour with him. Babies of this age are working hard at playing, being alert, and

having fun with you. They're working *so* hard that after an hour or so, they are exhausted, and they show this by getting crabby! Signs that a baby is sleepy include pulling on the ears and/or hair, rubbing the eyes, or grunting. The best time to schedule this shoot is when the baby has just woken up from a nap and has eaten. (Really, this advice is the same for any age.)

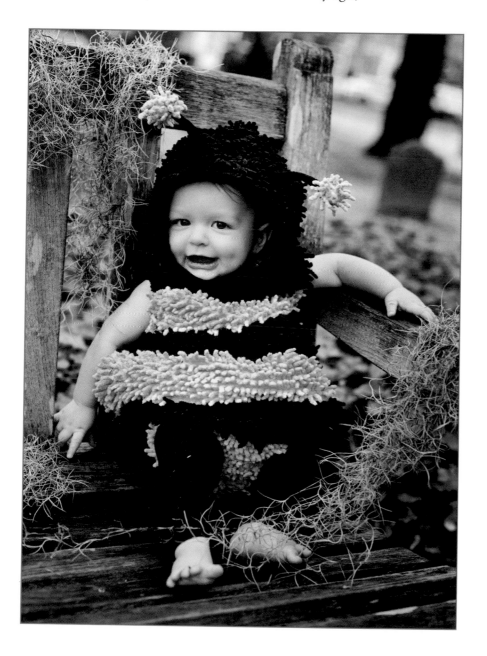

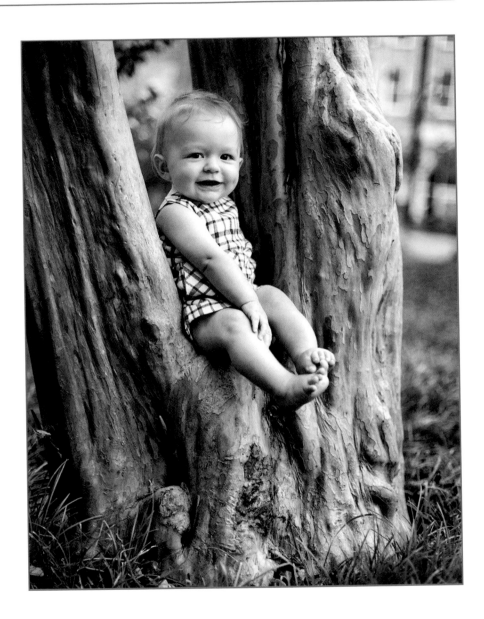

The Shoot

At six months, the baby may be crawling and sitting up (assisted or unassisted). Babies of this age are quite alert and super drooly. Show their personality, all of their crooked smiles, maybe even a tooth or two! The baby is much sturdier now and hasn't yet developed stranger anxiety, so you should be able to get some fun poses without her screaming at the strange woman with the camera.

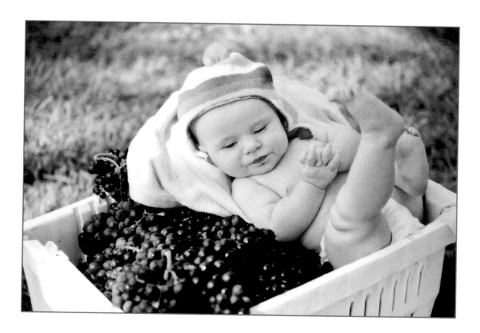

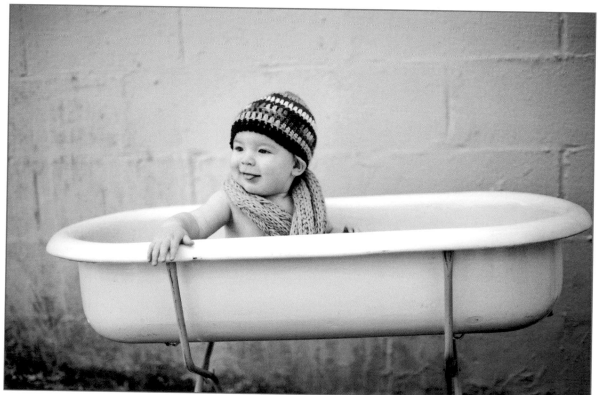

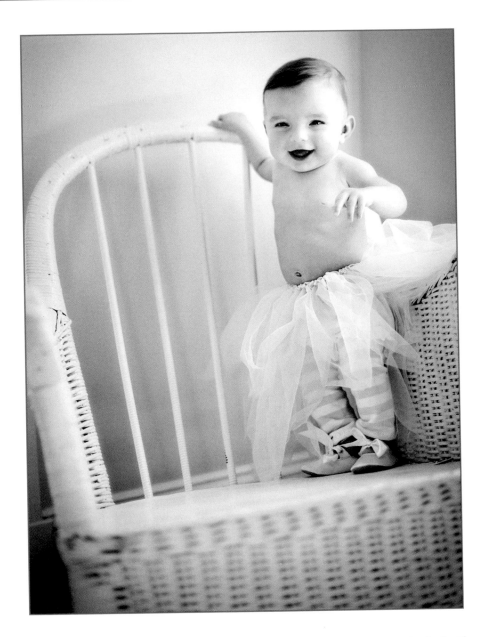

This is a fun age to incorporate mom or dad in the picture, particularly if you're outside and can get some good "family in the park/nature" types of shots. Have the parents bring the baby's favorite toy to entertain him with. Let the baby hold and chew on the toy—at this stage, they love, love, *love* putting anything and everything in their mouths!

Shooting at f/1.2, f/1.8, or f/2.8 will blur the background and make those sweet little eyes pop! Having the eyes in focus, looking right at you, will melt the parents' hearts! Try having the parents out of focus behind the baby, so everyone is incorporated in the photograph but the child is the most important and the center of focus.

Look for different angles that the parents may not see on a regular basis. No matter what age, I try to photograph children to give them "importance." If you are standing and shooting down on the child, not only does it make the baby look smaller, but it also doesn't give her a voice. If you get down on the baby's level or even below, it makes the child an equal, and you will capture more of who she is. Babies may be small, but they are growing and getting smarter by the day!

Is there anything cuter than a dimply little baby bottom?

Props

Consider having the baby in a bike basket or in a tutu, wearing cute little shoes and fun hats, playing in the snow or swinging in an infant swing on the playground. Flowers can be very cute, but make sure they aren't poisonous, because everything will go into the baby's mouth. Throw petals or bubbles so the baby will reach for them. Those are just a few ideas, but really, the possibilities are limitless.

Consider having the baby naked for some of the images. That sweet, squishy, dimply butt is to die for! Just be prepared for you or the props to be soiled at any moment.

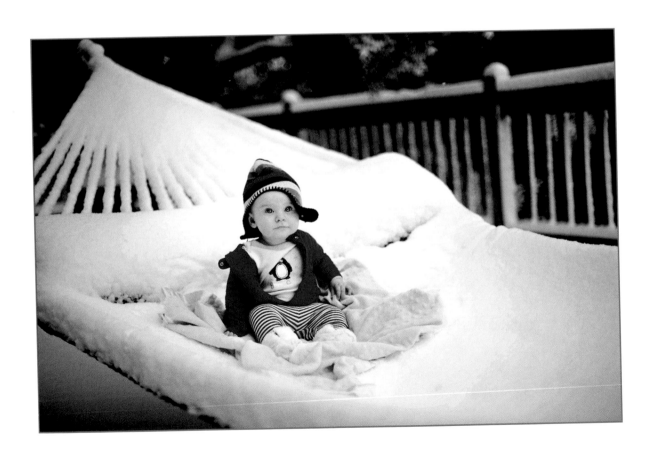

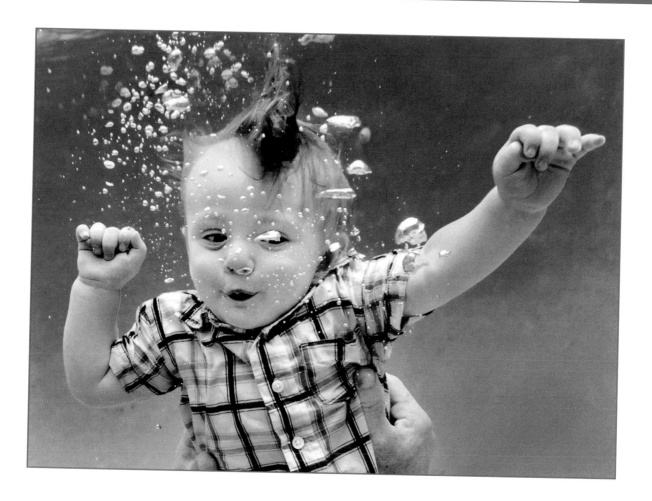

Nine Months

The little peanut who was once so tiny may be standing up now, holding onto furniture or mom's legs, and may even be able to walk! Babies at this age are really beginning to look like little people. Be sure to capture their natural expressions—all too soon, they will learn to start "posing," and you won't be able to get those free, candid shots.

The Shoot

At nine months, babies love peek-a-boo, clapping, and imitating you. They may stand and hide behind an object, cover their face, or belly laugh when you cover yours. They're really aware of their surroundings and may enjoy seeing animals at a zoo or playing with their dog or cat.

Stranger anxiety often appears by this age, so allow ample time for the baby to warm up to you. Have fun playing before you begin shooting. You want the baby to think of the photo session as a game.

If the baby begins to get crabby, distract him and let that pose or idea go. You can always come back to it later if you'd like, but for the moment you should move on to something that makes the child happy. Not only will this get you better photographs, but it will also put the parents at ease and make them happy. Regardless of whether parents admit it, they are nervous before a shoot; they are paying you for a block of time, and they don't know how their child will behave. If it's a newborn shoot, they don't know whether their child will sleep; for a nine-month shoot, they don't know whether their child will show her personality, smile, and have fun with you.

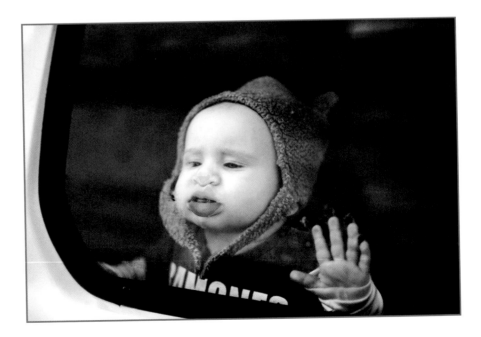

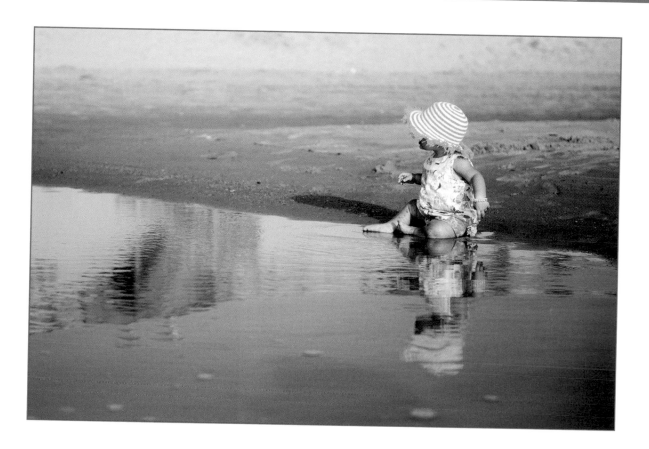

No matter how the baby behaves, make the best of it! Let the parents know that no matter what their child does, they will love the photos, and you will get lots of different expressions and work with them to get the best photos possible—even if it means rescheduling. The easier you are to work with and the more you engage their child, the more the family will look forward to having you back.

Props

Props are great at this age because the baby is interacting with so much more. You can photograph the baby in the water with her parents, sitting in a float, wearing sunglasses…. It's so cute to see kiddos in hats and glasses, but just know that they won't keep them on for very long!

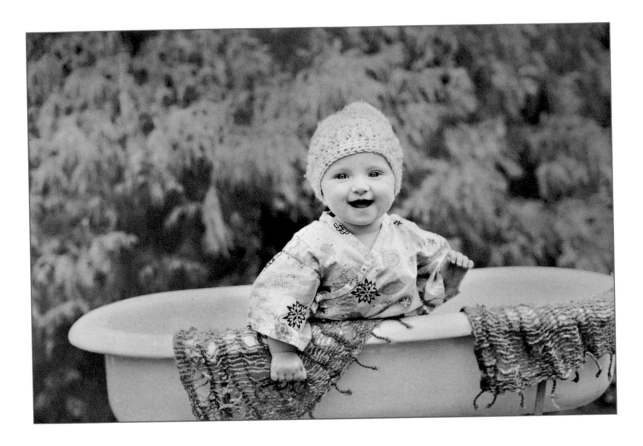

Think about seasons and what the parents like to do as a family. Do they go boating in the summer? Sledding in the winter? Is there a tree house the older kids play in? All of these types of activities can make a great backdrop for photos.

At nine months, most babies are eating solid foods, so you can photograph them discovering new foods. (Just be sure they're non-allergic foods—there are certain foods that babies under the age of one year should *not* eat, due to possible allergies.) Have the baby paint with foods or with nontoxic paint. Babies usually *love* ice cream, so try a soft-serve cone or maybe a big, bright lollipop—anything they can't choke on.

Twelve Months

You may want to do the 12-month shoot during the baby's eleventh month so that the parents can use one of the photos for the baby's birthday-party invitation. You can have the baby sitting in his highchair, smashing cake, playing with balloons, and so on. At a year old, babies may be walking, talking some, and really interacting with people—they are a ton of fun! They have ideas about what they enjoy and don't enjoy doing, many enjoy reading books, some like being pulled in a wagon or sitting in a baby-sized chair, and climbing is a favorite of many. And they get mischievous!

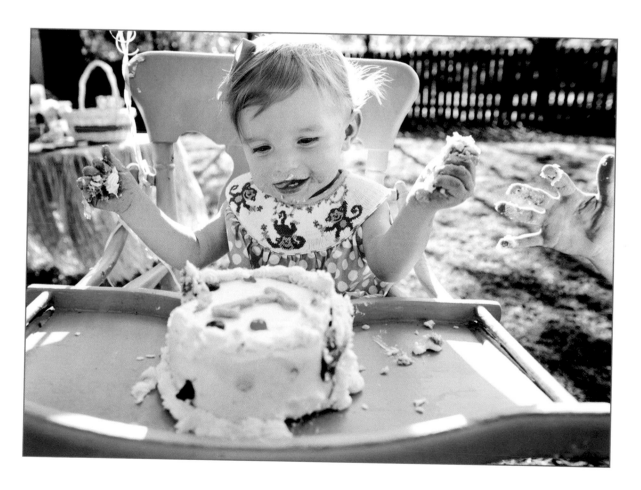

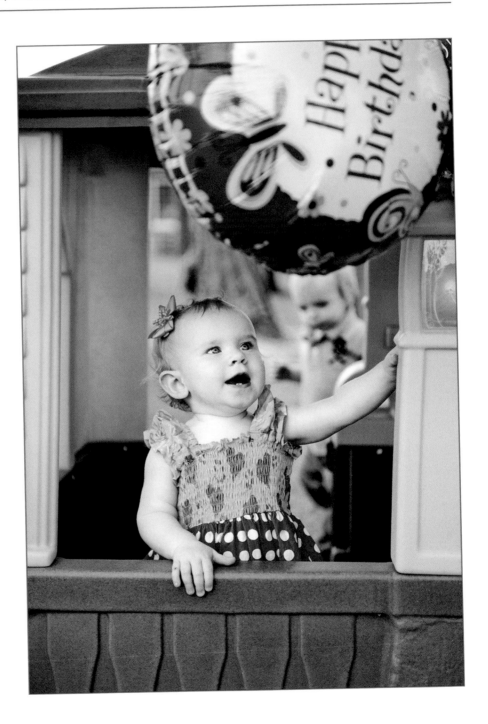

Some babies aren't walking when they are a year old, and this is perfectly normal. They may be crawling or scooting around on their buns or pulling up on furniture—photograph them doing whatever they enjoy. By age one, many babies have a special bond with the family pets, so include them!

Use your favorite images to design a birthday invitation right after the shoot. While you are doing the shoot, you can ask the parents what the party's theme will be and what the date and time will be so you can include all of the information on the card. It's easier for parents to envision the card when they see it, rather than trying to tell you what they think they want.

Designing the card can also speed up the purchase. Parents get busy, and even if they have the best intentions to use these images to make the invitations, if time creeps up on them, they may just send an email invite. This is another great chance to market to the parents' closest friends and family. These people have received the birth announcement and the birthday party invitation, and they may even get to meet you at the birthday party, if you're photographing that. The more often people see your name and your work, the better the chance they will book you to document their own lives.

If you are doing a first-year package, you could include the birthday party as part of the package. This is a great time to get family photos with grandparents, aunts and uncles, cousins, the baby's cake, and opening presents. What a great separate album this shoot would make! With your first-year package, you could sell an album from birth through 12 months, as well as an album of the first birthday party.

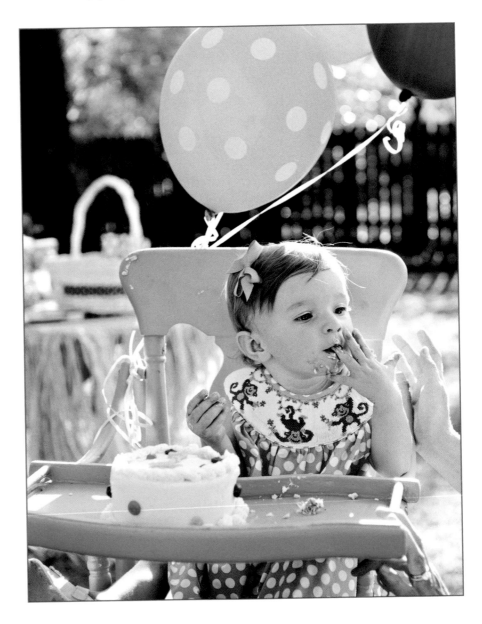

Photographing Multiples

Now that we've covered shooting during the first year, let's mix it up and add more than one child of the same age! When photographing twins or triplets, you might have to use Photoshop to achieve the desired portrait. For example, if you're trying to get both babies sleeping at the same time, you might have to shoot one sleeping at a time and combine the images.

Keep in mind that these babies lived together for 10 months in their mother's womb. Usually, if one starts crying, it won't wake the other up—they're used to it. In fact, they often feel happier when they are touching each other.

Even though they are twins, though, they have two totally separate personalities. Make sure to show these! One might be quiet and shy, whereas the other is outgoing and excited. Don't put them in a "box" together; let each one have his time to shine.

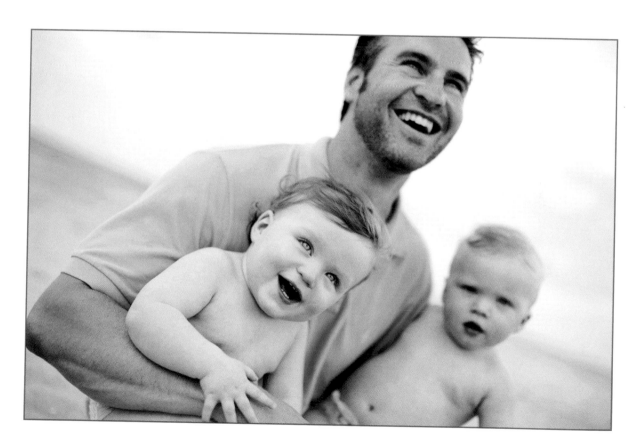

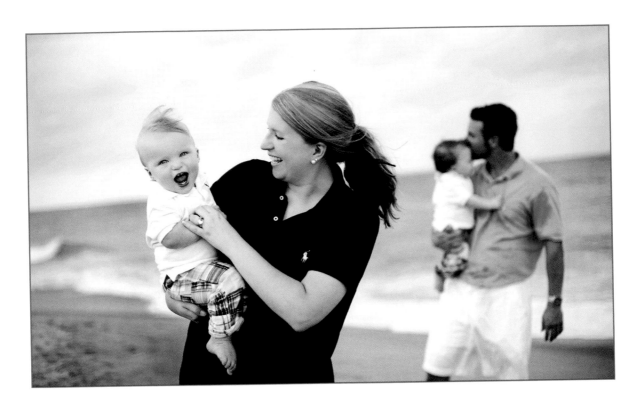

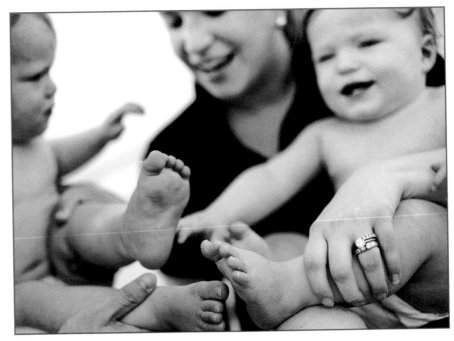

Shooting Scenarios

In this section, I'll discuss a few common shooting locations/scenarios and how you might approach them.

In the Client's Home

If the client has a large, stylish, well-furnished house, it's your lucky day! You'll have many options of where to shoot and what light to use, and you'll likely have a whole array of props from the parents, as well as the ones you brought.

A large, well-furnished house can seem like a shooting dream!

One drawback to shooting in a home like this is that it can be overwhelming to have so many options. You might be in such a hurry to get to the next backdrop that you don't get the best position of the baby in front of the backdrop you're currently using. The reality is that you may not be able to use every background and prop you'd like, so you'll need to walk around the home, see what you like the best, and prioritize. The baby may not last for five backdrops, so start with your favorite and then go to your second favorite and so on.

A small home without additional props might seem like a much harder option than the home that seems to have everything you could imagine or want. And in some ways it is, because you're limited with your backdrops, and you're limited to the props you brought. If you aren't expecting this, it's easy to get a bit panicky and not know what to do.

First of all, remember that babies are tiny, so you don't need a ton of room. What you *do* need is good light that you know how to manipulate. Move furniture as needed so that you have better light to work with. This will force you to be creative and change your thinking. I find that as soon as I change the way I view something, it becomes easier.

When I walk into a home and I don't immediately see something that inspires me, I really begin concentrating on the baby, new positions, and using the simple props that I have. For example, if a brown couch is the best thing you have to shoot on, you can make the baby be the focus of the picture and have the brown go black so it looks like a studio setting. You can drape a blanket under and behind the baby to add texture and a new color to the "studio." Change the baby's hat and/or diaper cover, and you'll have several settings without ever even moving the baby.

Case Study: The Antique-y Home

In this home, there were many beautiful places to shoot. I loved the bright-yellow, vintage kitchen because of the lighting and the colors. The wallpaper in their dining room was sweet, and I knew it would go great with the baby's skin. The muted pinks and greens with the old family photos in their living room would lend themselves to timeless images, too.

In this home, I was able to get the warm, familial feeling that I wanted.

There were lot of wonderful shooting options in this home.

The lighting was the best in the kitchen. There were two large windows, one of which (above the sink) I used for my main light, and the other (above the stove) added fill light to the baby's back and side. The flower and sugar jars were bright and cute, and the baby had several outfits from which to choose, including a bright dress, a white diaper cover, and big pink pearls.

The bright dress went great in the kitchen. Because the kitchen was my favorite and the one about which I was most excited, I photographed it first. I decided to use an LED light on my camera for a bit more fill. I also dialed my EV compensation to +1 to expose for the baby and make the window go white.

We hadn't planned for the baby to open the flour jar and begin playing in it, but we allowed for the unexpected, knowing she would be super messy. While she was playing, someone pulled up in the driveway, so she got up to investigate. That is how the photo in Figure 5.1 happened. Some was planned, but most was not.

Figure 5.1

Sometimes going with the unexpected gives you excellent results!

In the Studio

The studio is a wonderful place to photograph babies, because you have full control over the lighting (whether you're shooting with strobes or in daylight). You also have all of your props available, as well as all of your backdrops. However, keep in mind that these represent *you*. Your client chose you to photograph their child because she loves your work, but you'll need to work extra hard at incorporating into the shoot the client's style and colors that will match her home.

Regardless of the light you're using in your studio, remember that the farther away and the smaller the light is, the more harsh and contrast-y it will be. The larger the light source and the closer it is, the softer it will be. So, when you're photographing babies in the studio using strobes, you'll want to use large, soft modifiers, a large square, or a rectangular softbox. You can always add background/rim lights, but for your main light, have it be close to your subject.

To really be able to "see the light," turn off all other lights, close your drapes, and have your modeling lights on so you can see where the light will fall on your subject. Shoot at a shutter speed high enough that you don't bring in any ambient light and you only capture what you see. If you're shooting at 1 second, for example, and you have a fluorescent light on, you'll get the fluorescent light in the image—it will tinge your picture green. You only want to capture the strobe light.

Of course, this is a rule that is meant to be broken once you understand the lighting. And you can always add in ambient light and gels if you want a certain look.

In Low Ambient Light

The main times you will run across this lighting are during the holidays or at birthday parties. When you're photographing kiddos in front of the Christmas tree or blowing out their birthday candles, you want to be able to see the lights from the tree or cake. If you use flash, you'll overpower these dainty lights (and flash will lighten all the natural light, too), and if you only use these lights, the rest of the image will be dark.

By using these lights with window light or a video light, you will be able to illuminate the rest of the photograph while still being able to see the candle-light. You can put a warming filter on the video light or a diffuser to make it softer. Remember, the closer the light, the softer it is.

Use a slow shutter speed to allow in more natural light, but remember that to avoid the image being blurry, your subject and camera must be completely still. The slower the shutter speed, the more ambient light is allowed in. When shooting indoors, you can use a wide aperture to let in more light, but remember that it also gives a shallow depth of field, so only the focal point will be in focus. If you're shooting indoors, open all blinds and drapes to allow for the most natural light possible.

By letting in ambient light, you are also letting in the color of the light. So, for example, if the holiday lights are multicolored, they will make your subject have multicolored lights around him, depending on how close he is to the lights. Also, if you have the overhead light on, it is likely a tungsten bulb that will cast a yellow color on your subject. (Or, it may be a fluorescent light that will add a greenish tint.) You can overpower this by using a video light with a daylight or warming filter, or you can correct it in post-production. It's always easier to shoot properly in the first place than to correct later, but you might not always have the tools you need to do this.

At the Beach

It is very difficult to photograph babies outside, as they may be in the best mood around noon, when, generally, the sun is extremely bright—particularly on the beach. In this scenario, you'll need to find a shaded area and avoid dappled light or use backlight.

There are three main elements to consider while shooting outdoors:

- Sun direction/intensity
- Wind direction/intensity
- Background

Where is the sun coming from? If you shoot with the ocean in the background, will the baby be backlit? Depending on where the sun is in the sky, your sky could go white with the baby being backlit if you don't add any fill light. Or, the light could cause sunspots on the image. These can be used artistically, but if the sun is too bright, it can also wash out the child and make the image so bright that you can't see the child well.

Ideally, what you're looking for on the beach is a low sun, so that the light doesn't cause the skin to be red or shiny. You want the least amount of wind possible, as wind can bother babies' ears and blow sand in their eyes, as well as in your camera gear. Sand in your gear can ruin it as well as put spots on your sensor and make your lens salty or hazy, so your pictures look out of focus.

To get beautiful lighting on the beach, where the wind isn't blowing right in the baby's face, you might need to have the baby facing the ocean, with the dunes/houses/boardwalk in the background. But what if your clients want the ocean in the background? How do you deal with these elements?

- Option 1: Wait until the sun has gone down more so the light's not as intense. However, with babies you might not have that luxury. Once they get tired or hungry, your timeframe is over.

- Option 2: Look at your surroundings. Can you move the baby up closer to the dunes so that they cast a shadow and the baby is no longer in direct sunlight? The dunes may also block the wind. If you can, you have solved two problems but added an additional problem: If you expose for the baby in the shadow, the ocean and everywhere that is in the sun will be several stops brighter and will be blown out. You might not even be able to tell the ocean is there. You will need to balance the light between the shadows and the highlights. To do this, you'll have to add fill light—whether by bouncing light in with a reflector, using fill flash, or using a video light.

■ Option 3: Use a scrim to block the sunlight that will be hitting the baby. For this option, you will need to have several assistants with you. Also, please know that this isn't the best option on a windy beach with a baby, because the scrim can blow out of your assistants' hands and hit the baby. It's also distracting to have so many people on a baby shoot, and if the baby is mobile, there is no way you can have your assistants effectively hold the scrim above the child's head for consistently great lighting.

Try shooting from the dune line so you have sea grass and other graphical elements in your image besides the ocean. Just be aware of the shadows the grass can cause based on the lighting you choose to use. Having sea grass and other colors in the photo brightens your image and adds color, as well as interest. Although the beach itself is gorgeous, having other colors and shapes make it even more interesting. You also want to represent the whole beach, and the grass is another part of the beach—it makes it look more majestic and breathtaking. You want to have an interesting foreground, middle ground, and background, as it creates depth and interest.

Take props to make the child comfortable during this shoot. You don't want to just lay a baby in the sand. If they can walk and they aren't used to the sand, they might hate it! Plus, babies put everything in their mouths, and if you give them a prop, they may chew on that instead of eating sand—always a good thing! Also, if babies are sleepy, they may put their hands in the sand and then rub their eyes—and then you have a super unhappy baby.

When shooting outdoors, be sure to dress babies for the weather. If it's cold out, bundle them up in cute hats, blankets, and scarves. If it's warm out, don't overdress them—have them naked or in sweet sunhats or bathing suits. If the child is uncomfortable, you won't get the best images possible because she may be cranky.

The first year is one of the most fun and challenging times in a parent's life. Everything is new, and the kids and families are learning so much together! Most parents would document every second of their child's life if they could, so you already have a willing buyer for your portraits. Now you just have to make it easy for them to hire you, schedule their shoots, and receive their images. The shooting and spending time with the kiddos is the fun part, but don't forget about over-the-top customer service and experiences!

6

Post-Production

How will you process your images? There is no right or wrong way—just a way that works best for you and your brand. You may use Photoshop/Bridge, iPhoto, Lightroom, Aperture, Photo Mechanic, or some other software. Most of these allow you to view your images, mark your favorites, and add keywords and metadata. For heavy editing, Photoshop is still the main program used.

iPhoto will allow you to organize your photos and do very basic editing. Aperture, Lightroom, and Bridge allow you to extensively edit and adjust images, especially in RAW format. These are more targeted for the professional photographer, whereas iPhoto is intended more for a consumer level.

Narrowing Down Your Images

Like any photographer, you undoubtedly shoot *many* more images than you actually show the client. For every one terrific image, you probably have three or four outtakes or just not-so-perfect shots. Don't waste time editing those blooper images; instead, use your image-management program to star or flag only the images you want to keep and then discard the rest.

I use Bridge to load, view, and star my keepers. However, as I mentioned before, there are other programs that can do this as well. I also add keywords and metadata to each session, so if I'm looking for something specific, I can do a search and find it. And I put my copyright information in each image so if the image is used without my permission, there is no question that it is mine. A copyright should read like this:

© 2011 Brooke Mayo Photography, Inc.

To narrow down your images, focus on what will sell and what's positive. If you shoot 300 images during a session, you'll want to edit this number down significantly. This is part of what your fee covers—choosing the best of the best and showing those to your client.

So, how many images will you show to your client? Have a number in your head, but don't promise anything. What happens if you promise 50 images, but in the end you only have 45 that you love? Do you put in work that's not your best to get to the magic number? Not a good idea. You don't want to show images that aren't your best; it dilutes the ones that are.

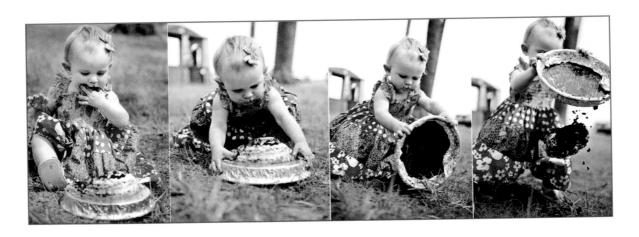

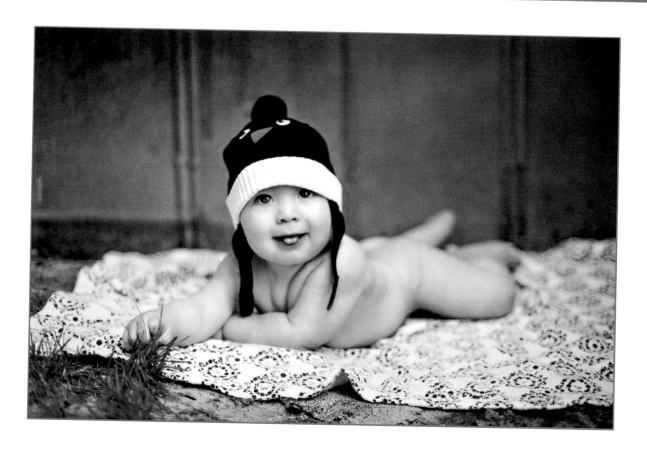

Some images will be easy to weed out—they just plain won't be up to your standards. But in some cases it's more difficult to choose where to cut. If two images are very similar, choose your favorite and throw out the other one. Clients may not be able to tell the difference between the two, and they'll wonder why you included two of the same image. Remember, the fewer images the client sees, the easier time she'll have choosing what to purchase.

Make sure you keep enough images to make spreads in an album and to tell a story. Keep sequences, and in the sales session, you can show these as story-boards or suggest them for album pages.

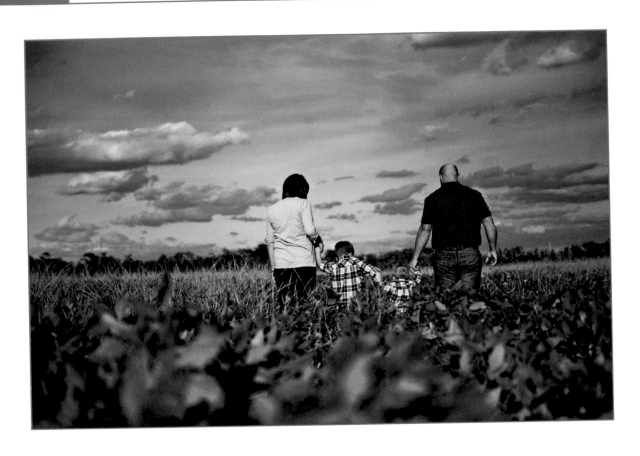

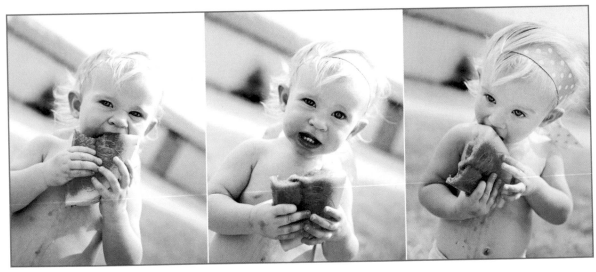

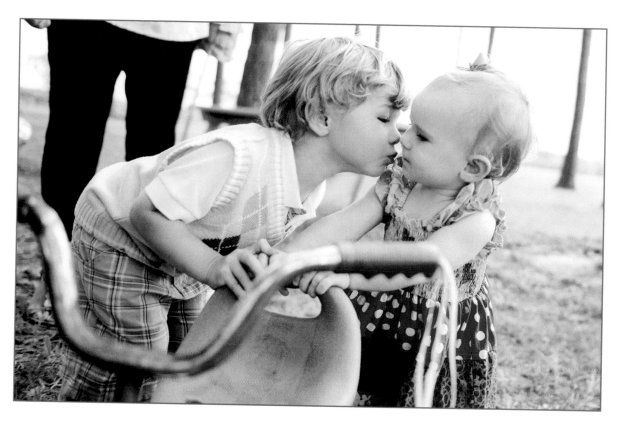

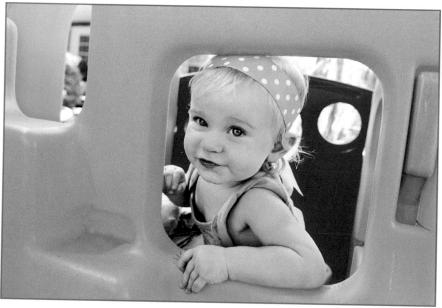

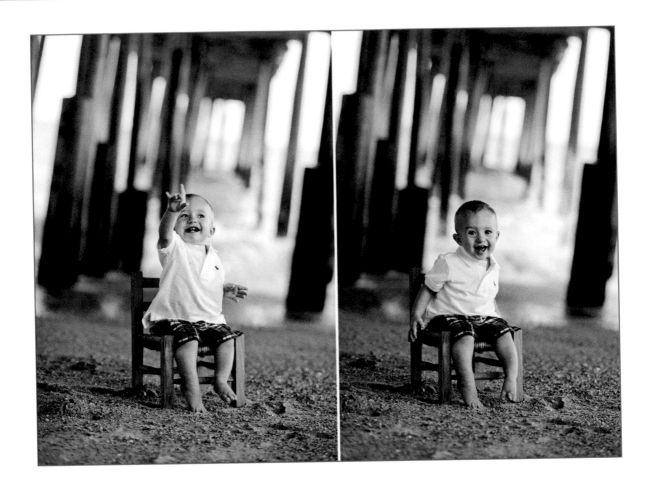

Image Editing and Retouching

Image editing is largely a matter of personal preference. There are certain "rules" of photography that many like to follow, but in the end it boils down to your own aesthetic and what fits with your brand and style. Some photographers heavily retouch their images, while others prefer to do as little retouching as possible.

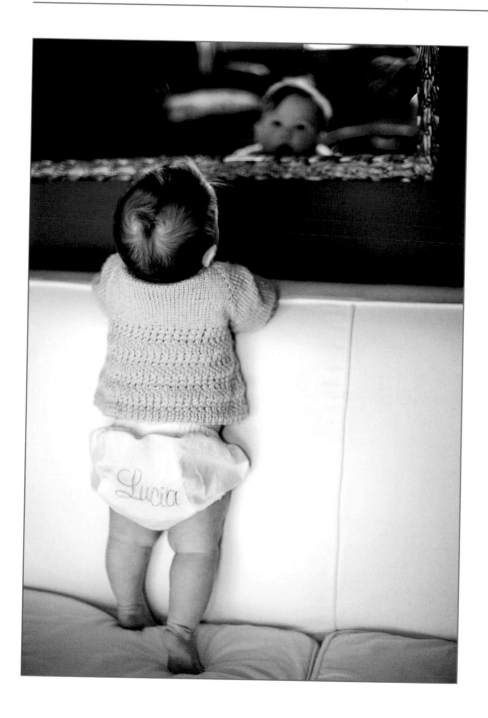

So what about you? Will you fully retouch all of your images? I suggest fully retouching a few of your favorites—the ones you put on your website and blog—and only color- and density-correcting the rest of the shots. If you fully retouch all the images, you are investing your time into images the client may never buy. Instead, show your clients what a retouched image can look like so they can envision it; then tell them that whatever they order can be retouched like what they see on your website and blog. Make it clear that the images you are showing them now are proofs, but that you can retouch any they choose to order.

A word about retouching: Make your images look similar during the editing process. Don't use a different action on each image; you want your brand and style to be consistent throughout the set.

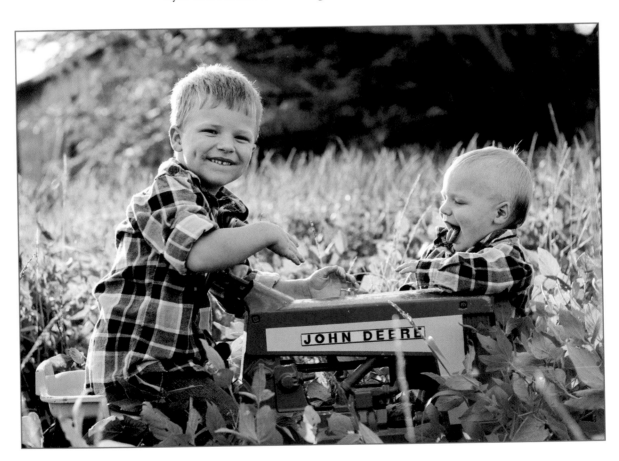

So what are actions? Very handy devices in Photoshop that let you automate certain tasks. You can use actions to save time (and money) when processing and retouching your images. You can run actions while you are off having a fun lunch, playing at the pool, or lounging in bed! Let the computer work for you and save you time. You can write actions for almost anything that you want to do to many images at once.

Here's how to write an action:

1. Open Photoshop and make sure your Actions palette is visible. It's generally a tab on the History palette, but this may vary depending on your workspace. If you don't see it, select Action from the Window tab in the menu bar. You should now see the Actions palette. If you don't have any actions yet, you'll probably just see the Default Actions set.

2. Sets allow you to group actions. For this example, let's call the set Post-Production and write an action called RAW to JPG. To make a new set, scroll over to your Action menu bar. In the bottom of the palettes folder, there is a folder, two icons to the left of the trash can, called Create New Set. It looks like a file folder. Click this icon to create a new set. Name the set Post-Production so you can easily recognize it.

3. Now you are ready to create the action. With your new set selected in the Action menu bar, click on the Create New Action icon, also at the bottom of the Action menu bar; it looks like a piece of paper with the bottom-left corner folded up. Again, give it an easily recognizable name, such as RAW to JPG. Now you have an empty action to which you can record.

4. To create the action, begin by clicking Record after naming your new action. You can stop and restart the process of recording your action by clicking the square icon, Stop Playing/Recording, and by clicking the circle icon, Begin Recording, respectively. Once recording is initiated, each step performed—from opening the image to creating adjustments to resizing, saving, and closing—will be tracked step by step. You may also play a previously recorded action in the action you are currently writing.

5. Perform all the tasks you would like to include in this action.

6. Use the Save As command or menu option to save the image and select where you would like it saved. Be careful if you just hit Save, because this will write over the original image (if it is a JPEG). It's best to save the copy in another location where you save all images on which you have run actions. Also, if you are using the action to put your image on your blog or other website, you may want to use the Save for Web function, because it compresses the image so it is smaller for the web. It also overwrites any metadata and your settings that are saved in your image when you save for web.

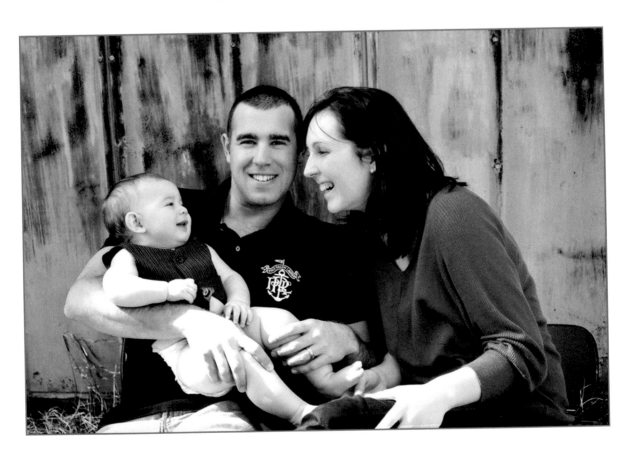

7. If you want image to be closed after the action is run, include the step to close the image in the action.

8. Remember to click on the square Stop Recording icon to complete the process of creating a new action.

9. Test the functionality of your new action. Go to Bridge, choose the images you'd like to process, select them, and then go to Tools > Photoshop > Batch and choose the action to run.

10. Save the action by mousing to the top-right corner of your Actions palette. Click on the icon with the downward-facing arrow and three horizontal lines. Click on Save Actions.

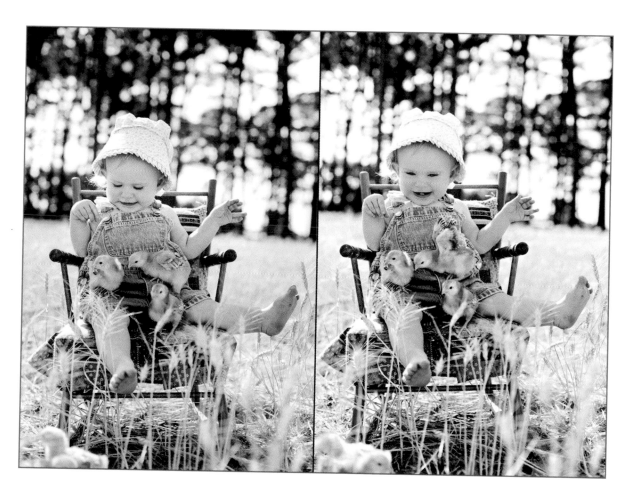

If you need to change or add anything after you record the action, you can go back and edit the steps.

You can also import previously written or purchased actions. To load actions, click on the icon with the downward-facing arrow and three horizontal lines in the top-right corner of your Actions palette's folder. Scroll down to the Load Actions option. Remember, when you import and export actions, you are dealing with the whole set, not a single action.

After you have all the images processed and you've chosen your favorites, retouch them to the nines for your blog and for posting on Facebook. For example, depending on the image, I will generally make a duplicate layer of my background layer by dragging the background layer to the Create a New Layer icon, which is directly beside the trash can at the bottom of the Layers palette. I never retouch on my original layer because if I make a mistake, I don't want to have to go back to the very beginning and start over.

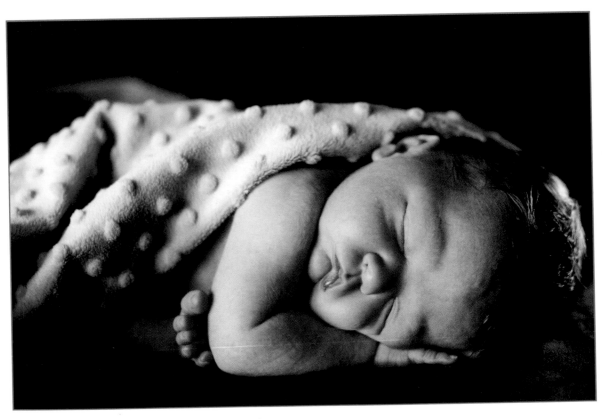

The original (this page) and retouched (next page) images.

You can make several layers for each of the individual corrections. Name the layers so you know what you did on each one. For example, I might name one layer "Brighten" and open my Curves palette from Image > Adjust > Curves and then brighten my midtones and darken my shadows. I never want to lose all the detail in my shadows or highlights.

I might also add another layer to airbrush a baby's skin to clear up any blotchiness. There are several ways to do this. You can purchase actions to smooth the skin, or you can use the Clone stamp set at a low opacity or use the Spot Healing brush or Patch tool to remove blemishes. You can also use a new layer and add blur; then, you can change the opacity of this layer and erase it when needed.

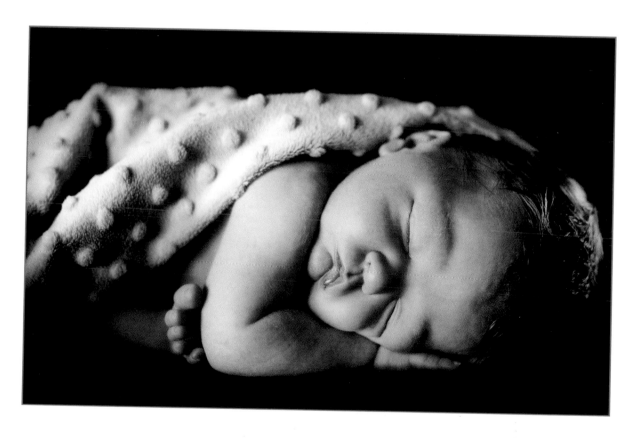

I also dodge and burn where necessary. And before I save and close the image, I sharpen it by going to Filter > Sharpen > Unsharp Mask. Again, there are several ways you can do this, but this is the method I prefer. I do this on a separate layer so I can sharpen the whole layer and erase where I don't want it sharp.

Before you save, make sure to flatten your layers if you're happy with the way the image looks. You might want to save it separately by going to Save As and naming it a retouched version rather than overwriting the original.

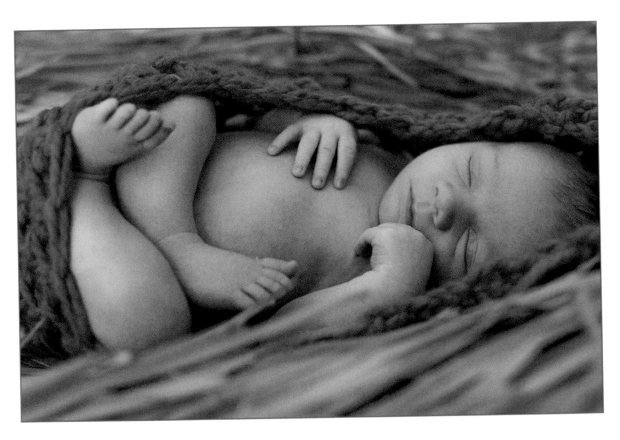

The original (this page) and retouched (next page) images.

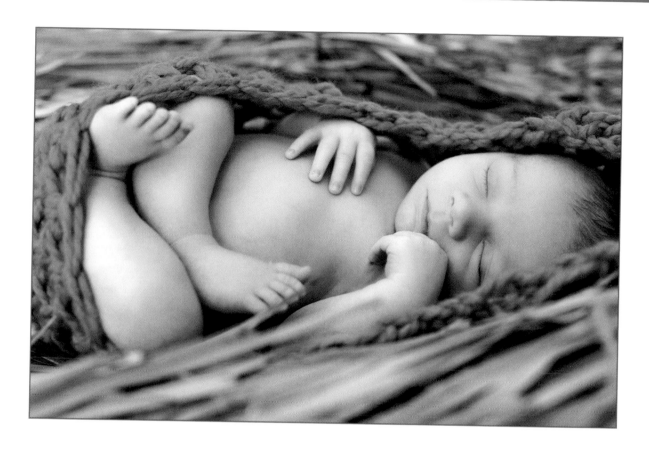

Sample Workflow

We've talked about the organizing and managing your images as well as retouching and editing them, but how does that look as a big picture? Different for everyone, of course, but this section will describe a typical sample post-production workflow.

1. Download the images from your memory card to your computer.

2. Copy all the images to two backup hard drives.

3. Working from the images on your desktop, edit the images inward—that is, star or flag only the keepers and throw out the rest, and only from your desktop, because you never know whether you will later need the ones you didn't keep.

4. Edit the keepers again, further cutting down your image selection as necessary.

5. Open the keepers in an image-editing program and retouch and edit them as you like. Then export them to JPEG if you were shooting RAW. You can edit the same way if you shot JPEG.

6. Back up edited RAW images and the processed JPEGs to external hard drives. You can discard the original backup of all the images to save hard drive space and keep storage costs/space down after the client has viewed all of his or her images. Keep them until then to make sure you didn't accidentally forget to process some image and that the client doesn't want an image reprocessed differently. Make sure you let clients know how long they are able to go back to having a color image if you changed it to a black and white, if this is an option you offer your clients.

7. Back up the images online and upload them to an online viewing program if you choose to show or sell your images this way. I suggest having a place where all your images are backed up online so you can access them anytime from anywhere.

8. Blog about the shoot and the images.

9. Post your favorites to Facebook (with the client's permission).

10. Hold a viewing/sales session with your client. If the client is out of town, you can Skype or use another video chat system to walk your client through the retouched photos and what options you offer. For example, you can show the images large on the screen and also show canvases/albums.

11. Mail a thank-you letter to your client.

12. Create a birthday card for the baby and the mom and mail it two weeks before the baby's birthday. (You can set a reminder on your computer or smartphone.) Remembering that mom had a really tough and exciting day the year before and giving her a pat on the back goes a long way. Often mom is forgotten in the excitement surrounding the baby's birthday, so I always like to celebrate the birthday with mom *and* baby.

13. Process the orders you received at the sales session.

14. When the images are returned to you, check for quality and repackage them in your branding.

15. Submit any images you like to magazines, blogs, and websites for added publicity. (Make sure you get the okay from the family and you have a model release!) This may not lead to sales, but it can give you bragging rights. I had an article published in my hometown newspaper that brought in more business than I could've imagined—the largest weddings we have photographed and the most baby business. It didn't give us worldwide publicity, but it targeted the right audience—people who knew and trusted us, had heard our name before, and wanted art to showcase their family.

 Find magazines you'd like to submit to by looking online or going to a bookstore. You can look in the first pages of the magazine to get the editor's contact information and then email the editor and ask how the publication likes to receive submissions. To have more editors open your submission and to ensure that it doesn't get lost in the shuffle of all the other mail coming into the publication, make the package look pretty and exciting and send it via UPS or FedEx.

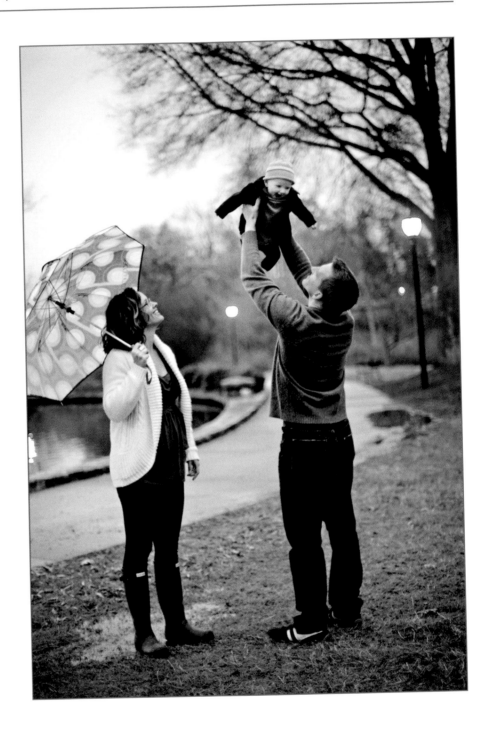

7

Marketing and Sales

Selling is one of the tougher parts of this career for many photographers. It takes a certain personality to be a truly good salesperson, and you may or may not have that personality. But even if sales isn't really your thing, you can take steps to make sure you market your product as effectively as possible. Relationship-based sales are often easiest, for example. When people trust you, they can come to rely on you as a trustworthy source.

Marketing Your Product

Before you can sell anything, you have to market your product. But where do you start?

Market Happiness

First of all, appeal to your clients' emotions. If your images show happy people, you're selling a fun and happy experience, and people will feel good about working with you. Your clients want to remember all the happiness of having a child: Although it's not easy, as my dad says, you only remember the good parts. So capture them!

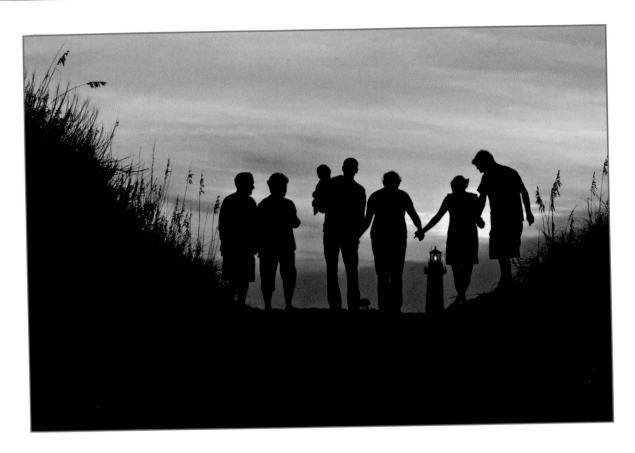

What makes people happy often depends on their age. For example, when I was younger, I generally felt happy all the time but was super happy and excited when there was something to look forward to or when something happened that made me even happier (a friend came over to play, I got a new Cabbage Patch kid, or we got ice cream—well, that last one still makes me super happy!). As an adult, I'm happiest when I'm with my family and friends, when I don't have anything stressful hanging over my head, when everyone around me is healthy, and when my clients are happy. It's peaceful. Often, adults feel as happy when everything is calm and peaceful around them as they do when they're doing something truly pleasurable. Keep this in mind when you think about your target market. Think about what would make your clients happiest and then use images in your marketing materials that reflect this. Because you're probably marketing to parents with young families, your marketing materials might show the kind of calm peace that makes these types of parents happiest!

Market to Your Current Clients

How do you market to current clients? There are the obvious tactics of issuing coupons or running promotions, but there's more to it than that. When you give the client the images or album in the studio, make the packaging beautiful and have it look like a gift—make it fun for her to open! That way, when she opens it up, she is eagerly waiting to see what's inside. Include a thank-you card or a gift certificate the client can keep or give to her friends for a certain percent off her next portrait session. Or, you might include a gift certificate to a children's clothing boutique or a children's museum. Now's a great time to partner with other businesses! It's trusted and direct marketing for both of you.

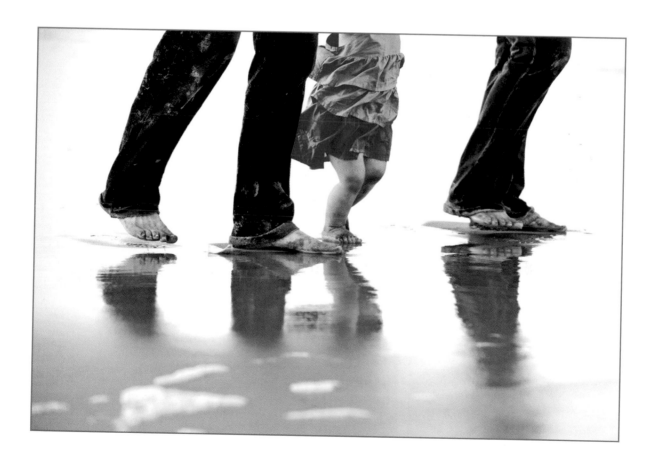

Gain Referrals

Referrals are your best, most trusted, and cheapest marketing tool. Build all your other marketing around them.

To gain a referral, you must be on time, exceed the client's expectations, be liked and trusted, and respect others. By being on time, you show your clients, employees, friends, and colleagues that you respect them and their time. Being late tells them that you think your time is more important than theirs.

Also, return phone calls within 24 hours, tops. I have a four-hour policy during work hours. If someone calls after business hours, I return his or her call first thing in the morning.

Gain people's respect and trust by respecting their goals and listening to their ideas. When you do this, you are making people want you in their lives, and they'll want to refer you to their friends and colleagues. Mutual respect goes a long way in this business.

Remember that your actions can work for or against you. If you treat people with respect and exceed their expectations, they are likely to refer you to others. But if you treat them with disrespect or your work fails to meet their expectations, they'll be just as quick to spread the word about you in a negative way. In fact, an unhappy customer or employee generally will tell five times as many people about you as a happy one will.

Network

Another way to market your business is to network with other vendors and photographers who are in a similar price range. If a photographer who refers you charges significantly less than you do, the client he refers won't likely be educated about your prices and services, and she may experience sticker shock. However, if a photographer, client, or vendor who is in your price range or who you have worked with before recommends you, the client will be used to the price range you're in and will know what to expect in terms of quality, style, service, and price.

Go to social functions where members of your target market may be or where you can meet other vendors you'd like to work with. Introduce and reintroduce yourself to others in a confident and approachable manner. People want to see the face behind the name and get to know you. Remember, you *are* your brand, so keep it strong.

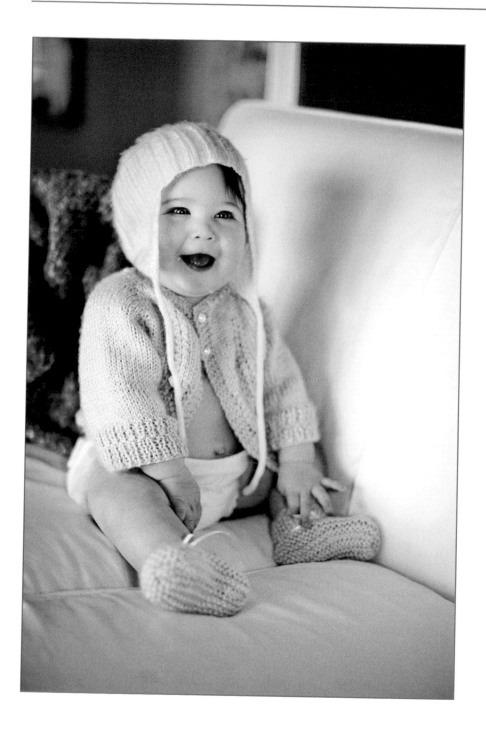

If you recognized someone you've met before, say something like, "It's great to see you again! I'm Brooke Mayo. I believe we met at the Smiths' holiday party…." Find some common ground to connect on and then listen to what the person has to say. Ask her to talk about herself, and be genuinely interested! Don't look around for the next person to talk to—you want the person you're speaking with to know you value her opinion and ideas and you think what she's saying is important. And *please* have your phone off! How rude is it when you're in a conversation, and the other person picks up his phone or reads a text or email?

When you go to these types of functions, have a drink—but not too many. You don't want to be drunk and act poorly or say something you'll regret.

Be friendly, helpful, and kind to all you meet. It's not just about business; it's about being a good person. Be approachable and talk to everyone, especially the person in the corner who looks nervous—we've all been that person at one point, and how great did it feel when someone came up to talk to you? Get these people to open up; great listeners make great friends.

Above all, get out there. You never know what getting out and about could mean for your business. You might book a job or meet someone who can introduce you to someone else.

Networking is not accomplished only in a professional context, though. There's a personal side to networking as well. Many of us work from our home and are on the computer each day, so we accomplish a lot online, but nothing compares to face-to-face connection. Make it a point to get out a few times a week and have lunch with a friend, another business owner, or another mom, and leave your phone in the car. Make whoever you are spending time with the most important person in the world during that time—there's nothing more annoying than being in a conversation and having the other person start texting or looking at his phone. It makes you feel unimportant and unappreciated.

Laugh and have a good time while you're out—it's infectious! Enjoy each other's company. What better marketing is there than getting out and having fun—no computer or technology necessary? It won't even feel like work, even though it is!

Use social networking, too, such as Facebook, Twitter, your blog, LinkedIn, and BranchOut. Have a positive online presence on all of these social-networking sites. And who knows? While you're out and about, you might recognize someone you're Facebook friends with but whom you have never met in person. There's no better time to introduce yourself and mention one of their posts: "I saw your photos of your kids baking a cake with their grandma this morning—how adorable! How old are your kids?" Even though some social-networking connections don't seem "real," they are, and they can be helpful for business and for making real friends. We'll discuss this more later in this chapter.

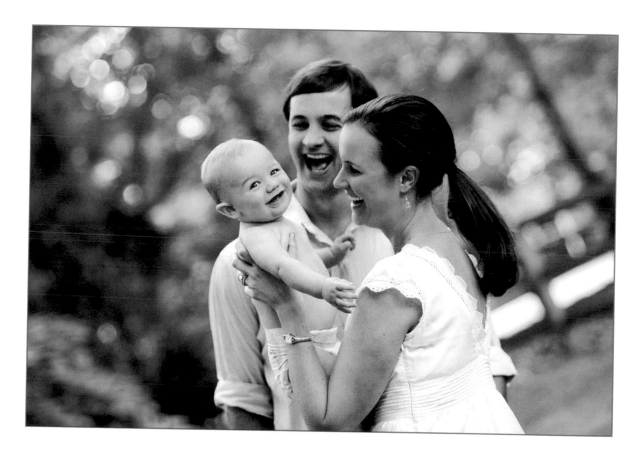

Market with Other Companies

You can share advertising by marketing with other companies. Do a promotion with a baby-clothing store, a daycare, or a children's museum. You could have large fine-art portraits displayed in a high-end baby boutique, and when their client spends a certain amount, the store can give her the gift of a photography session, a free 8×10 with any session booked, or a gift certificate for a certain percentage off a session. Have the boutique give a brochure to each client who purchases something, and leave a stack at the register or near the door as well.

Another idea might be to run a promotion to photograph the boutique's clients in the outfits the store sells. You could offer 15-minute sessions to anyone who shops on a certain day and spends a certain amount of money. Then give the boutique photos from this in return for them sending an email to their mailing list with your contact information and any specials you may have, as well as photos and a link to your blog or Facebook page.

Don't Forget Out-of-Towners

If you live in or near a resort area and the majority of your clients are from out of town, it's important to reach your target audience months before they arrive for their vacation. If you leave brochures in rental homes or around town, it can bring business, and it enforces their decision to use you, but by the time they get around to calling, you will probably already be booked, as most vacationers will need the session booked in a fairly tight timeframe.

So how do you market to this group? Think about the first thing they generally book—their accommodations. Market through the local realty company, hotels, or beach clubs where people are staying. The booking agency will know who booked their low-, midrange-, and high-end homes, so that gives you an idea of who to target. Now, keep in mind that you may think your target audience is comprised of high-end home renters; however, they might not value family as much as the midrange home renters who stay at a more modest house to save money for child-friendly activities or photographs. The people renting the higher-end homes may be couples or families who spent most of their vacation money on the accommodations. Although this is not always true, it's something to consider when you're choosing to whom you will be marketing.

So what will you do for the companies that put you in touch with their clients? They want to recommend someone who will increase their bookings, and you want them to have experienced your work firsthand so they can give a strong recommendation. You might hang large canvases of their families in the office where guests will be checking in. The booking agents have spoken to you, emailed you, seen your pricing information, and booked you. Now when their clients arrive, they'll see large canvases and get even more excited about their photo shoot. If you're lucky, they'll begin picturing a 30×40 of their child playing on the beach that they can hang above their couch.

Again, make sure you display what you want to sell. If clients see khaki and white in the photographs, and you told them to wear polka dots and funky shoes on the beach, they will be confused.

As an added incentive, you might give these clients a gift. Think of gifts that don't cost you a lot and that get your name out there even more. A gift of 25 holiday cards is a good idea, because clients will send these 25 cards, which include your work and contact information on them, to 25 friends and family members. This is also a great way to up-sell; you already have the cards created, and the client may order more than 25. Trusted marketing and a profit to boot—without any extra work!

Market in Little Ways

Marketing doesn't always have to be a major undertaking. There are countless little ways you can market your services without spending a fortune on a massive marketing campaign.

For example, after a shoot, send a small gift or thank-you card to the client. This will make the family smile and think of you. Send them something they can display around their home so that when they look at it, it will remind them of you.

If you go to a restaurant, leave a nice tip and your card—you never know when your server will need the services of a good photographer.

Talk to pediatricians, obstetricians, children's boutique owners, and even dental offices to see whether you can hang photographs of babies or children in their office and leave a stack of your business cards. It's a win-win situation—they

get free artwork, and you get free publicity. It's especially helpful if the photos are from clients who go to the office or boutique. If you do this, make sure to show what you want to sell—maybe it's a collage or a graphic piece with photos, or maybe it's simple framed pieces. You want to catch people's attention; you want it to look like an art gallery and give parents something to look at when they walk into the office.

If You're a Mom, Be a Mom

If you're a mom, get involved with other moms and parents in the community. Take complimentary photos at playgroups—you're not only documenting your child's friends at this age, you're also showing other moms the quality and professionalism of your work, even when you don't have the best light or circumstances. Your fellow moms might not need photographs right then, but they will think of you the next time they do.

Share Testimonials

Saying you're great is bragging, but having others say you're great is marketing. On your marketing materials, website, and Facebook, showcase your education and testimonials. With your clients' permission, provide their names and any other info about their family or shoot they want to share. Anyone can write a wonderful testimonial, but making it real and showing that it belongs to a family gives it so much more credibility. People want to be able to relate to the testimonial and the parent from whom it came.

Display Publicity

Publicity is better than any advertising. If you have any publicity bits, show them! Hang up copies of any news articles about yourself and your business and put them in your information packets and on your website. Have other businesses with whom you may share customers blog and Tweet your publicity.

For a small business such as a photography studio, local publicity is better than nationwide publicity. Although national publicity is good for bragging and gives you more credibility, local publicity brings in the clients. The most business I received from any publicity was from a front-page feature in my hometown newspaper.

One thing to keep in mind about publicity: There is only so much you can sell. If you market your services on Groupon or other social shopping sites, you could get hundreds or thousands of new clients. Are you prepared to handle all of these? If not, and if you can't deliver what you promise by the date you promised, you just ruined your reputation.

Services such as Groupon are best used when you don't want to give discounts to existing customers; instead, you want to gain new customers. For this reason, this type of service is best used by brand-new businesses, rather than existing ones.

If you plan to use a service such as Groupon, make sure to read and reread the copy they will be using to make sure they sell your product accurately. Bear in mind that they also take a large percentage of any money you take in, and they take any credit-card fees out of your percentage.

Enter Competitions

Enter competitions frequently. Having to look through all your work and choose the best of the best helps you to look at it with a more critical eye and to see what you could've done better with each image. This is a great way to grow as an artist. It also keeps you thinking about new ideas and fun ways to shoot.

Your biggest competitor should be yourself—competitions are a great way to challenge yourself and get recognition. When you win a competition, you can use it for marketing; it establishes you as an expert and a well-known artist.

There is a new website called Pixoto (www.pixoto.com), where you can enter your images for free and then go to what they call "image duels." This is where you look at two images side by side and choose your favorite. It's a fun game, and you get to see beautiful photos and see different ways of shooting. You can even look at them with a critical eye and think about what you would have done differently.

You can also hold competitions on your blog or Facebook page to try to increase traffic, get more people viewing your images, and gain more referrals. For example, you might offer your clients 12 free wallet-size images if they have more than 15 unique comments about your images on their Facebook page. Or you could have a contest on your blog by posting one image from each of your shoots from that week or month and then having your clients email their friends to vote on their image. The client with the image that gets the most votes could win thank-you cards, extra pages in their album, a framed portrait, a canvas—whatever you choose. I always try to give away cards, because they're free marketing. A canvas is gorgeous, but only the people who come to the client's home will see it.

Give Back

Be involved in your community—the more people who know you, the more people you'll have who want to work with you.

Donate to nonprofits affiliated with your target market(s). You can just give money, but then you're missing the marketing aspect! Instead, set up a shoot and donate a percentage of your profits to the organization. Your clients will feel good about using your services, and if you market the shoot in a way that doesn't sound self-serving, you'll probably gain some new clients, too. These new clients might choose you this time because of who you're donating to, but now you have trusted access to their friends and family when they blog or Tweet about your images or promotion. The organization to which you're donating may Tweet, Facebook, and advertise you and your sessions as well. A great time to do this is when you begin offering a new product or service—you'll get more hits on your blog due to the free advertising.

Teach Others

You're a photographer, so why not teach others photography? You can hold seminars and classes on how to use a point-and-shoot or a dSLR. Moms love to take photographs of their kids. They can't hire a professional for every moment with their child, so they want to know how to take good pictures on their own. And if they enjoy your seminar, you can bet that when they *do* need a professional, they'll come to you. After all, you've established yourself as an expert by teaching a class.

You could host small classes yourself or teach at a community college or even at a photography conference. However, keep in mind that at photography conferences, photographers are there to *learn*, and not to buy your product. I've heard from many photographers recently that they are tired of going to conferences and classes because people are constantly trying to sell to them. In this scenario, be an educator, not a salesperson.

Online Marketing

Online marketing is one of your best tools. Show what you want to sell on your website, blog, and/or Facebook page. You can post your best shots, your most creative work, new things you're working on, and even shots of your photographs hanging in your clients' homes—in the form of canvases, storyboards, and series of images. (As always, make sure it's okay with each client before you post any images. If there are, say, four families in the shoot, you have to get a model release from each family and ask permission from each family to post images.)

When you think about online marketing, remember that you should feature what you want to shoot. Don't feature the type of work you don't enjoy doing. For example, some of your clients may want edgier images than you like to shoot—if you've done edgy work but you don't particularly want to be asked to re-create it, don't feature it on your site.

When asked to critique websites, the biggest thing I see is that it's difficult to identify photographers' goals based on their sites. What is their vision, and what do they want to shoot? They explain their vision to me, but when I see their website, it's nothing like what they just told me. When I ask them why, they usually express that they're afraid of losing customers by not showing

traditional, posed portraits, for example. But, if you show images that are different from your vision, just to appeal to a mass audience, you won't acquire the clients you want—the kind that will allow you to create *your* art from their family.

But, if you want to change your style, or if you have a new vision you want to share with your clients, show it. Do several complimentary shoots (maybe for your best clients as part of your rewards program) in the style you want and show the results on your website, blog, and Facebook page. When people see what you can do, those who like that style will come to you for it.

Blog It

Although many people are getting their information from social networking these days, blogs aren't obsolete. They are a big part of your online presence. So blog, blog, blog—and do it quickly! The key to blogging is to show a few of your favorite images shortly after the session, while your client is still super-excited. The excitement will make her want to share what she sees immediately, and her friends will love seeing the images the day of or the day after the shoot. Your client will likely have been talking about the shoot for weeks, and she'll be excited to have an immediate photo to show her friends. They'll be wowed at the timely turnaround, and your client will give you rave reviews. I find that when I post images quickly, I end up getting several referrals and inquiries that day.

But to attract a wide variety of readers, pretty pictures aren't enough. People come to blogs to gain something. You can share information about where you got your props, describe what ISO/f-stop/shutter speed you used and what type of lights you like, and even show the setup of what you shot. Don't give it all away, but share enough to get people interested. Sharing this information will attract newer photographers as well as established photographers who are looking for inspiration. So, talk about the shoot and how you made it comfortable for the family, and perhaps describe the challenges you faced and how you overcame them without the clients worrying.

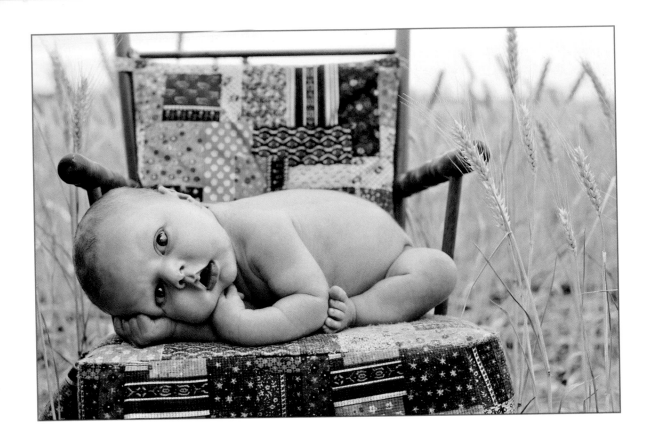

Make sure you have a Share It button that people who are viewing your blog can use to send your post to Facebook or Twitter. If they find something useful or beautiful and they want to share it, let them!

Use Social Networks

Your website and blog are obviously huge components of your online marketing, but don't neglect social networking as a marketing tool, either. Put images on Facebook and tag your clients. (Of course, always ask permission first!) Your clients' friends will see the images, and you will then be a trusted "family friend." When I post photos on Facebook, I see an immediate return, with others sending messages that they want me to document their baby or family or birth.

To gain the maximum exposure, think about when most people are on Facebook—mornings, evenings, lunch breaks, weekends? It depends on whom you're trying to reach, to some extent. Work-at-home moms may be on Facebook at a different time from parents who work away from the home, and parents with school-age kids might be on a different schedule as well. You just don't want the images to get lost in their feed, so keep in mind whom you're trying to reach and when they might be on Facebook.

Although Facebook is great for marketing, it can also eat up your whole day if you keep it open! I use Facebook like I do my emails—I want to be available and present, but I don't want it to consume my life. Check the comments on any new photos you published that day, as well as your Facebook messages twice a day. Update your Facebook status via Twitter every few hours with something interesting, not just what you're doing. You might set up days to cover how you Tweet, such as:

- **Day 1: Lighting suggestions.** When you see new light in your office, on a shoot, or after a walk or lunch, Tweet what it was like or what you saw yourself shooting in that light and how to use it. For example, "Enjoyed my lunchtime walk today; could see kids running through the field in the noon sun!"

- **Day 2: Props.** Go through your closet while you're getting dressed and say why you chose what you wore that day. For example, "Can't wait for my newborn shoot today. Wearing my fuzzy sweatshirt, because you never know what you'll use for a backdrop!"

- **Day 3: Software.** Talk about what you're doing in post-production. For example, "Having fun editing my portrait session from this morning. Adding saturation to the background while desaturating the skin tones."

- **Day 4: Firsts.** If you have kids of your own, this should be an easy one. Tweet about any firsts your kid had that day and talk about how you captured them. For example, "Poppy stood for the first time today! Moms, always make sure to have your camera within arm's reach!"

- **Day 5: Ideas.** Tweet about some shoot ideas you have. For example, "Went to the grocery store and saw the cutest pumpkin. Can't wait to carve it and get a shot of a baby in it!"

Make your Facebook and Twitter updates easy, fun, approachable, easily replicated, and useful. Just don't Tweet your brand-new ideas. Share things you've done before and that people may have seen, but that don't give anything away.

Always be involved and approachable—after all, it's not called "social networking" for nothing! Never, ever say anything negative on Twitter, Facebook, or your blog—or in public, for that matter. Word will spread like wildfire, and before you know it, all your marketing efforts will have been ruined due to the one negative or insensitive comment you made. Keep to what you learned as a kid: If you can't say anything nice, don't say anything at all.

Something to Hold Onto

In all the excitement over your online marketing options, don't forget about business cards and brochures. But don't be old-fashioned; be different! You want to have a printed piece you can give to people, but if you have a tri-fold brochure like everyone else has, it doesn't make you stand out. Create something unique that people can use and will want to keep.

How often do you receive a business card or brochure and quickly throw it away? Usually it's because you don't currently need the service. But you could go from not needing that service to needing it in a day, a week, a month…. So, what can you make that your potential clients will want to keep? Perhaps something beautiful they can display in their home, maybe a funny conversation piece, maybe something they will want to use later—be creative!

And then, when you come up with a creative marketing item, be sure to pass it out to anyone and everyone.

Brevity Is Best

Be brief in your marketing and correspondence. Keep your sentences compact and not flowery—today's generation wants to get to the bulk of what you're saying quickly.

On Twitter, you're limited to Tweets of 140 characters or fewer, but if you post only 100 to 110 characters, there is room to re-Tweet and spread your message to more.

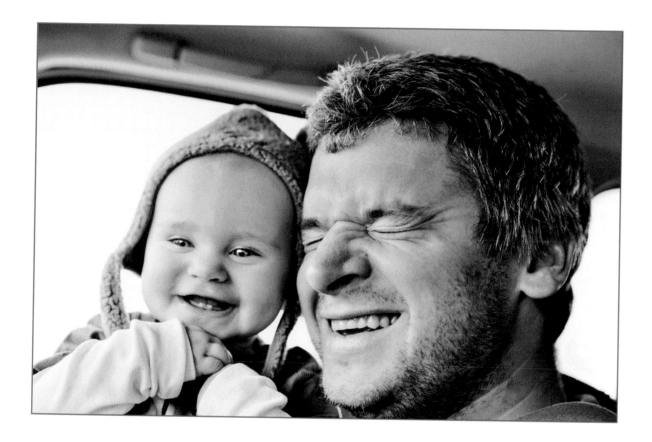

If you have a promo video of you shooting, keep it to less than two minutes. You might want to show people more than that, but keeping it short will keep people watching it. After two minutes, you'll lose most of your audience.

Brevity even extends to your phone correspondence. When you're talking on the phone, you don't want to take up a lot of the client's time or your own. Have an agenda for what you want to discuss. You should still be very polite and interested in the client's family and what they have to say, but don't talk for too long, or you will lose their attention.

The Big Sell

In some ways, you're always marketing your work. That is, your online presence (website, blog, Facebook page) serves as a constant advertisement for the art you create. But no doubt your biggest sales opportunity comes right after the shoot. Your clients hired you to shoot images that they have every intention of buying. Now all you have to do is create a comfortable atmosphere in which you can show them what you have to offer.

At the photo shoot, give clients a card or booklet explaining what's next. This booklet should explain how and when they will be able to view the images and how much various products cost. It's also wise to include photos of each product, so the parents can get an idea of what they might want to order. You can set a time for them to come to the studio to meet you after the shoot. Make the process as easy and fun as possible for them.

Consider What to Sell

First, you need to consider what you'll sell. Prints, no doubt, but there are many other options as well. And when you show the options to your clients, show them large—the larger you show, the larger you'll sell. Show them canvases, mounts, collages, albums—I even saw recently a company who prints on the decks of skateboards!

Will you offer predesigned albums? These sell best once the client sees her family in them. However, choosing images for an album can be a daunting task. When you meet with your clients to show them their images, go through all the images first and mark the ones they like. Then suggest that they take all these images and make an album. You can have sample albums from other shoots so clients can get an idea of what they'd be purchasing.

Now that many dSLRs shoot video, you can shoot video of parts of the session and sell this as an add-on or as part of your package. Some album companies now have a place on the album cover for an iPad. You can load an image slideshow or a video onto the iPad and sell this with the album. You can increase your profit by offering (and charging for) a feature like this, and it adds a huge "wow" factor for anyone clients show the album to. The more your clients talk about you and show off your work, the more business you will receive from referrals.

Set a Timeframe

Always tell clients that it will take longer than you think it really will for them to view their images. It's always better to get the images to clients more quickly than they expect. If you tell them they'll be able to see their images in one week and then your computer dies, you may not be able to deliver on this promise, as you'll have to get your computer fixed before you can work on their session. Give yourself a buffer so you don't let your clients down. If you tell them they can view their images in two weeks and then you have them ready in five days, they'll be so excited!

In business, you have to be honest. If you can't make a deadline, let your client know. But it's better to avoid missing a deadline altogether. It's better to under-promise and over-deliver than to over-promise and under-deliver. You show your clients respect by not promising them something you know you can't deliver. How frustrating would it be for you if you ordered an outfit for your photo shoot the next week, the company promised it would be there by Tuesday for your shoot on Wednesday, and it never came? Wouldn't you rather be told upfront that it wouldn't arrive on time so you could make other arrangements? The same holds true for your clients. If you can't have their images ready in a week, don't tell them you will.

Set Up a Viewing Session

If you're going to the clients' home or having them come to your studio to view the photos after the shoot, go ahead and set a date at the pre-consultation to do this, so they can get childcare and plan for a date night. Tell them how long to plan for this, so they don't feel rushed. You can even have beer, wine, champagne, snacks, and soft drinks available at the viewing for a more festive atmosphere. Coordinate with a local winery or brewery to have their beverages at the viewing—they might even donate!

You want everyone who will be purchasing images at a meeting; however, you don't want too many people there, because they tend to talk each other out of buying certain images or sizes. If you have eight people who need to come to the post-shoot session, break it into four meetings of two people each. This way, you control the sale, and you sell individually to each couple.

Show your clients and others at the post-shoot meeting the best images and tell them not to worry about deciding on their favorites right away, but that if they like them, they should say yes the first time through. You can run through the images again for people to pick their favorites. The first time through, it's best for everyone to just sit back and enjoy the show.

When you're showing your clients their images, remember that less is more. Think about grocery shopping: When you go to the grocery store to buy ice cream, each one is similar yet different—chocolate swirl, chocolate fudge, chocolate chunk…. It can be frustrating to look at each one, try to figure out what's different, and then choose one. I don't know about you, but I'd rather have the grocery store offer me only a couple of choices. I don't want to have to sort through tons of choices; I want it narrowed down to the few *best* choices. When I get too overwhelmed, I just don't buy anything!

The same holds true for your viewing session. Although having more choices seems appealing, having fewer leads to more sales. If you show your clients all 100 images you shot of their baby, their minds will be reeling in no time—especially when you have 20 shots of the same basic pose, with only miniscule differences. On the other hand, if you whittle the show down to the best 25 images, each one unique and beautiful, your clients will be delighted with the results and excited to pick their favorites and buy prints and products.

However, this can be difficult if you are photographing many different families at once. If this is the case, pick your favorites for each family, separate them, and then only show the particular family and group photos to each specific family in their viewing and ordering session.

After you show your clients the images you've selected for the viewing, go back and show them your favorites. You can tell them what you would do with each of the images. (These should already be retouched, so they stand out from all the others. This also saves you time on retouching later, because you have already retouched them.) Then, go through all the images again and have the clients say yes to any images they want to buy. By saying yes to those, they are saying no to the rest. Finally, go through all the "yes" images again and walk clients through what they want to purchase. Suggest images for a collage or wall portrait and albums. Sell the large images first and then go on to the gift prints.

ProSelect is a great program to show your clients their images, let them choose their favorites, and show them what one or more will look like above a couch or bed or over the stairs. If an image is shown in black and white, do your clients have the option of having it in color? And vice versa? If so, is there a charge for this change? Clients will ask these sorts of questions, so it's best to present this sort of information upfront to avoid any confusion later. The information booklet you give them at the pre-consultation can include this type of info.

I suggest thinking of every question a client could ask and making sure you have an answer for it. A good way to do this is to have your family pretend that they are the clients and ask you really hard questions. I find that a few times a year, I am shocked by the questions I'm asked that I have *no* answers for!

Provide Purchase Incentives and Information

Give your clients an incentive to purchase images at the post-shoot meeting. You might offer a discount for orders placed that night. You might also put them online for seven days so they can order for friends and family. If you're doing the post-shoot meeting in their home, make sure to minimize the distractions and bring examples of all products you want to sell—you sell what you show!

Some photographers choose to have everything leave their studio "finished." That means no digital negatives are sold, and the wall portraits and even 5×7 gift portraits are framed. These studios obviously can charge more for each image, because it's finished.

If your studio sells only finished products, let clients know in advance that after the shoot, they must buy images that are framed and ready to hang. If you don't sell digital files, let them know this up front—you might even consider having them sign a contract saying they understand this.

If you sell finished images, one added bonus is that when the client comes to pick up his order, it feels *heavy*. If the client just spent $5,000 on his order, leaving with bags and boxes of heavy framed prints adds much perceived value to what he just purchased.

It's important to let your clients know upfront how long you'll keep the images you shoot. You can't keep all of your clients' images indefinitely; you would have rooms and rooms full of hard drives! You can always keep your favorites for personal use, but set some general limits. I back up all the unedited images from a shoot for six months, in case the client wants them reprocessed or I want to reprocess them for personal use. And when pricing your services and products, don't forget to include the price for storage space!

Add Value to Your Work and Products

You don't want your clients to pay thousands of dollars for something they feel they could've gotten at Walmart. Even if your client purchases only 5×7s, make them look beautiful! Not only in the retouching, but in the packaging—make sure your client's package looks beautiful and professional when she comes to pick it up or when she gets it in the mail.

Also, sometimes it's nice to have something that sets you apart from the rest. One thing we do is offer a little value-added service. If our clients live close by, we will go to their home to deliver and hang the images—and, of course, photograph them after they are hung. This is quite an impressive service, really—how often do you get art that you love, but you just can't find the time to find a stud, get out your tools, and hang the image? Think about what little value-added services you might be able to offer to make you just that little bit extra-special.

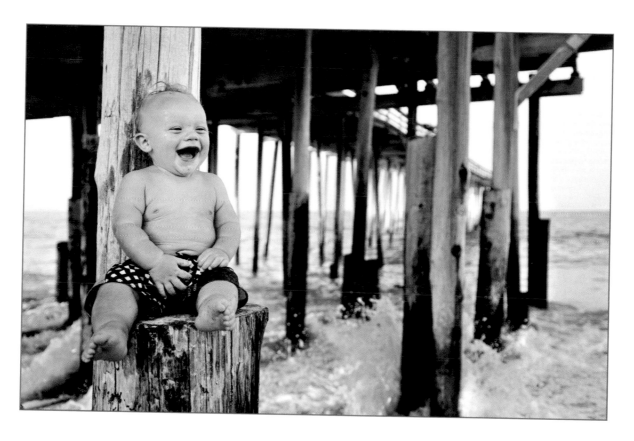

8

Loyalty Programs and Keeping Clients

Naturally, you want to keep the customers you have—they trust you and love your work! Your loyal clients may not be your wealthiest ones, but they will be your biggest cheerleaders. They will bring in more trusted clients who are in your target market. And by doing more shoots per year for each family, you'll be able to sell to them more often. To build a strong business, you want long-term, loyal, profitable relationships. To achieve that, customer retention should be your number-one marketing priority.

Retention Strategies

So, how do you keep your clients coming back? Number one is obviously by doing good work for them. If you continually do your best to provide them with beautiful portraits, that obviously will be a key factor.

But there's more to retention than that. Your attitude is key as well. If you're friendly, professional, and pleasant to work with, people will want to work with you again. Return emails and phone calls promptly. I recently had a wedding client who lives out of state, and she had a baby photographer for her first pregnancy who documented four sessions throughout the child's first year.

The following year, the client was pregnant with her second child and wanted to do maternity and newborn photos with her trusted photographer, but that photographer never called her back after several emails and calls over four months' time. The client was so disappointed—she loved this photographer and her work and wanted nothing more than to work with her again, but the photographer lost a trusted client because she failed to return calls and messages in a timely manner.

Another way to retain clients is to keep your personal life out of your business life as much as possible. If you can't do a shoot when the client requests, say you have another meeting or shoot, not that you have to pick up your child from school and you don't have a sitter. And if something is wrong in your business, take responsibility for it and fix it—don't make excuses. Never, ever tell a client something is her fault! If your client tells you that you didn't capture a good photo of her and her child, don't tell her it's because she was frustrated with her kid.

If your shoot is supposed to be an hour, make sure it's an hour or longer—don't shortchange your clients by cutting their time short. Children often get fussy or agitated by the end of shoots, so if you feel sure that you have plenty of great pictures of the family and have covered all the bases, you might suggest the family eat ice cream together, go back inside and have a flour fight, or let the kids get in the ocean if it is a beach shoot. Photograph them having a good time—this is where some of my favorite pictures come from, because you can capture genuine moments when the family is having fun together.

When you show up to a shoot, be prepared. Have your batteries charged, your cards formatted, and your camera set the way you want it—don't take the time the client is paying you to be there to document their family to do something you should have done on your own time.

As an added retention strategy, look for ways to reward your clients' loyalty. For example, you could let loyal customers be the first to know about your mini-sessions, giving them a chance to sign up early for a prime spot. Or, let them know first when you have an opening. Give them the prime slots you have available for shoots. You might even send them gifts. I enjoy shopping for little-bitty clothes and fun baby toys, and it's even more fun to wrap and package them and stick them in the mail! Whenever I'm out and about, if I see something adorable, I pick it up—you never know when you will want to mail something to a client. I've always loved making care packages, and who better to make them for than your clients?

I always send gifts for any new babies in my clients' lives and thank-you cards for each order or session completed. For wedding clients, I send a gift certificate to be used toward their next session (maternity/baby/just because) on their one-year anniversary. You could also send your clients gift certificates to give to their friends for a certain amount off their session or a certain number of prints after they finish a session with you.

If you see your clients' kids outside of shooting them and you play and have fun with them, it will make the times you *do* photograph them even more fun, and you will get more natural expressions. If you teach a class, offer to have their kids come model and then provide the parents with complimentary images. You could also offer clients discounted reprint prices or a complimentary session, or you could have their child be the one you call when you want to try a new technique.

You can have a rewards program, but what's a reward if the client expects it? It's better to give unexpected bonuses because you want to, not because the client is waiting for it.

The bottom line is that you want all your clients to remember your name and think of you first when they think of photographers.

Customer Service and Hospitality

Most people remember generosity, honesty, and kindness just as much as they remember negativity and crabbiness. If you treat your customers exceptionally well, they will remember and appreciate it. When I'm looking for a company, I choose one that has impeccable customer service and that makes me feel as if I'm their only client and they are doing things for me. The same is true for most people—they appreciate being treated well.

Negativity, on the other hand, will ruin your business in a second. It will spread quicker than you can imagine. A business that is built on referrals won't last very long if negativity is introduced!

Be mindful of this if or when you hire any associates or employees. A good attitude will be key for anyone working for or with you. Anyone who works for or with you represents your business, and you want that representation to be a positive one.

If you hire an employee, make sure they know that they represent your business even when they aren't working. So, if they go out to a bar, they need to behave reasonably. If they're going to be taking their shirt off, obsessively hitting on people, or being belligerent, they're not someone you want to hire. Let employees know that talking about your business to their friends or clients is not okay, either.

When you're shooting or meeting with clients, always be positive, even if you are frustrated with the baby or child or the lighting. Be positive and brainstorm how to make the shoot better with what you have, even if the situation seems negative. If you show frustration, your clients will pick up on it, and the whole mood of the shoot will change.

No matter what is going on in your own life, be excited about every shoot and every client. I love when I walk into a shoot, and the client mentions how infectious my excitement is—if I'm excited and positive, it keeps my clients excited and happy. The more excited they are, the more they trust me, and the more they will purchase, because it's a great experience.

A great way to remain positive and upbeat is to have a personal project that really gets you excited. It may be photography-related, or it may be decorating your home, making a garden, or volunteering. Whatever it is, do something outside of your regular job that makes you happy. When you're happy, it's easy to stay positive at your job.

I think of photography as who I am, day in and day out. It's not just a job to me; it's the way I view the world, how I carry myself, and who I am. I consider it in all my decisions.

If the client is hesitant or concerned about something, listen to her concerns, address how you will handle them, and make the client feel better. Reassure her that it won't be a problem. Stay approachable, and if something is wrong, listen to the client, restate the problem she communicated to you, and then state how you will fix it. Above all, never, ever be negative. To anyone. You want to be the positive person about whom no one can say anything negative. Period.

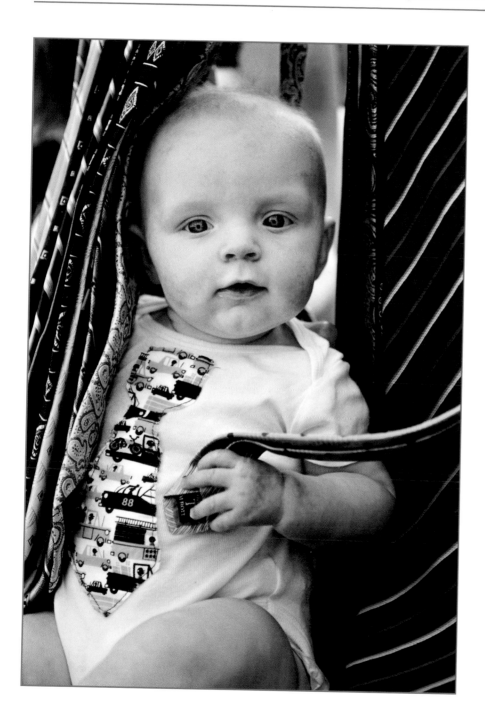

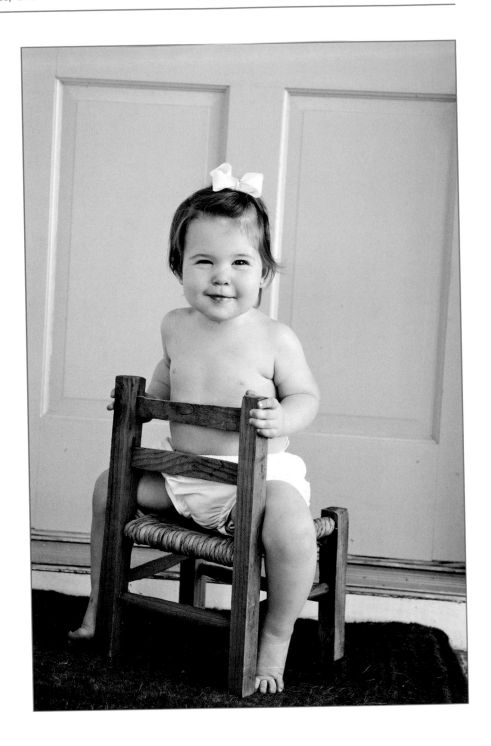

It probably goes without saying, but you should always know your clients' names and make them feel comfortable. In your initial contact, which might be via email, have a draft script ready that you can personalize with information for the client's family, kids, and location. Explain who you are, how booking works, and what they can expect, and then ask them questions. Get an idea of exactly what they are looking for so that you can send them a personalized quote. The more personalized the email or phone call and the more positive you are, the more excited they will be. From the very first contact, make each client think he or she is your only one. Remember, your clients are the reason for your business.

Go above and beyond for your clients. Send thank-you cards and post photos on Facebook and on your blog (with their written permission, of course!) within a day of the shoot. Posting photos on websites and blogs can get into privacy issues, so always check with your clients to see whether they prefer that you don't post them or whether they are okay with you posting them without a name or location.

Send anniversary and birthday cards, just to let them know you're thinking about them and to keep your brand fresh in their minds. If the client is expecting a baby, send her a baby gift or something for her—this gift should be something *not* related to photography and something that doesn't involve you making money off of her. It should be a genuine gift to let the client know you are thinking about her and that you care.

These small gifts and tokens can turn into profit later; the client will remember you and your customer service, even though it's not presented as customer service because you aren't currently working with them. Actions like this breed friendship, trust, and recommendations.

The Clients You Don't Want to Keep

In a perfect world, all of our clients would be wonderful. Our interactions with them would be pleasant and painless. There would be no bad clients.

Unfortunately, we don't live in a perfect world. Every now and then, you'll get a client who is unpleasant to deal with, who has unreasonable expectations, or whose wants just don't fit with your style or business. When you come across these clients, don't be afraid to turn them down. In some cases, it's just not worth the headache and heartache to try to satisfy an unreasonable client. And in some cases, it may just not be a good fit. If a client who you thought was in your target market turns out not to be, don't be afraid to discuss this with the client, possibly return her retainer, and let her go. Hopefully, she will appreciate your honesty and may even continue to refer you to others who are a better fit with your business. Make the break as easy and painless as possible; return all money and write her a letter telling her it was wonderful to meet her and that you are there to help in any way possible.

This is why you interview your clients just as much as they interview you. You want your goals, vision, and personality to click.

9

Keeping Your Work Fresh

Being invited into the life of a family and documenting the birth and first years of their child's life is a huge privilege. Treat it as such. At each shoot, try to create something that has never existed and something that will amaze people—this will keep you and your clients excited!

So, how do you keep your work fresh and exciting? First of all, be critiqued and critique others—it will help you become a better photographer. Get together online or in person with a group of photographer friends once a month for a critique session. Don't have a group of photographer friends yet? Professional Photographers of America (www.ppa.com) is a great place to meet other photographers in your field.

You don't necessarily have to stick to photographer friends for critiques and feedback, either. Work with people who want you to succeed and whose opinion you value. Perhaps it's someone whose business you use (your lab or accountant), or maybe it's your employee or one of your friends outside the photography business. They all have interest in your business, and in order to keep you as their client or employer, your business must succeed. If yours grows, so will theirs.

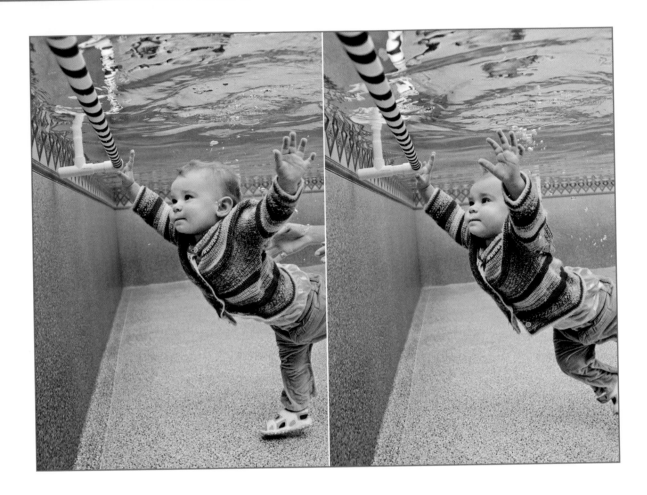

You could have your friends look at a session and state which images they'd buy and why. They can help you with your pricing and presentation, and they can tell you your strong and weak points and help you choose which images will sell best.

Be completely honest with these people. Tell them your goals, fears, and ideas. They can help you take an inside look at your business and make changes in your shooting technique, marketing, and products. It's a good idea to do this monthly, so you can make changes and revisit your plans every few weeks. If an idea isn't working, you want to change it as soon as possible, and if an idea is amazing, you want to be able to capitalize on it.

If you're just starting out, find another photographer to shoot with. You can do the same if you've had your business for years—it's always fun to shoot with someone else to see how they do it. You can learn so much from working with someone else—not only shooting techniques, but also how other people work, communicate with their clients, pose their subjects, use sales techniques, follow a workflow, and so on.

It's easy to get stuck in a rut, especially when you work alone most days. So, find inspiration outside of your comfort zone. You might work with someone who has a totally different approach and style from yours—you can always pull bits and pieces of what you learn and make it your own.

To further avoid getting stuck in a rut, be your own worst critic and challenge yourself. Come up with new ideas and places you'd like to shoot, play with challenging lighting, and give yourself assignments. These assignments may not be in the style you shoot daily, but they will give you more knowledge to add to your toolbox. You never know when something at a shoot won't be what you expect, and you'll have to problem-solve on the spot. For example, if you shoot primarily with daylight, use strobes for a shoot—in all sorts of ways! You can always practice photographing a ball, move the light around, and see how and where it falls. I know it's not the most fun thing to do, but it will help you visualize which type of light creates which look.

In one of my beginning photography classes, we had to photograph a ball for a week to see where the light fell at different times of the day and what happened to the light when it was far away versus close. We also had a class where we were only allowed to shoot black-and-white film for the first few months. Taking color out of the equation really helps you concentrate on composition. The photo has to be interesting; it's not just bright colors that make it beautiful. That class was a ton of fun because during our critiques, you never saw the typical sunset or sunrise or beach photo—the things that make these interesting are the colors. Instead, you had to have a strong foreground, middle ground, and background.

A good place to start looking for inspiration is magazines—fashion magazines, *Newsweek*, kids' magazines, and so on. See what colors go well together and what the newest styles of clothes are. Even if you don't incorporate these into your photography, it helps to be up to date on trends when you're talking to parents.

Find inspiration in unlikely places. Don't look at your competition and get jealous or wish you could do this or that—challenge yourself. It will make you a better photographer, focused on positive energy rather than jealousy and doubt. Besides, by looking at a competitor, you could indirectly copy her style, design, images, or marketing, and that's not what you want for your business. You want to be proactive; you want to be the one to come up with new ideas. So, use everything *but* your competitors for inspiration! Walk around town and look at posters, buildings, people, museums, fashion—anything you enjoy to help you think of new ideas. It's not just work; it's a lot of fun!

My best advice is to travel. Leave your town, state, or country. Get a new perspective on the world by seeing something totally new. The new work into which you incorporate this inspiration will be eye-catching and interesting.

When I travel, I limit the equipment I take with me for a few reasons. One, I don't want to have to carry a ton of equipment and risk it getting stolen, broken, or lost. Second, it is a challenge to have only one camera body and one lens and to be able to tell the story of your trip and family with one lens. How can you use it in different ways to get new angles and perspectives?

Even if you can't travel far out of your local area, don't stop learning! Go to museums, galleries, classes, seminars, and workshops—even if the class isn't about what you usually shoot, you can learn a lot and apply it to your photography business. Check out WPPI (*Wedding and Portrait Photographers International*), DWF (*Digital Wedding Forum*), ASMP (*American Society of Media Photographers*), PPA (*Professional Photographers of America*), and APA (*American Photographic Artists*). You can make some fantastic connections and learn a lot from these organizations. They have many classes each day where you can learn about business, shooting, technique, lighting, sales, equipment—they really have classes on everything! Take a look and see what interests you. You will meet tons of photographers—having impromptu lunches and chats is where I tend to learn the most and make the best of friends.

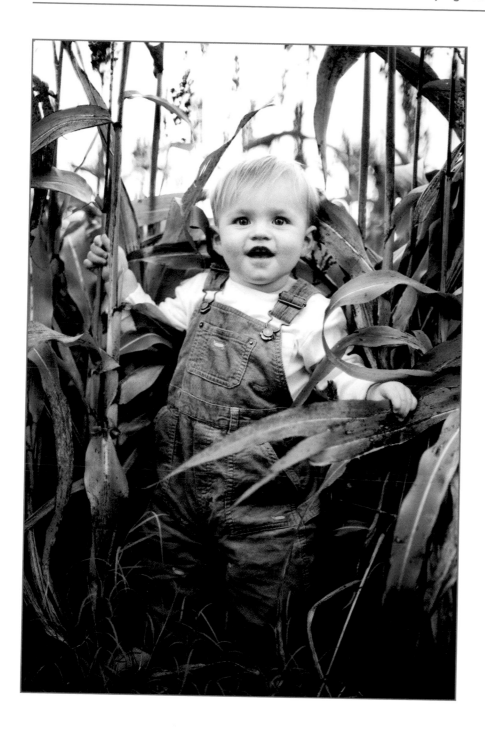

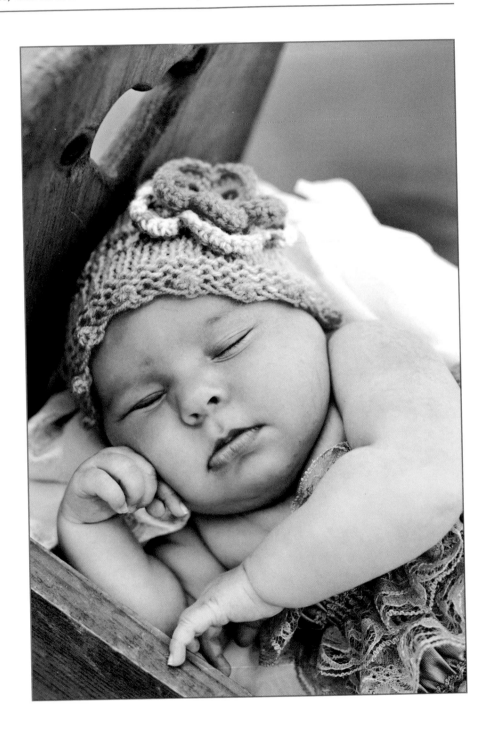

If these types of things don't suit your needs, get photographers together from all different backgrounds and have a retreat once a year. Share openly all you know and any new resources you have: album companies, design software, ways to handle having your own family and a business, best ways to pack your equipment while traveling—you name it. Above all, be 100 percent open— after all, that's why you're there.

Don't stop with yourself, either. Send your employees to conferences—it's a great way to keep them inspired and can be a huge perk of the job. They get to travel, meet others in their field, learn something new, and have a fresh eye for their own photography. They may learn a quicker workflow along the way, which will save you money on retouching and processing, as well as free up their time for other things that can make you more money, such as shooting or sales.

Photographing beebsters is a ton of fun and hard work! If you take nothing else from this book, remember to treat others the way you want to be treated. If you're honest and upfront, you listen to your clients, and you are fair, it will get you far.

Best of luck with your photography business—enjoy it! I look forward to seeing your images that are photographed in a way I've never seen before!

About the Author